SHAPED BY WAR

IMPERIAL WAR
MUSEUM

SHAPED BY WAR

DON McCULLIN

Jonathan Cape London

'LIKE ALL MY GENERATION IN LONDON, I AM A PRODUCT OF HITLER. I WAS BORN IN THE THIRTIES AND BOMBED IN THE FORTIES.'

Don McCullin, *Unreasonable Behaviour*

1

EARLY YEARS

1935–1957

Cecil Beaton,
St Paul's Cathedral,
London during the Blitz,
1940

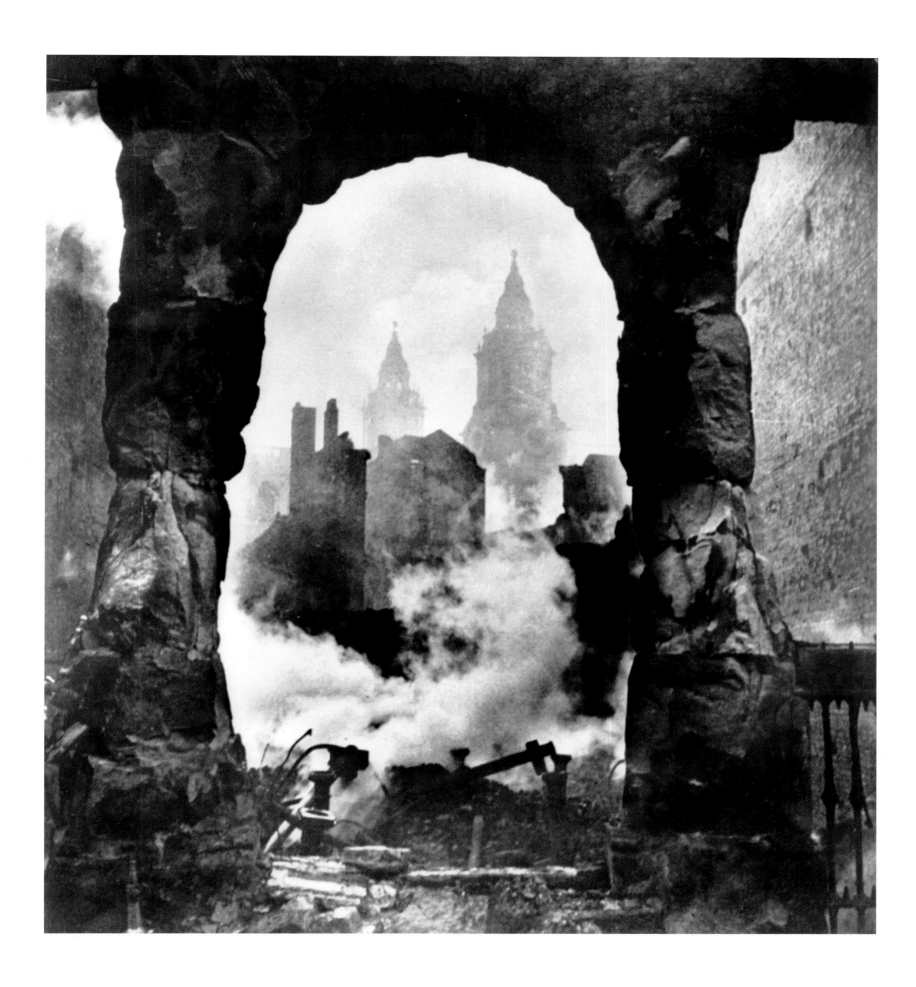

Bill Brandt,
Air-raid shelter,
London, 1940

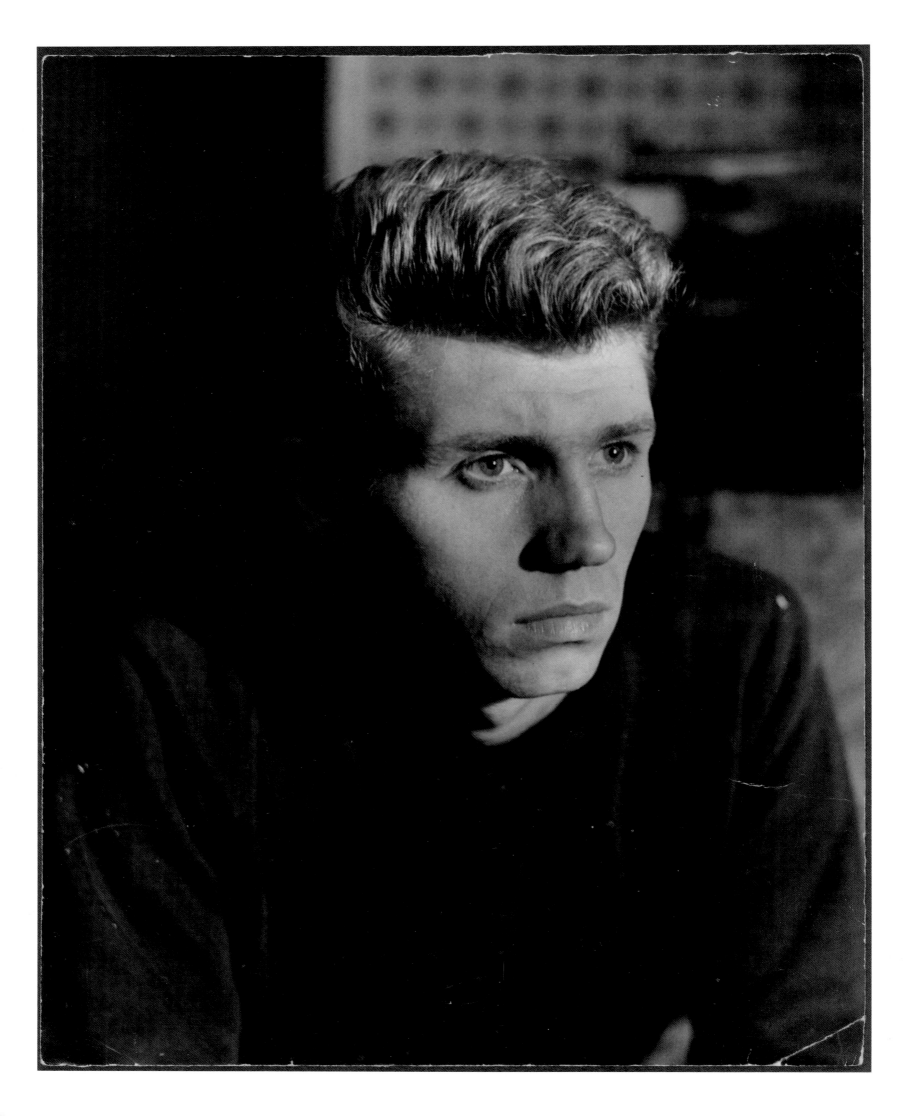

McCullin is an Irish name. My grandmother lived and worked in the Tottenham Court Road area of London and I believe she had a liaison with an Irishman in Camden Town. One of my sons has been scanning the Internet and has even discovered hillbilly McCullins living down in Munro, Louisiana. I came from North London, not far from Camden Town, and then lived in Finsbury Park until I was twenty-five. There were three children in our family – myself, my sister, Marie, who was only a year younger than me, and my brother, Michael, who was seven years younger. He fled from England and joined the Foreign Legion when he was about twenty. He walked through the gates of the Legion barracks in Marseilles and stayed there for thirty years. I think he suffered the envy of watching my life unfold as I went to extraordinary and dangerous places. He felt left behind. He used to be an electrician's mate, wiring up supermarkets, and there wasn't much of a future in that. He came out of the Legion as an adjutant in their Parachute Regiment. Personally, I feel that thirty years in the Foreign Legion would have been the waste of a lifetime.

When the Second World War was declared, I was plucked out of my primary school and put on a bus with my gas mask. We were sent off very quickly, because bombing was threatened. We were rushed off to somewhere in Huntingdon in Cambridgeshire, but we came back. Then my sister and I were dispatched to Somerset with the express wishes of my mother that we were not to be separated. We arrived in a charming village called Norton St Philip, about twelve miles from where I live now, and everything went wrong. My sister was taken in by a very nice family who were slightly *well-to-do* and I was sent to a farm labourer's council house. She got all the trappings like being served at table by ladies dressed in black-and-white outfits. Sometimes I used to go up to the house, the big house in the village, and look through the window and was chased away. I would be told that my sister was

having her tea and it wasn't convenient for me to be there. I grew up with a very defined attitude about those who have and those who have not. It was strange to be looking in at this other world. Bill Brandt, the great photographer, whom I admired so much, took pictures of women dressed in black and white waiting at table or preparing baths in rather grand houses. Life tends to repeat itself visually.

I stayed a year that first time. I remember my father coming to visit and I chased him up the road, crying and pleading for him to take me home. It must have been hard for him. I couldn't do it with one of my own children. He walked away and got on the bus that took him to Frome Station, and back to Paddington, and eventually to horrible Finsbury Park.

I went home for a couple of years, but the bombing was intense and frightening, so my mother shipped me off again. I was sent to Lancashire, which was a totally different experience. I had been in beautiful Somerset, full of leafy glades, slow-moving streams and slightly docile-looking cows munching away on their grass. Suddenly, I was on a train going north to Manchester, a much harsher environment with much tougher people. I've always found the people in the north of England *strong*, not just tough, but strong and warm-hearted. In those days there was still the legacy of Victorian Britain. There was that discipline and harshness. I went to a family who had a chicken farm, but unfortunately they turned out to be rather wicked.

When I arrived I was immediately taken to a barber. My head was shaved and I was made to wear clogs. In the Lancashire towns there was the clunking of clogs on cobbled streets. I was out in the country on a farm where the people were terribly unpleasant. I started getting beaten by the man of the house because I wouldn't eat things like boiled potatoes with their skins on. He was very cruel and punched me in the face. We slept on mattresses on the floor. There were no comforts. During the whole seventeen weeks I

stayed with that family I never had a bath until the very end. The night before I returned to London, they took one of the dustbins in which they kept the chicken feed. They emptied it and filled it up with hot water.

I look back on it now with some shame for that farmer. But that time helped prepare me to stand on my own two feet. These early experiences can be good or bad for us. Some people can handle them, others can't. I realise now that I certainly grew up then. I'm not going to say I was *grateful* for the experience, for I didn't have much of a childhood that was attractive. I had a fascinating childhood, but it was not the childhood I would offer a child of my own

The war was coming to an end when I got on the train to return to London. It was crowded with soldiers with their greatcoats on – those great big itchy greatcoats – and there was I coming back with my little bundle of possessions plus a huge bunch of holly for my mother. I must have been a real nuisance on that train because there was hardly room to stand, let alone sit. It was terrible. By some stroke of irony when I was fifteen I was working in the dining car of a London, Midland and Scottish train that went between London and Manchester two or three times a week. Events repeat themselves.

It wouldn't take long to describe my education, because I had very little. Finsbury Park oozed poverty, bigotry and all kinds of hatred and violence. Again, it was preparing me for something I didn't know was coming. Whatever I've learned, to this day, is what I've picked up and taught myself. I failed to achieve anything in my younger life. I simply didn't have the ability. I was also slightly disabled with dyslexia, which, back then, those old Victorian schoolmasters wouldn't buy. Lots of thrashings came my way. They thought I was malingering and I really suffered. I think what I am or what I have achieved has been acquired at a purely emotional level. Quite a distinguished writer went away after spending a couple of hours with me at home. In her piece she wrote all kinds of nice things about my work, but she said, 'He is not a learned man.' I was slightly offended by this, because I thought it sounded as if she was putting me down. The truth is I *have* learned things, and I will always learn for the rest of my life. This has nothing to do with my photography. I believe that we will always be students of life. The moment we think we've cracked it is when we've lost it. I will never believe my photography hasn't still got something to teach me.

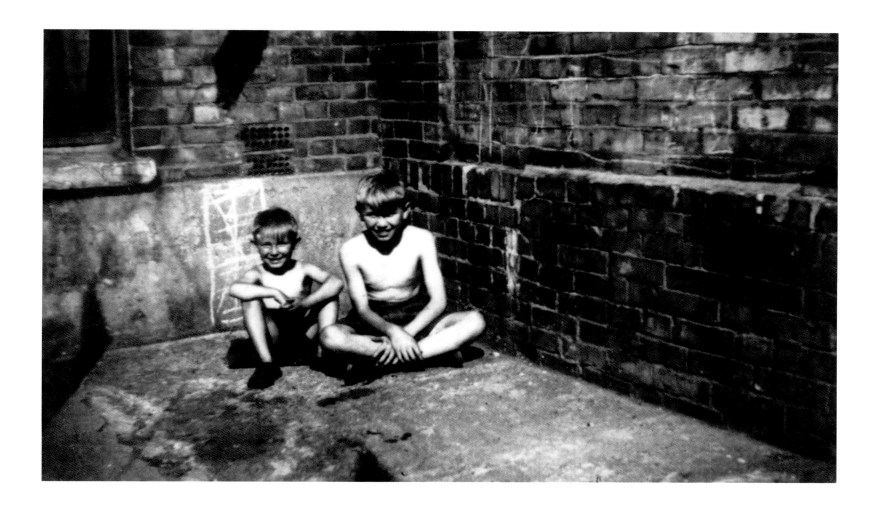

I studied photography by buying a whole stack of books in Cornwall in 1965 when I was working for the *Observer*. They were called *Photograms* and the volumes I managed to acquire began in 1886 and ran up to 1926. They cost me ten quid, which was a lot as I didn't earn much. Those books became my photographic university. I still refer to them today. You never stop learning. You never stop discovering. I'm constantly being surprised.

Music is the other element that's helped me a lot. My mother remarried when I was young and my stepfather brought an old wind-up gramophone with a stack of 78rpm records into the house. They were all records of opera. You wouldn't believe that a little twelve-year-old boy from Finsbury Park was listening to *I Pagliacci* or *Aida* and all kinds of wonderful arias sung by Caruso. These things were handed to me on a plate and were received with a lot of gratitude. I was like a kind of tumbling stone. I was rolling down the slope, not picking up moss but knowledge. I'm still doing it today.

I returned to a blitzed London. I became accustomed to broken buildings and devastation and also to certain smells. The recognition of certain smells is a strange experience in war. In Cyprus, my

first war, I remember going into a house and the first two things that came rushing to my nostrils were the smell of warm blood, which is an awful thing to have to mention, and the smell of burning mattresses. When I burn my household rubbish, these evocative smells come back to me. Smells and human cries come flooding back on a regular basis. When I went to war, I didn't need any tuition. I'd been in the bombing since I was a child. I'd seen the devastation of London. I hadn't seen any dead people though. The first dead person I ever saw was my own father.

My father never leaves my mind. Here I am, seventy-three years old, thinking of and missing my father. He was tragically invalided by chronic asthma. He could only walk twenty-five yards before having to pause and grab the oxygen. At night he sat almost upright on several pillows because he couldn't lie down. He never complained. Despite the awards and recognition, what I've really achieved in my life is to honour my father's name. That's the biggest achievement in my life. I don't really think my photography has changed the world in any way whatsoever. However, over the years I've changed my feelings about my father's suffering. He only survived until he was forty. When that happens to your father

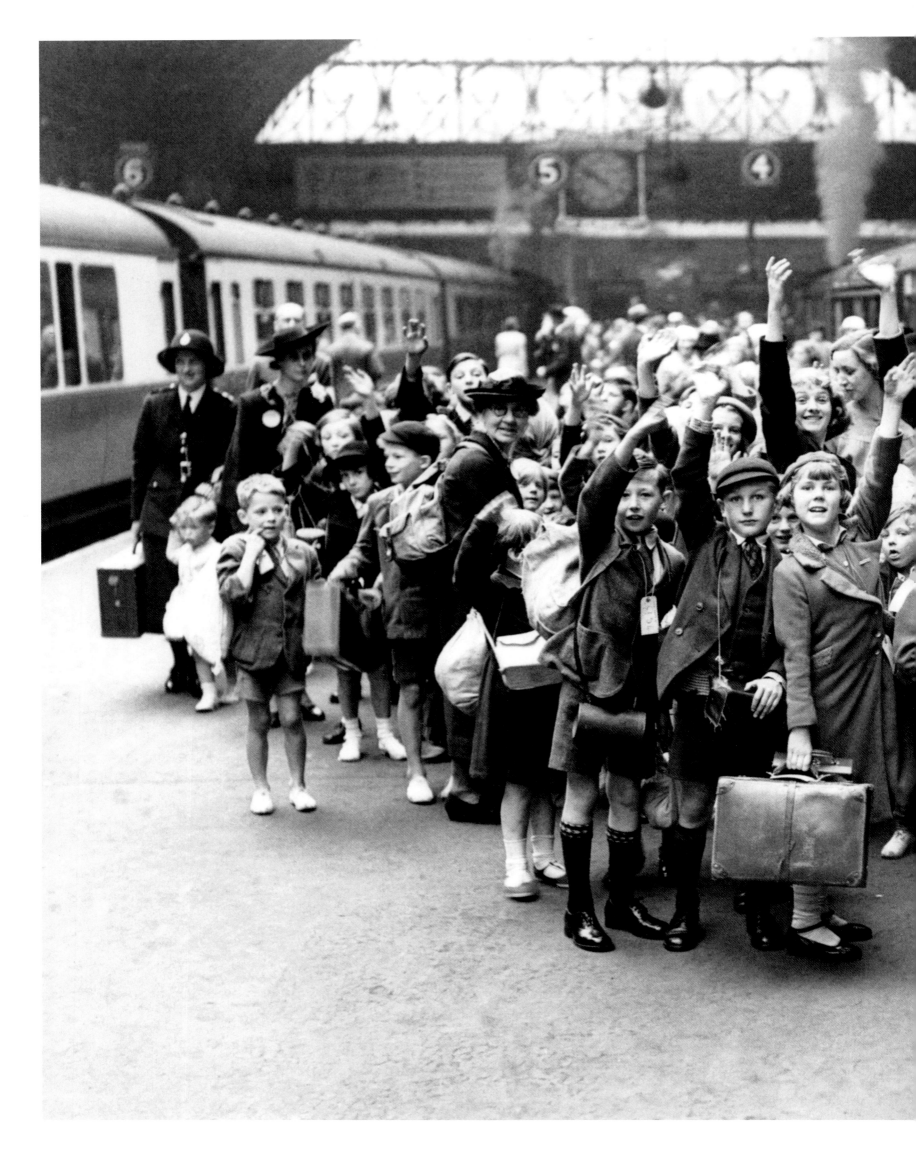

Evacuees, Paddington
Station, London, June 13,
1940

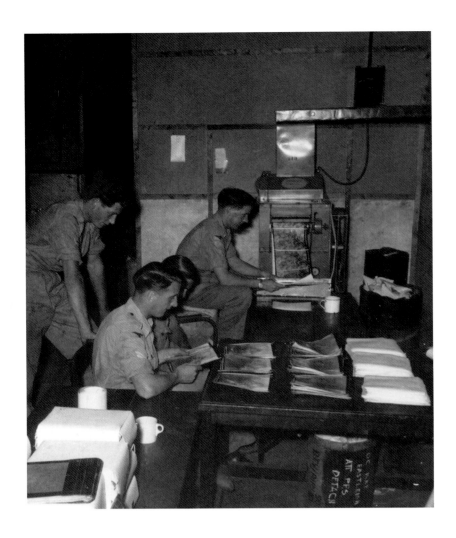

and you're creeping up to your forties, you say to yourself, 'I've got to get past forty. I've got to get past this terrible barrier.' And of course, I've been very fortunate.

Inevitably I faced national service. It was almost impossible to avoid. If there had been a real war, I never would have shirked my responsibilities. I would have been the first in the queue. But national service had become a way of policing the Empire, even though the Empire was in its twilight period. I looked upon it as if we were just cheap labour going out to police the world. Having escaped from school at the age of fourteen I didn't want a further two years of my life snatched from me. I didn't like the authorities in those days. I had no time for anybody that might have tried to stifle my freedom. The idea of going into the services and having my hair cut appalled me. I came up with some contrived story that I worked in a film studio and I wanted to go to a photographic unit, because I didn't want to be sent off to be an infantryman. That was the last thing I wanted. So I wound up in the air force and was sent to a photographic depot at RAF Benson in Oxfordshire. But it wasn't a photographic job. I was supposed to sit and renumber a million cans of Second

World War air film, which I really didn't want to do for two years.

I've always been a reasonably good moaner and whinger. I was talking to other people on the camp who said I should apply for a foreign posting. I was told not to apply for the place I wanted because they'd send me to the opposite place. I followed this great wisdom and put down where I didn't want to go to, and they sent me there. Instead of going to Malaya, where there was a really good photographic unit and access to a wonderful part of the world, I wound up in the Canal Zone for a year.

Purely for our own safety, in the Canal Zone we were confined behind barbed wire. There was hardly anything worth doing. A three-day guard duty came round every three days. I lived in a tent. The food was appalling – I was always hungry. To my joy, in 1955 I was sent down to Kenya, because the Mau Mau Rebellion was raging. I was dispatched there on a six-month loan to another photographic unit in Nairobi. My whole world changed. All kinds of wonderful things happened. I could get fresh milk, beautiful pineapple and great chunks of meat – proper food for a change. I could go out of the camp and into the town of Nairobi. I actually started dabbling in photography, because I

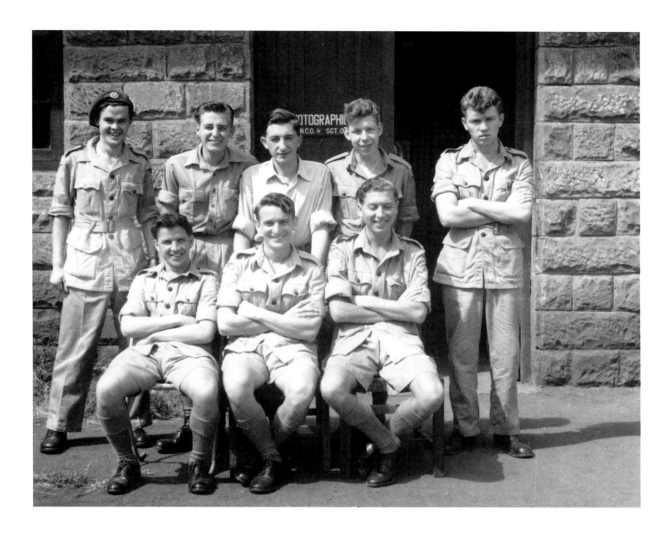

was using what they call a bulk-processing machine. Each night I would sit down and print three and a half thousand photographs taken from a Canberra bomber the day before. Though the film was actually processed by another member of the staff, I was handling photographic paper and chemicals. I started to develop an interest in photography. For thirty pounds I bought a new Rolleicord camera. I went into Nairobi and photographed people at the bus stations. That was my first real encounter with film and photography.

Sometimes I used to fly in Lincoln bombers just as an observer, which was basically nothing more than a joyride for me to get out and see parts of Africa. Often I would go in the early morning. Six Harvard fighters would take off in the mornings and strafe the jungle areas where there were suspected Mau Mau hideouts. I would sit behind the pilot. My life was beginning to blossom, giving me more confidence. I was seeing a different world.

I had been brought up on post-Second World War Hollywood films, which were meant to entertain. They were totally over the top and showed people dying after being shot in a Hollywood sort of way. My real war in Kenya was all high-altitude surveillance. I never saw anyone killed on these early-morning raids.

Sometimes I thought I could be in a Hollywood film because I was so detached from the devastation in reality below.

Before national service the only places I'd ever been outside of England were to France and Switzerland for two weeks with a friend who had a motorcycle. That had been the first breakout for me. But there was a huge difference being in Africa from being on a bike in Europe. Nairobi wasn't like it had been at the time of *White Mischief* – a time of cocktail parties. Nairobi was crawling with soldiers, and the elite who had lived there for years had to put up with them. We weren't really wanted there. The privileged locals didn't have much time for us. They thought that we were probably rubbish and their very convenient, lazy lifestyle had been spoiled. These people had never lifted a finger and suddenly there was war and a lot of rather odd-looking, armed people in uniforms.

After I left Kenya, I was sent up to Aden in the Gulf for a week then on to Cyprus, where I completed my final six months of service in a most beautiful place right next to the Temple of Apollo. We were under canvas and were mixed up with the army. I have just completed a huge photographic essay on the frontiers of the Roman Empire. At the time I wouldn't have

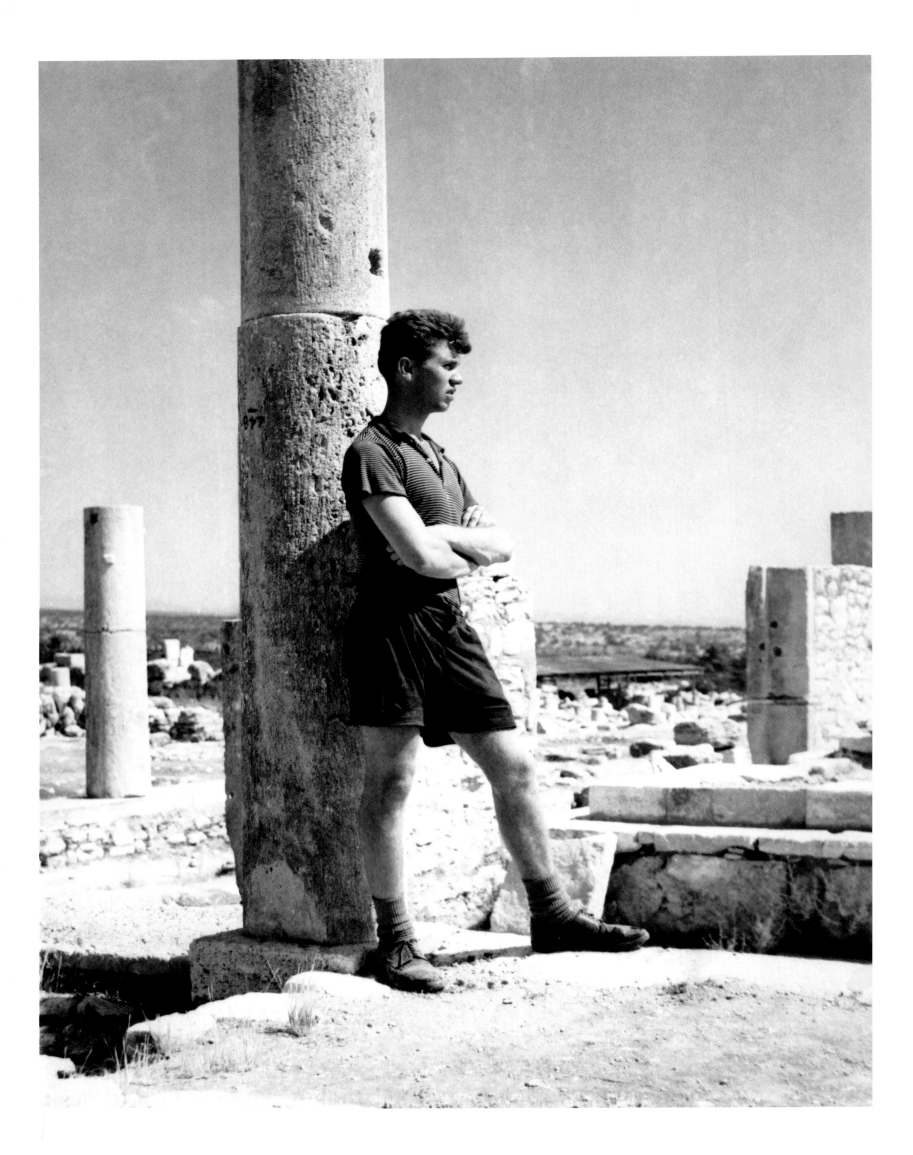

understood Apollo, the classical Greeks or Romans because I was uneducated, but something of the classical world made a lasting impression. My only interest in life was my freedom. All I wanted was to get out of the air force, let my hair grow and get back to what I used to be, knowing I'd fulfilled my commitment and that I wouldn't be called upon again. I finished my military service and I came out of the air force in 1956, the year of Suez. I was afraid I would be recalled. But they wouldn't have had any need to call me back. I left the air force at almost the same rank I went in with.

I brought my Rolleicord back to England, but I pawned it. I took it down to the pawnshop where my mother used to take my father's suit and got five pounds, a lot of money in those days. The camera was worth thirty pounds and my mother was uncomfortable about it. Not that she was in any way a creative person. The old 78rpm records were the only link to a culture of sorts going for me in that house. There were no books at all. I worked at Britains Toy Soldier Factory for a couple of weeks. We ended up with quite a good collection of toy soldiers, which my brother and I used to play with in the garden. We would throw clods of earth at those soldiers, that would explode and knock their heads off, exactly like artillery shells. One day my mother went and redeemed my camera. It was possibly the nicest thing she did. She used to spend a great deal of time clouting and chastising me. My father never struck me and I never hit any of my children. It's a rule I have.

Before the RAF I had been a messenger boy in Charles Street, Mayfair, and they gave me my job back – they were obliged to. I went back to an animation studio run by Peter Sachs, a very creative Jewish German émigré who'd fled from Nazi Germany. 'I gather you've had some work in the darkroom,' he said. 'There's a little darkroom job going here. Would you like to take it over?' So I had a darkroom of my own and I used to copy drawings from the animations. It was a simple job, but every day I would have to go back to where I lived in Finsbury Park. I was living a Jekyll and Hyde life. I'd leave Finsbury Park on the Piccadilly Line, go into Green Park Station and walk up Berkeley Street, through glorious Berkeley Square and into Charles Street. I was brushing shoulders with people who'd been to university, with creative and sophisticated people. I loved their conversations and their company. It began to brush off on me. A year or two later it became very difficult to reconcile the two worlds of Finsbury Park and Mayfair. I felt like one of those Chinese jugglers with my plates in the air.

Tragically, one night there was a serious gang clash in Finsbury Park. A policeman came to stop it and someone knifed him in the back. He died on the pavement at the bottom of Fonthill Road where I lived. A few months before, I'd taken a photograph of the boys I went to school with in a derelict, bomb-damaged building at the end of my street. They were involved in the gang fight. As these events were unfolding, people in my office in Mayfair who'd already seen this photograph told me to take it to the *Observer*. I rang the newspaper and explained who I was and what I wanted to show them. They welcomed me with open arms. The picture editor said to me, 'Did you take this photo? Will you do more?' I said, 'Yes I will,' and I did just that.

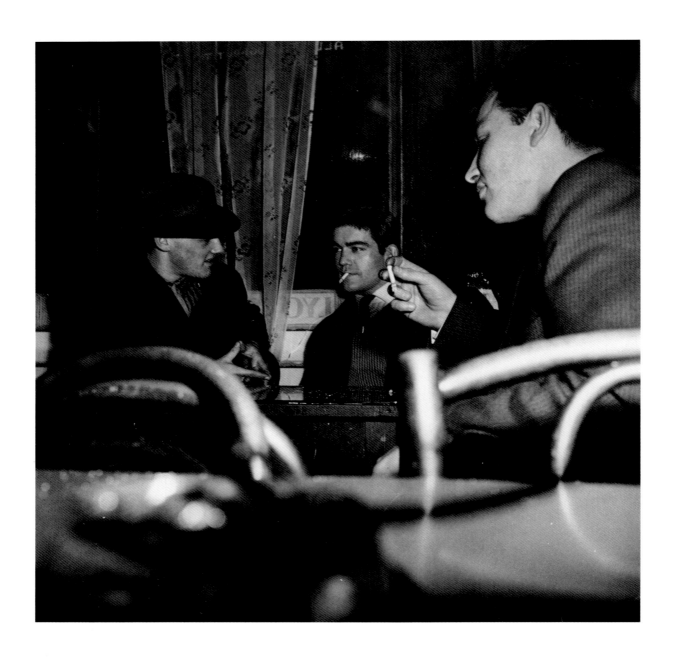

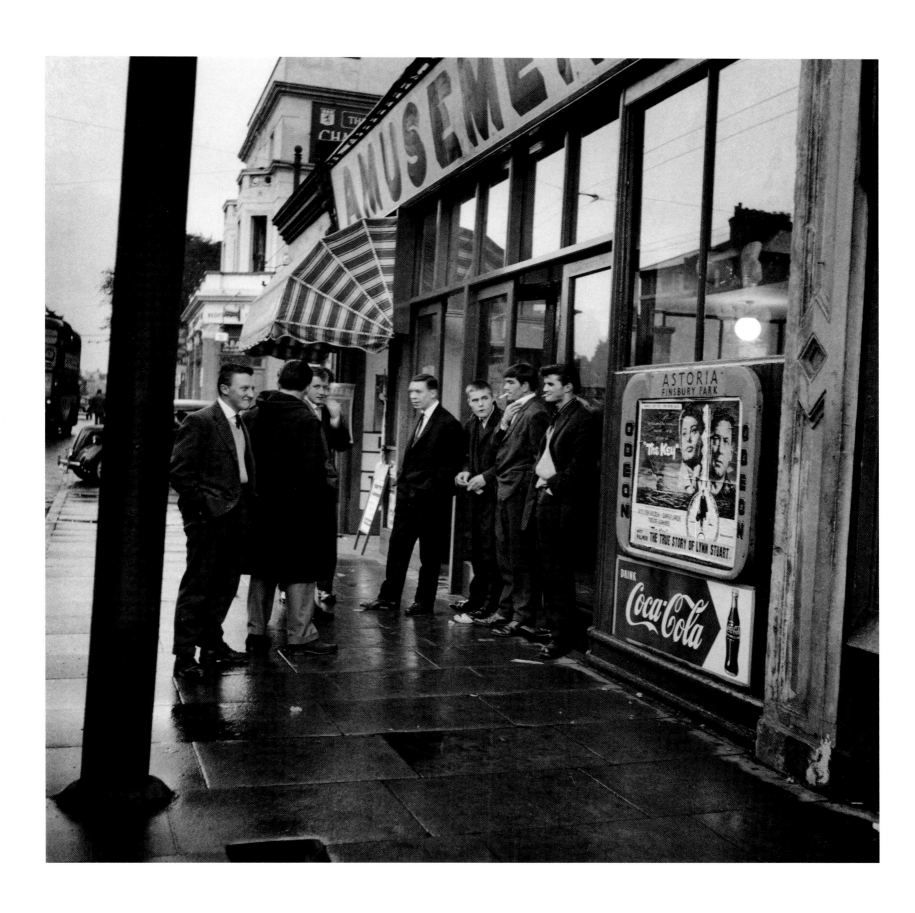

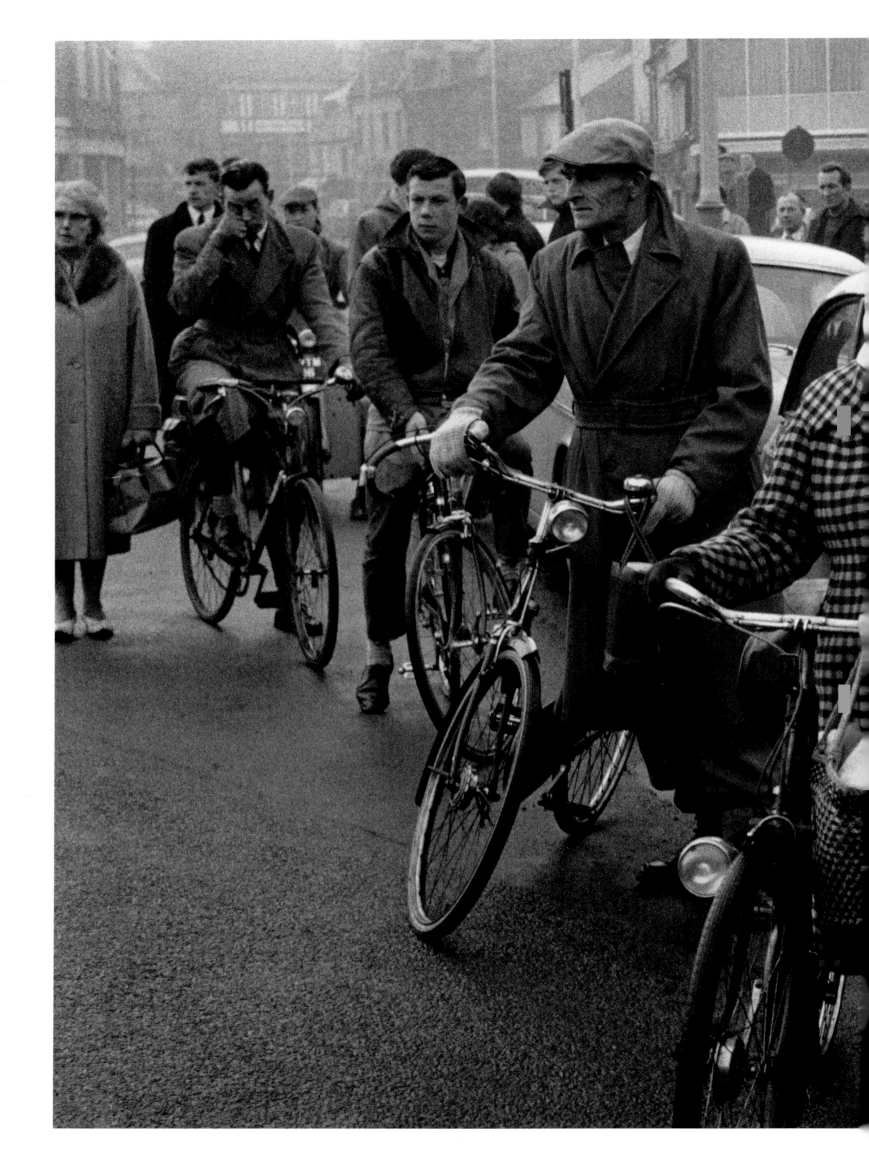

'Guv'nors' of the Seven Sisters Road

These photographs were taken by Donald McCullin, who has grown up with some of "The Guv'nors," the reigning group of young men in the tenement heart of Finsbury Park in North London. McCullin is twenty-three and works as a stills photographer in the film industry. He took up photography three years ago.

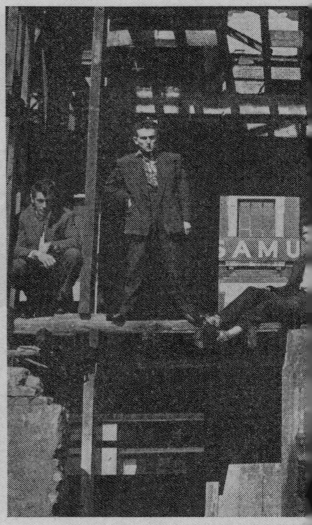

The kerbside discussion that decides the night's plans. There is never enough car-space to go round—someone is always left behind.

Prominent members of "The Guv'nors" summer evenings, wea

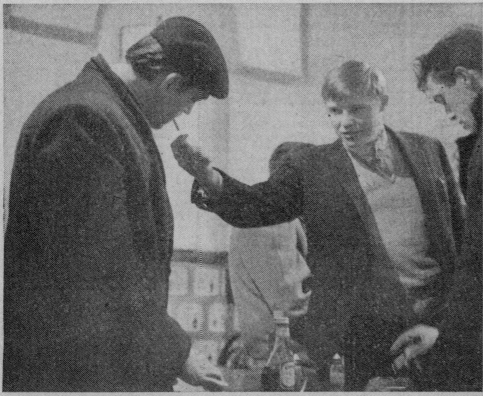

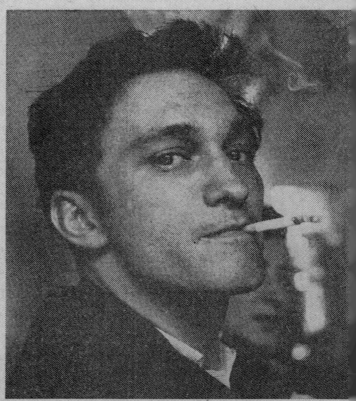

A light for the Number One "Guv'nor," the leader Terry. He is a cool, withdrawn cat—a night roamer, usually alone and unsmiling.

Johnny lives alone in two rented rooms. He's been in life. And is prepared to live it out the

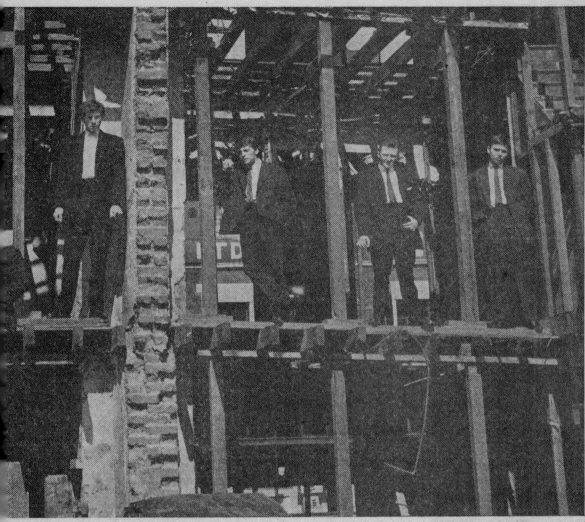

the scaffolding of an abandoned building that was set on fire on Guy Fawkes night. On their best suits, "The Guv'nors" play a tough, weekly football game.

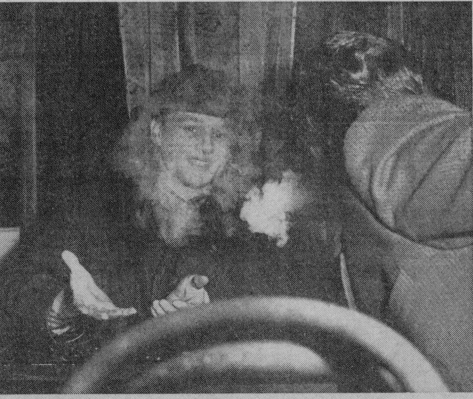

istrict all his *Bobby at one of the cafés where the long infuriating stretches of boredom are made bearable by the night-ritual of violent memories.*

Pages 24–25
Crowd awaiting the announcement of the execution of James Hanratty, Bedford Prison, 1962

Left
Don McCullin's photographs in the *Observer*, February 1959

27

The Guv'nors of Seven
Sisters Road, Finsbury
Park, London, 1958

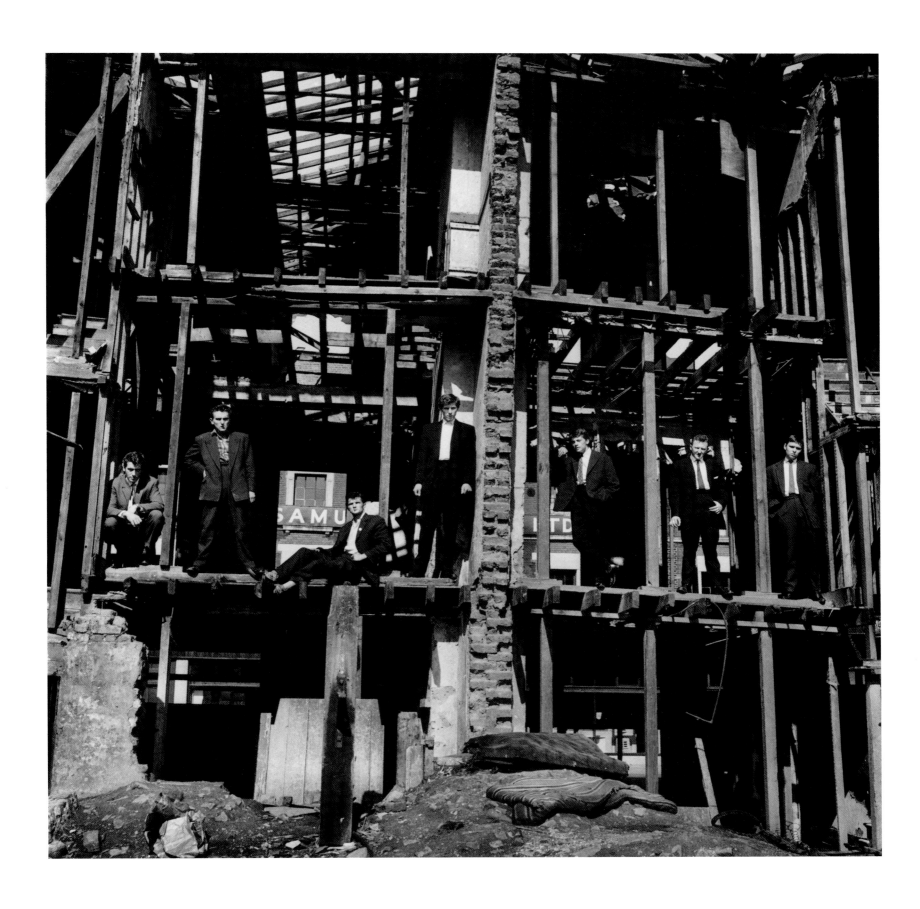

2

DISCOVERING PHOTOJOURNALISM
1958–1966

US troops,
Friedrichstrasse,
Berlin, 1961

**Constructing the Wall,
Berlin, 1961**

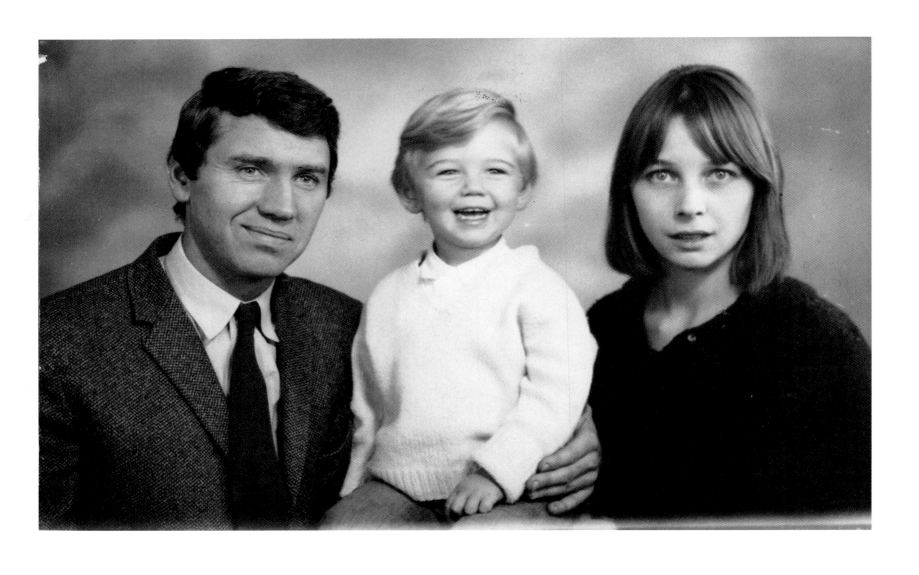

They published the photograph of the Guv'nors a few weeks later and gave me fifty pounds, a king's ransom to me. On the Monday morning after publication the phone in the animation studio never stopped ringing. I was offered every extraordinary photographic job in England. That was the beginning of my humble roots in photography. Sadly this start was based on the death of a policeman and capital punishment for the man convicted. He was called Ronald Marwood and was hanged in Pentonville Prison, not far from Finsbury Park. The jumping-off point for my whole life was based on a terrible act of violence and its consequences.

Not long after this, I got married and took my wife to Paris. This seemed very daring because neither of us could speak the language. She came from Muswell Hill in north London, a much nicer place than Finsbury Park. When we were in Paris I saw a photograph of an East German soldier in his uniform and helmet jumping barbed wire with his Kalashnikov. He was escaping to the West. I immediately understood the story. I asked my wife, 'When we get back to England, would you mind if I went to Berlin?'

Having bought a ticket to Tempelhof, Hitler's airport in Berlin, I rang the *Observer* and told them. 'We're not interested. We're not sending you,' they said. I explained I'd bought my ticket and was going, so, begrudgingly, they gave me the name of their correspondent, Patrick O'Donovan, who was in a hotel in the Savignyplatz , the area of the original pre-war *Blue Angel*. It was extraordinary. It could almost have been as if I had wandered into Christopher Isherwood's Berlin. I met up with the correspondent but we didn't work together. In the evenings we'd meet and I'd tell him what I'd photographed. I went straight down to Friedrichstrasse and started working with my Rolleicord. Of course, I was sitting on the biggest story in the world. I saw the East Germans drilling the foundations and building the Wall breeze block by breeze block.

The Americans were facing the East Germans across Friedrichstrasse and there was enormous tension. In places, Berlin looked like the war had finished just the day before. It was turning into the Berlin that John Le Carré was to describe. I watched the international photographers pass through. I was in awe of these professionals. I was like a little camera-club person from north London working with the camera my mother had retrieved from a pawnshop. But fate was waving some magic wand, directing me. It was so exciting. I felt I was in the right place at the right time. I had an almost magnetic emotional sense of direction pulling me to extraordinary places. I came back to the *Observer* and gave them the pictures. I won a press award for them and the *Observer* offered me a contract of fifteen guineas a week. I was on standby for them on Fridays and Saturdays and was the happiest person in the world. That's when my problems began, because I had to learn about photojournalism. It was 1961 and I was on the threshold of a new life.

How strange it was that a person with absolutely no education and no knowledge of anything outside of Finsbury Park was poised on the edge of the most threatening situation. We were almost at a Third World War. It was the beginning of my acquiring some pride and self-belief. I'd left school without any qualifications. I felt like a failed human being and there's nothing worse than to kick off your life with that feeling. Suddenly everything had changed. I was in Berlin by my own thinking. I have spent the rest of my life basing my professionalism on instinct. Later, I read *The Times* every day and followed up on what I learned from the news. I felt as if I was the sharpest knife in the drawer. I really was ready and I was fast.

The award gave me further confidence, but I've never put much faith in awards. It's very difficult to live with the guilt of winning awards after having witnessed deaths and the tragedies of other people's lives. I've got lots of awards at home, but some of them are actually

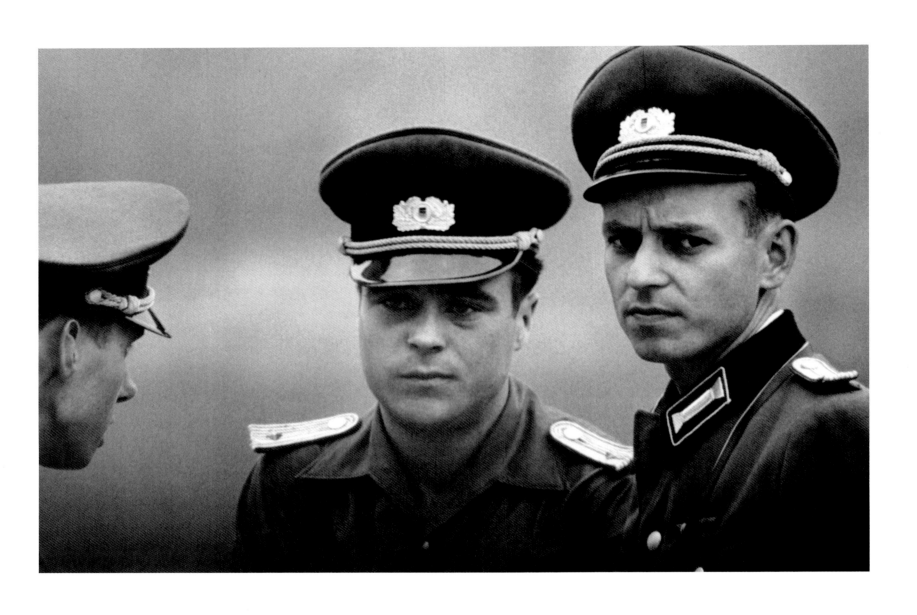

in the garage or the garden shed. I look back and ask myself if I should I have accepted them. Maybe I shouldn't be ashamed of it, but it doesn't sit comfortably with me that I'm being given these tokens of recognition because of the things I've photographed.

After Berlin I started becoming aware of the power of photography. I thought to myself that, for once in my life, I had a purpose. I had to use it. I thought I could turn people's minds and even change situations. I was naïve. I've looked back and seen the repetition of events that have got worse and worse. They never get better. The photographs may have helped shape attitudes, but they certainly have not turned anything around. After Eddie Adams took the famous photograph of the police chief in Saigon shooting a man in the head, the war raged on for another seven years. One barbarous event is simply followed by another, like the appalling atrocities that took place in Sierra Leone, where you had drug-crazed youths chopping off the hands and limbs of children and babies. Look at Rwanda. If I ask myself if I have done any good or changed anything, I actually don't believe I've changed anything at all. On many occasions I'm ashamed of humanity.

If I'd had the opportunity, I would have walked into the aftermath of the Holocaust and I would have certainly done my utmost to bring back the images even if they were listed as atrocity photos. I want people to look at my photographs. I don't want them to be rejected because people can't look at them. Often they are atrocity pictures. Of course they are. But I want to create a voice for the people in those pictures. I want the voice to seduce people into actually hanging on a bit longer when they look at them, so they go away not with an intimidating memory but with a conscious obligation. I think complacency is always going to be there. That's what you have to fight. You're not going to win, but at the same time you can help to beat complacency. I met an Englishwoman in Africa. She

said she became a doctor because she saw one of my pictures. That's all I want – just one doctor in Africa. For me that's better than winning a mega lottery. That's my reward. I can go to my Maker smiling.

When I was a child, my mother used to send me down the road to the barber's shop, which was within yards of the building where I photographed the boys in the derelict house. There were a few other shops down there. One used to sell meat for your cat, which was horse meat and used to smell appallingly, and there were some junk shops. I loathed going to the barber's but you always got a pile of *Picture Post* magazines. I started looking at photography as a child in a barber's shop. I would have looked at stories in those magazines produced by people like Bert Hardy and Bill Brandt. *Picture Post* was edited by Stefan Lorant. Europeans who'd fled from the Nazis worked for *Picture Post*. The magazine stories were the means of mass communication in an age before television.

The people in America who worked for *Life* excelled at storytelling. *Life* was a great magazine with a great photojournalist, Eugene Smith. He was emotionally troubled and totally involved in his work. He would drink and cry a lot. He had been horribly wounded in the Pacific War, but it didn't stop him continuing his work. He made a story about Albert Schweitzer's Lambaréné in Africa. He showed how Schweitzer encouraged people to come to the hospital and helped them feed and look after their relatives. Producing photo stories about wonderful people like that seemed like a good way to go through life.

I was sent all over England by the *Observer*. I covered miners' strikes and learned so much. But one day in 1964 the picture editor asked if I would cover the civil war in Cyprus. I left the next day in a state of high excitement. I'd been in Cyprus only a few years before. I went to the Lederer Palace Hotel in Nicosia

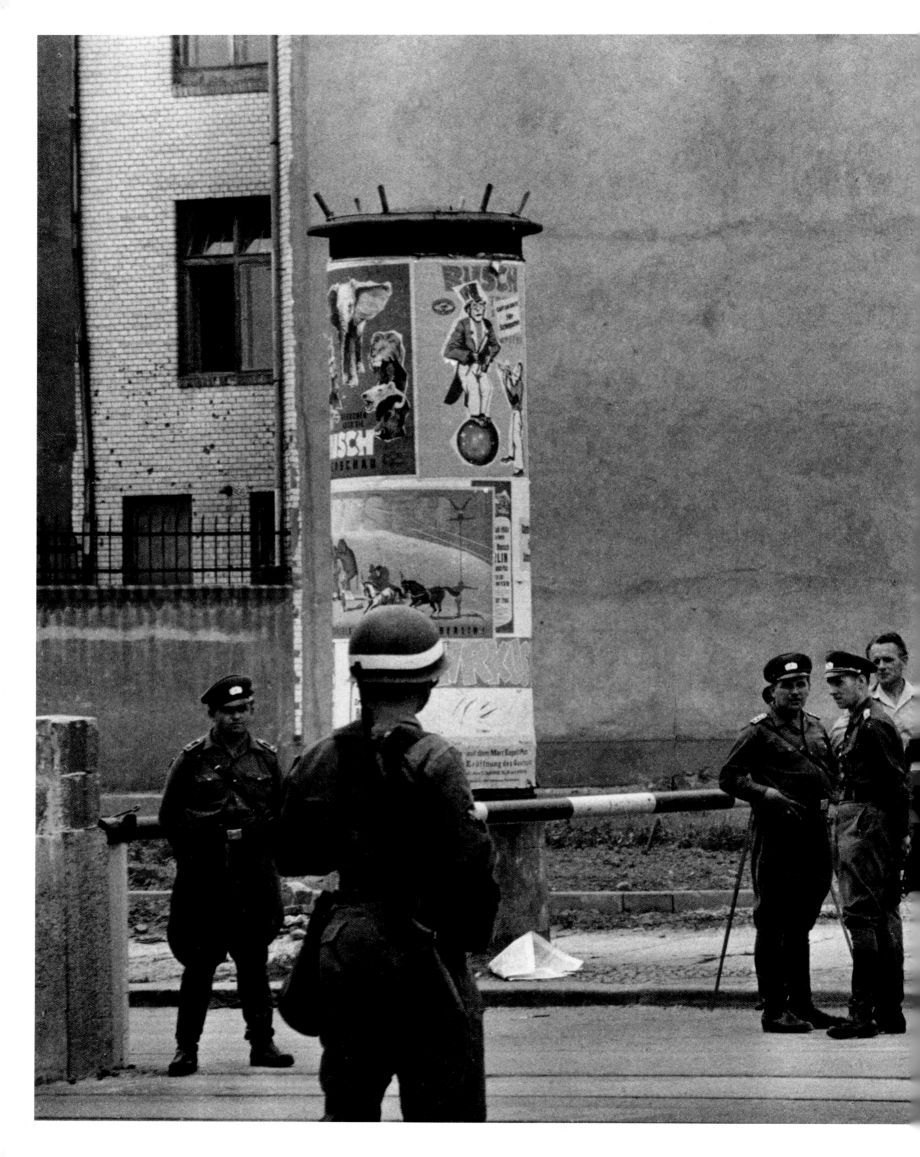

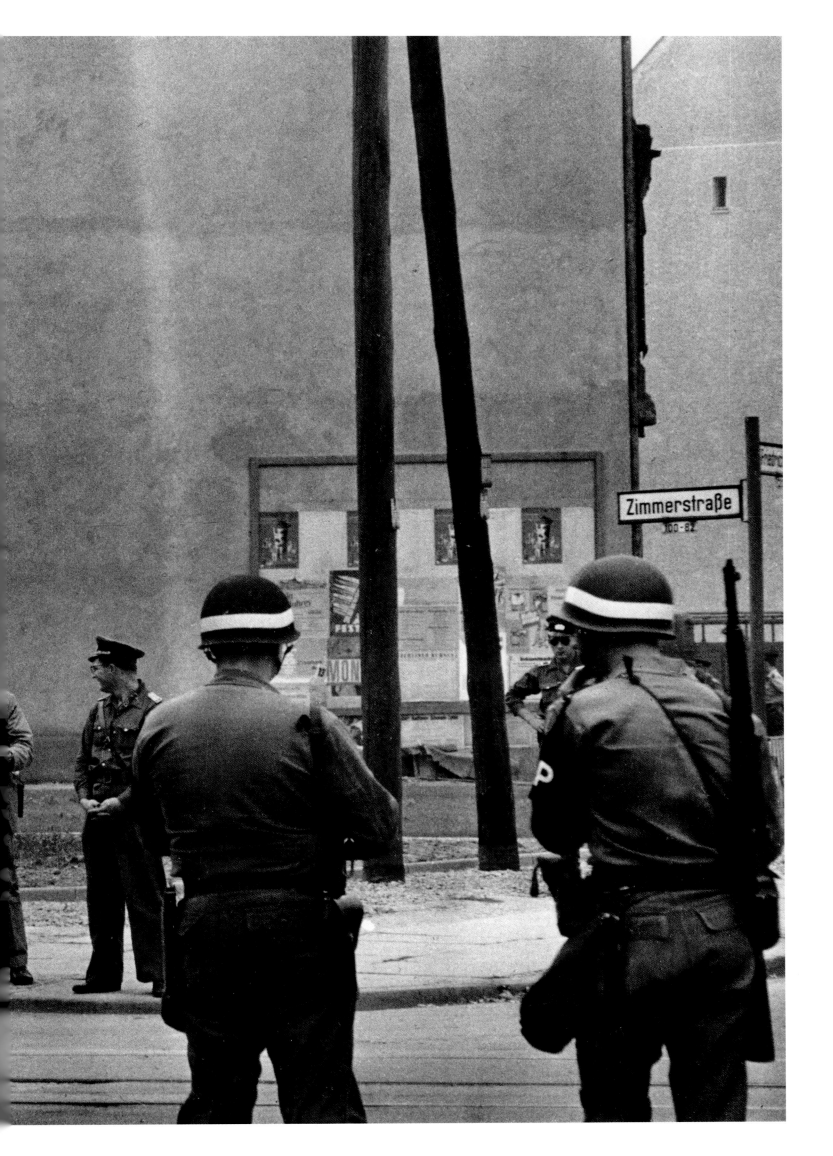

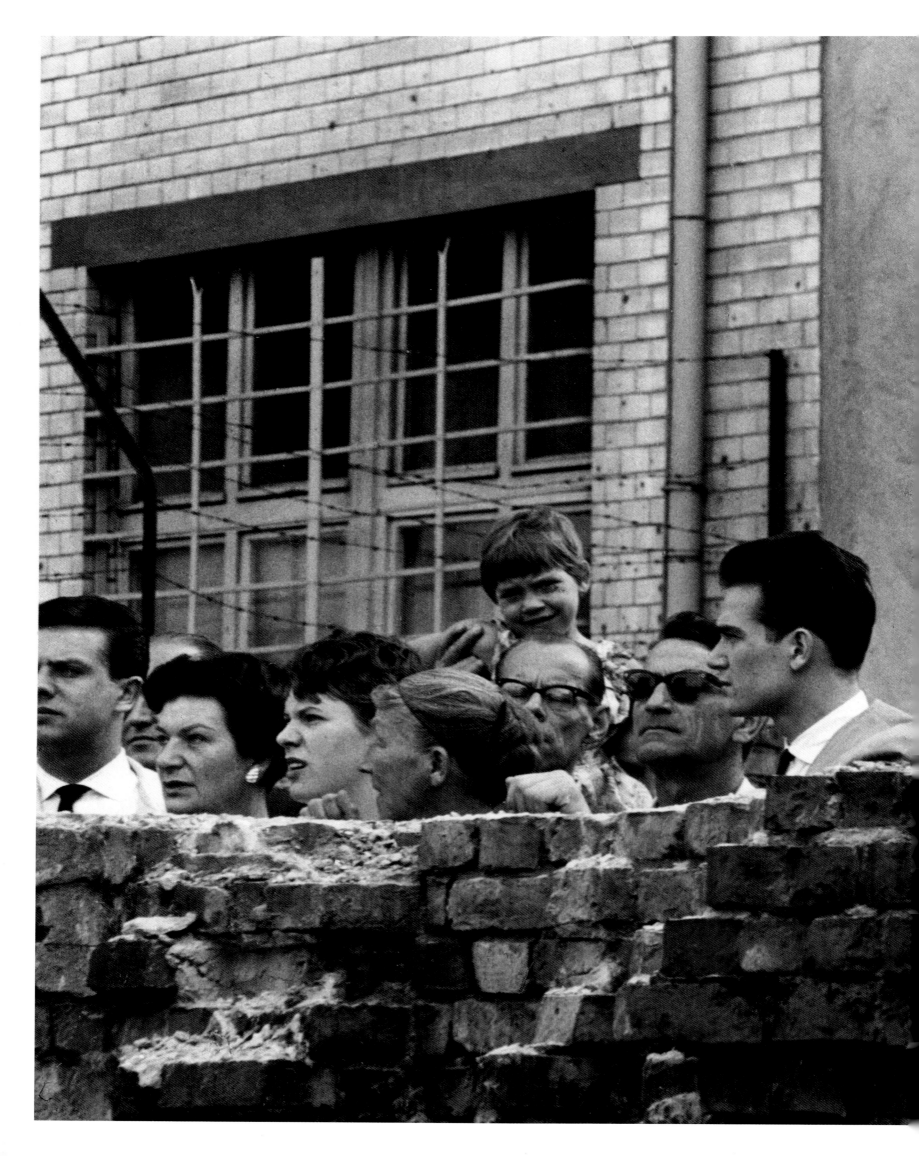

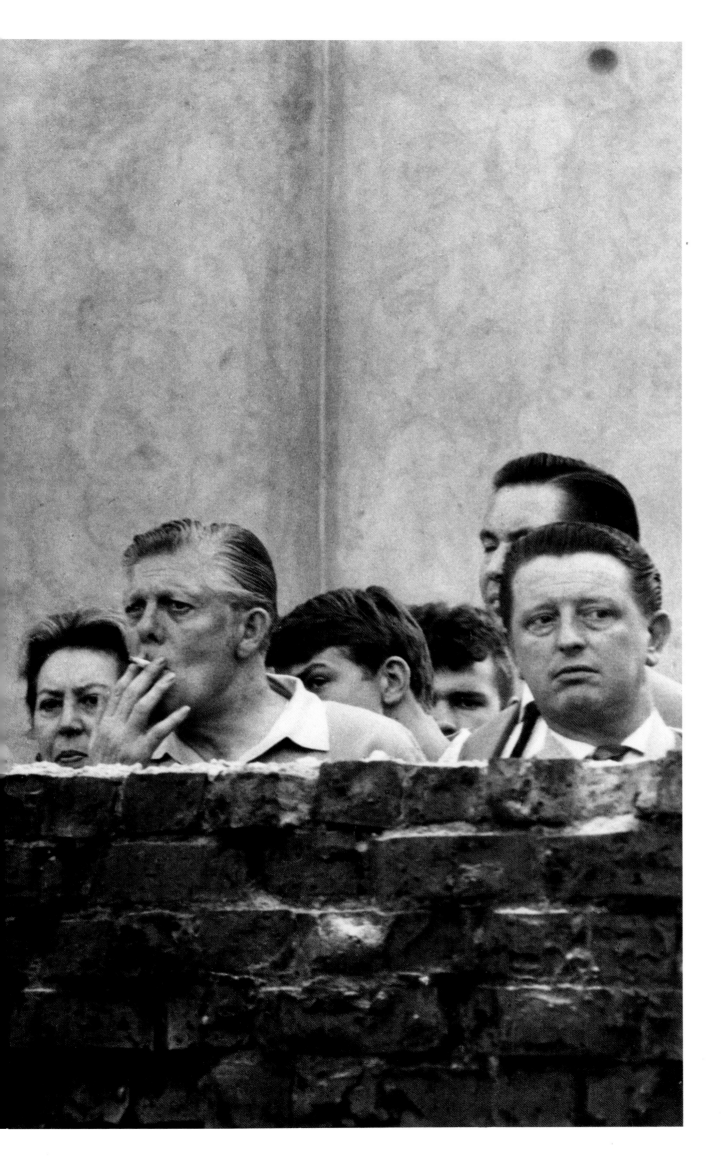

Pages 40–41
East German soldiers at
the Wall, Berlin, 1961

Pages 42–43
Border crossing,
Friedrichstrasse,
which would become
better known as
Checkpoint Charlie,
Berlin, 1961

Left
East Berliners watching
the Wall under
construction, Berlin, 1961

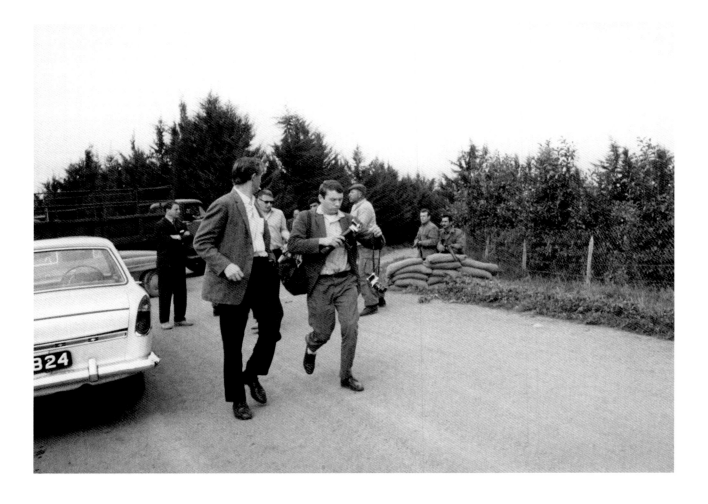

Left
Journalists, including Don McCullin, being escorted through the Greek lines, Cyprus, 1965, photograph by John Bulmer

Right
Don McCullin carrying a lady to safety, photographed by John Bulmer on McCullin's camera, Cyprus, 1965

where the press hung out. There wasn't an international press corps as there is today, when you can have a thousand people covering major stories like the Gulf Wars. There were about twenty or thirty people lounging around in the hotel bar. I was the new boy. They didn't like anyone they didn't know or who hadn't been tested. Luckily, a very nice man named Donald Wise, who worked for the *Daily Mirror*, said, 'Just arrived? Have a drink.' I didn't drink in those days and asked for an orange juice. That didn't go down very well but he briefed me. A man from the *Guardian* came over and I found out there was some trouble in Limassol. I joined up with the ecclesiastical correspondent from the *Observer*, Ivan Yates, who'd also just arrived. I persuaded Ivan to leave the rest of the journalists, hire a car and go round to my old camp near Limassol. We drove round to the other side of the island from Nicosia, and as we were going through Limassol I thought the exhaust had fallen off. The car was making a terrible noise, but it was not the exhaust. Bren guns were being fired over our heads – the Greeks were attacking the periphery of the Turkish section of the town. I drove the car in a zigzag into the Turkish quarter and got out. The streets were deserted. The Turks said the Greeks

were about to attack. Ivan wanted to get back for an appointment in Nicosia, so I got him out and came back. I spent the night in the safety of a Turkish police cell. In the morning the gun battle started in earnest. I was the only member of the press there as the Greeks were stopping the journalists from getting in. I didn't have the experience of an international photojournalist. I was still the man looking for the one best picture. I felt totally right to be there, like the foot that really fitted the shoe.

The first day in Limassol I saw a man coming out of the side of a cinema and the scene looked just like a film still. He had on a raglan raincoat and held a Sten gun in his arms. They were one of the worst weapons in the world – a small-calibre, useless, inaccurate gun. He wore a flat peaked cap and looked like a Sicilian bandit. He was followed by another man and then by women and children. Some of the women were running with mattresses on their heads, as if a mattress would stop a bullet, but the poor women were so afraid. It was basically ethnic cleansing, for want of a better phrase. I stood there photographing. I felt guilty about just taking pictures as everyone was rushing for cover. I ran over and grabbed one of the kids coming out of this building.

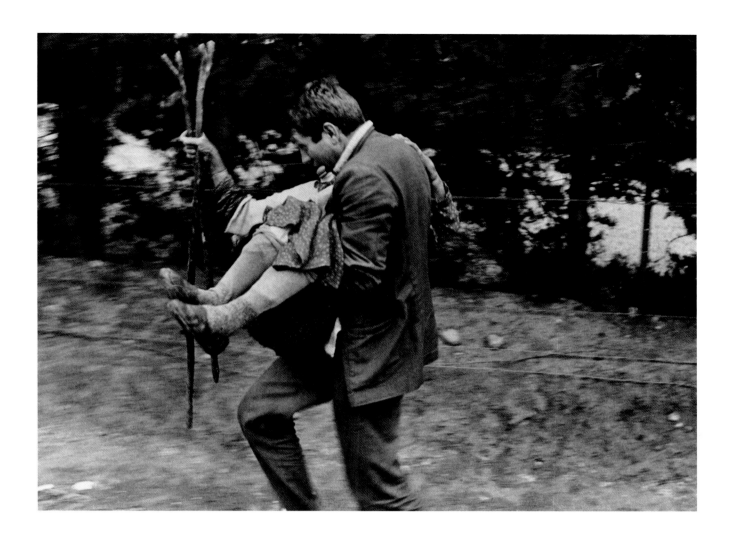

After the battle in Limassol I went back to the Lederer Palace and learned there was some trouble in a small village to the south. So in the early morning I got a lift down – I didn't have the funding for a car of my own. Some British soldiers were there as part of the UN mandate. They were trying to act as a buffer. They told me of some bodies. I walked up a slope in this very poor district. The frost had just lifted and there was dew on the stones. I walked towards a corpse and at first I avoided looking at the face. I remember the splayed feet. The dead man had lain the night in the open. And I raised my eyes from the feet and saw half his face was missing because he'd been hit with a shotgun blast at close range. I never took any photos. A soldier said, 'Go in that house there.' I knocked on the door. Nobody answered. I gently let myself in. I was met with the warm blood of two men in front of me. The floor was completely saturated with the blood of one and I could see another in the background. In fact, there was a father and his two sons. I closed the door behind me and started taking pictures. Suddenly a group of distraught people came in. It was the most awful moment. A woman entered screaming. One of the dead was her new husband. I was standing just by him. In the next room there was a pile of destroyed

wedding gifts, and there was I, this very young person with a camera. I thought they might attack me, but they didn't. I was really looking for their blessing to continue. I thought I'd received that because no violence was inflicted on me. I started quietly taking photographs with great respect. I was allowed to go ahead and those were the pictures I came away with. I returned to England and was sent to the Congo by a German magazine called *Quick*. So off I went to Africa and then back to Germany. 'Have you got a suit?' I was asked. I'd won the World Press Photo Award for the work in Cyprus.

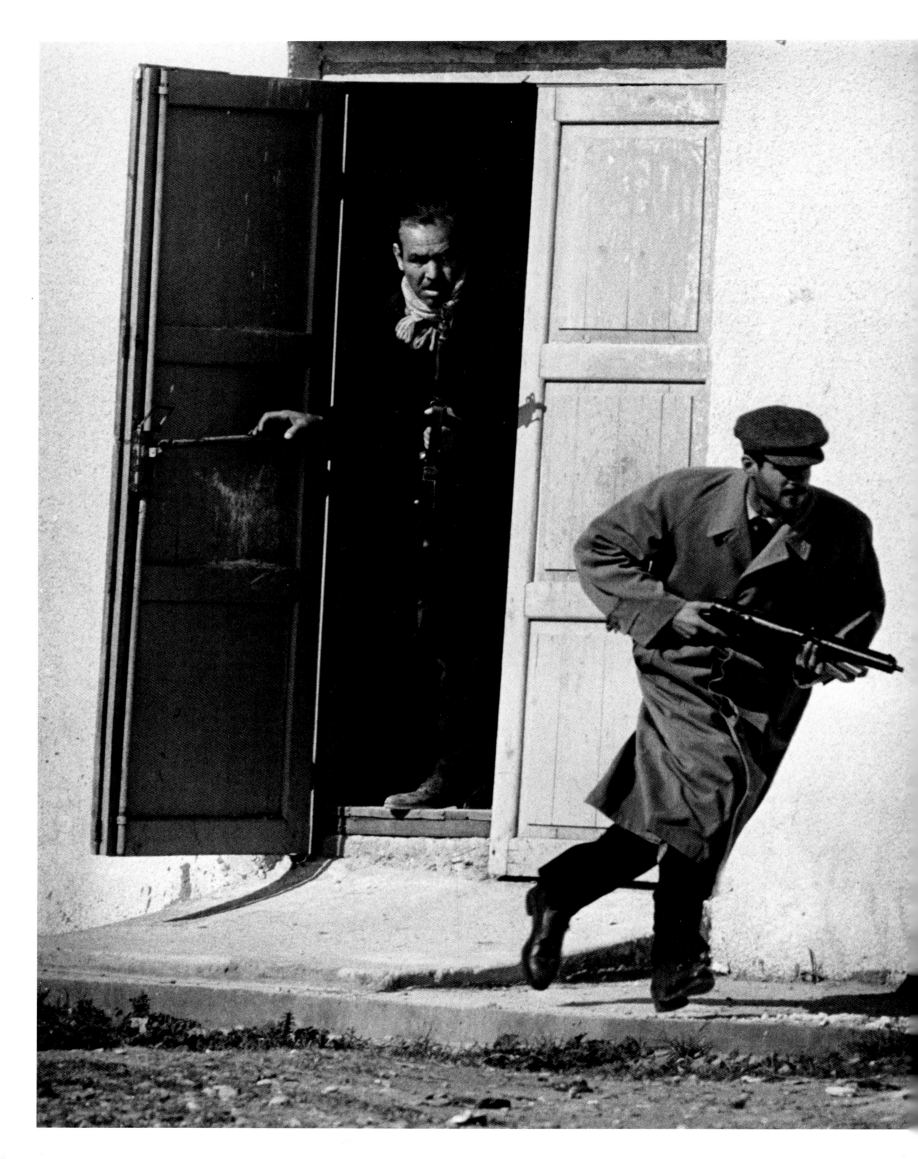

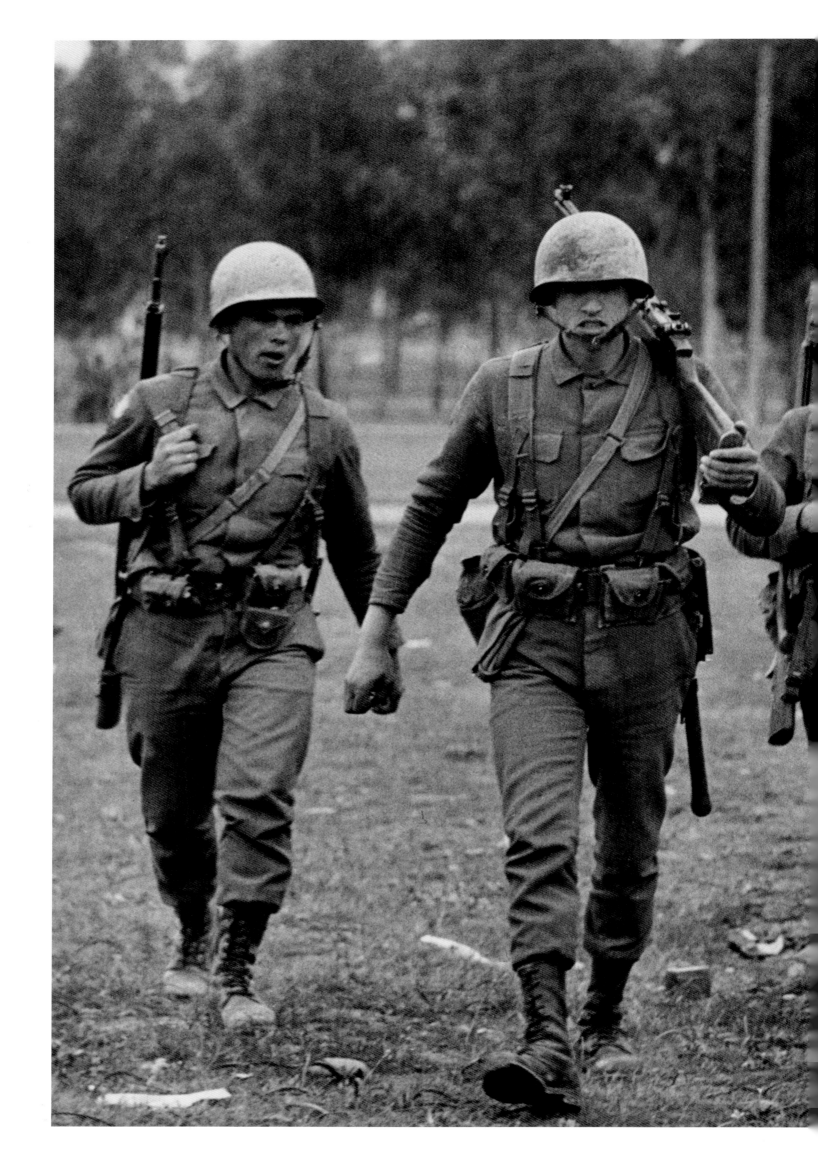

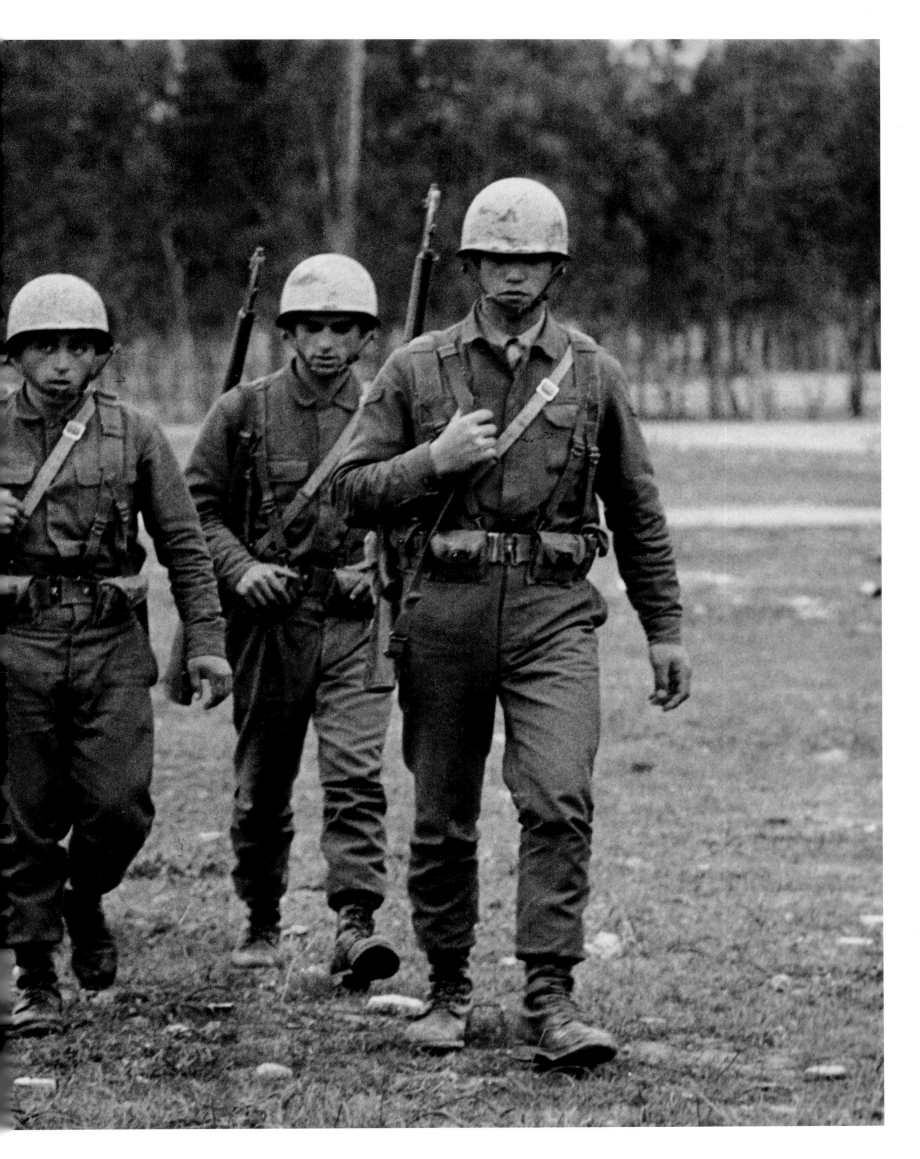

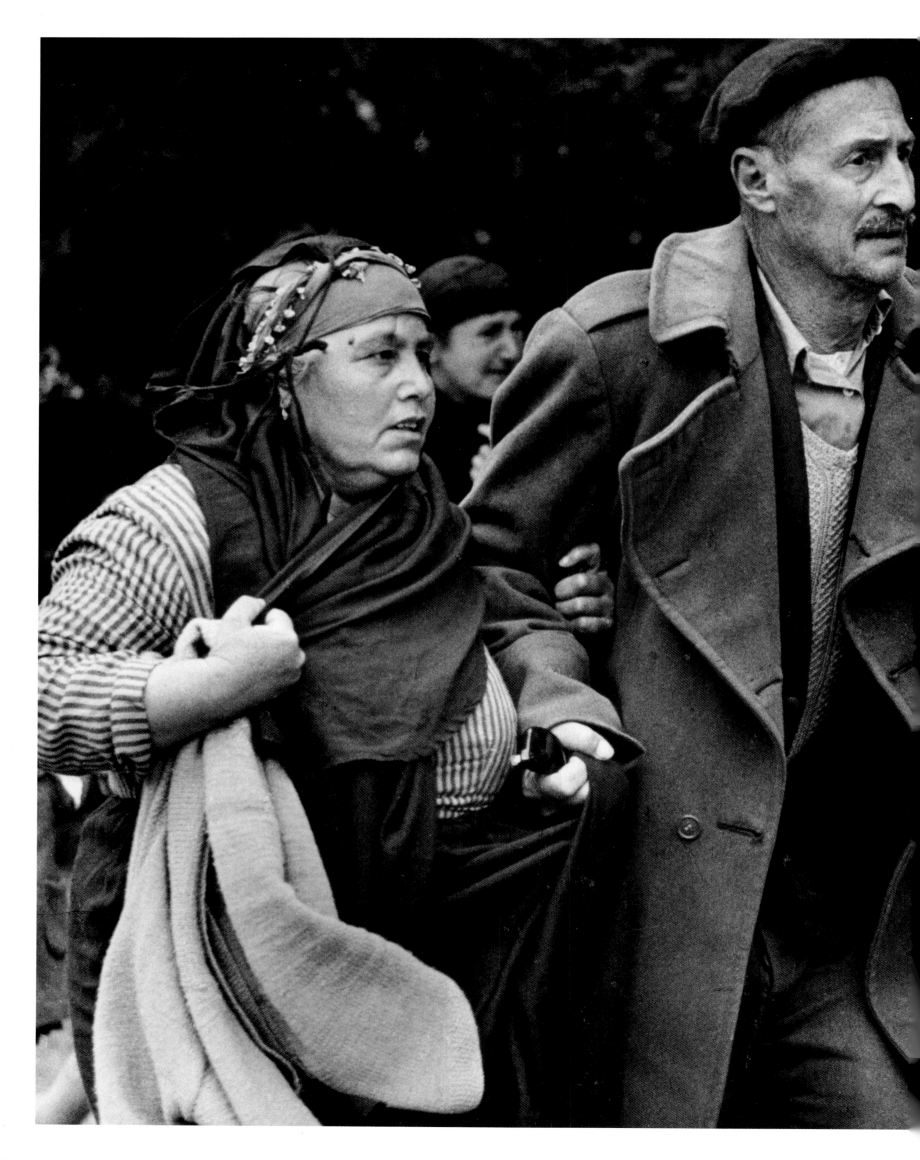

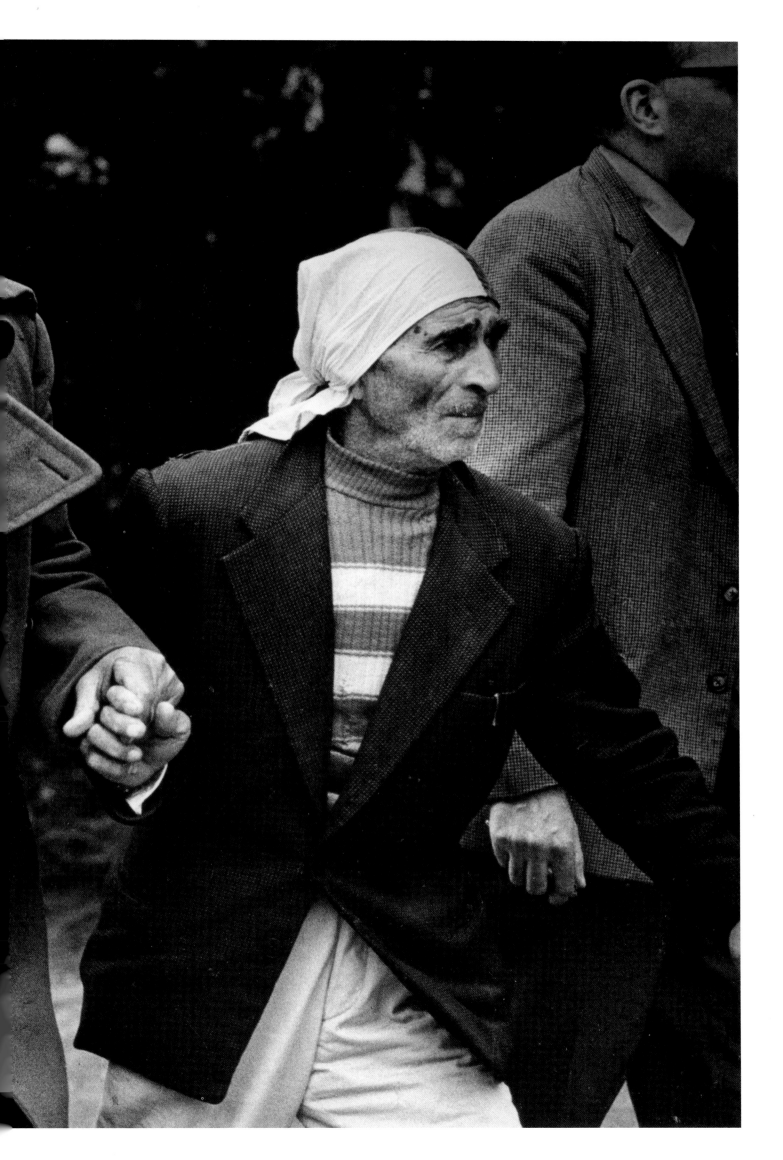

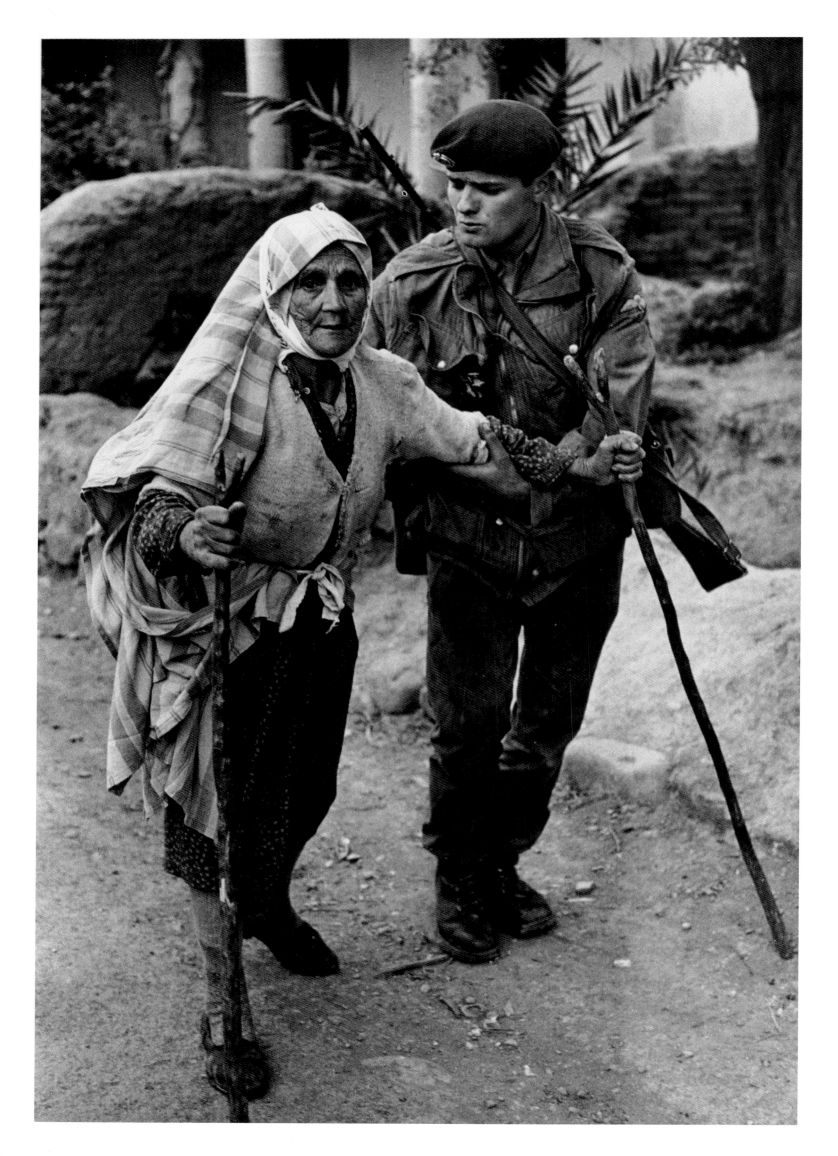

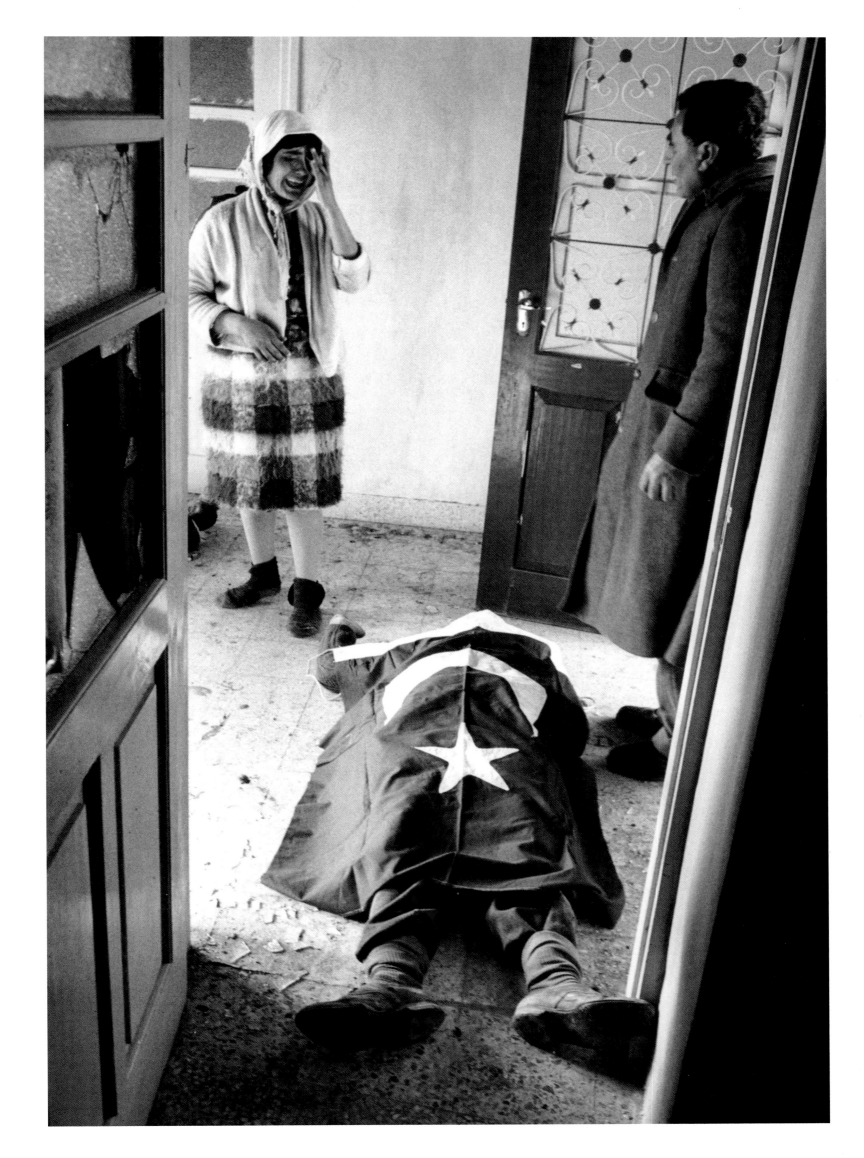

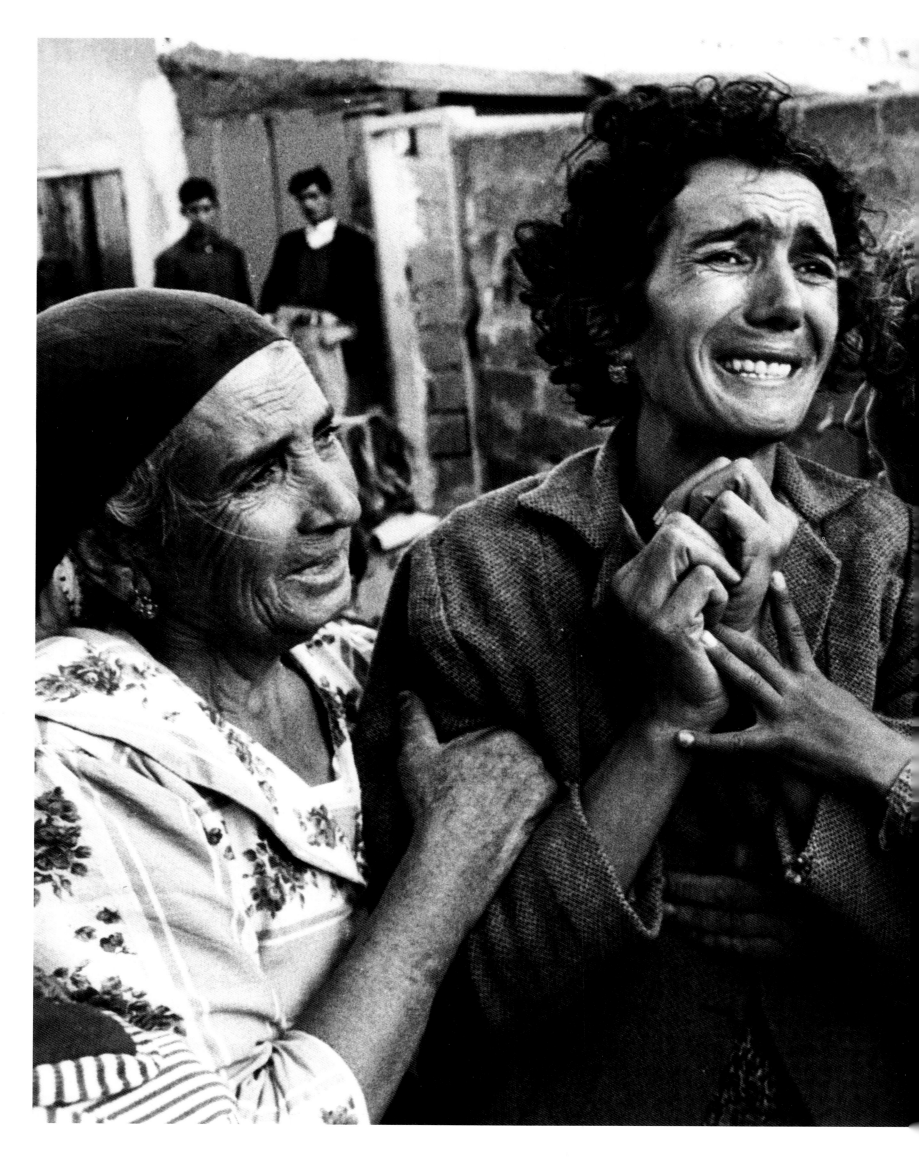

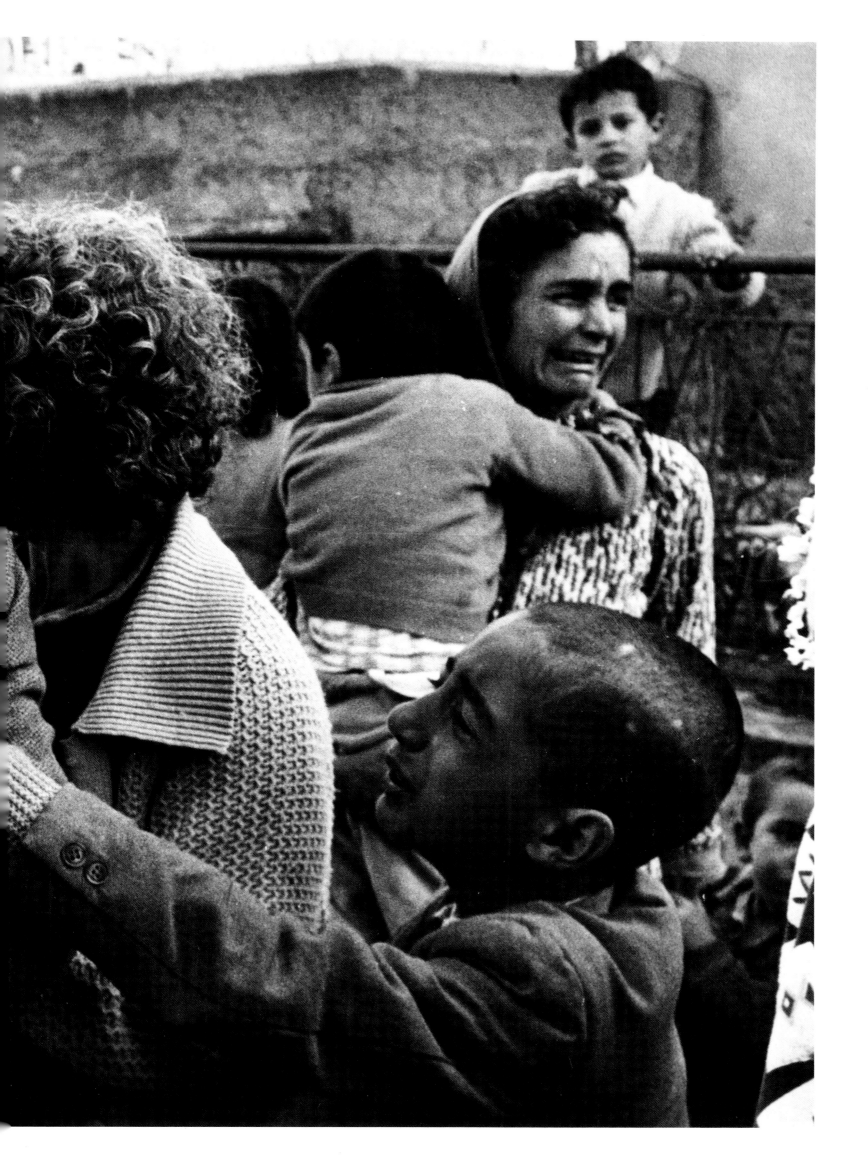

Pages 48-49
Turkish Cypriot sprinting
from a cinema door
under fire, Limassol,
Cyprus, 1964

Pages 50-51
Turkish soldiers,
Nicosia, Cyprus, 1964

Pages 52-53
Turkish Cypriots flee
their homes, Cyprus, 1964

Page 54
Turkish Cypriot refugee
being helped by a
British soldier (she was
subsequently carried to
safety by Don McCullin),
Cyprus, 1964

Page 55
Turkish Cypriots,
Limassol, Cyprus, 1964

Pages 56-57
Turkish Cypriot woman
mourning the death of
her husband, Ghaziveram,
Cyprus, 1964 (Don
McCullin was awarded
the World Press Photo of
the Year for the picture)

Right
Rhodesian mercenary,
Paulis, near Stanleyville,
Congo, 1965

Pages 60-61
Congolese government
troops abusing Simba
prisoners accused of
participating in a
massacre of hostages,
Stanleyville, Congo, 1964

Pages 62-63
Don McCullin's first
coverage of the war in
Vietnam, *Illustrated
London News*,
March 6, 1965

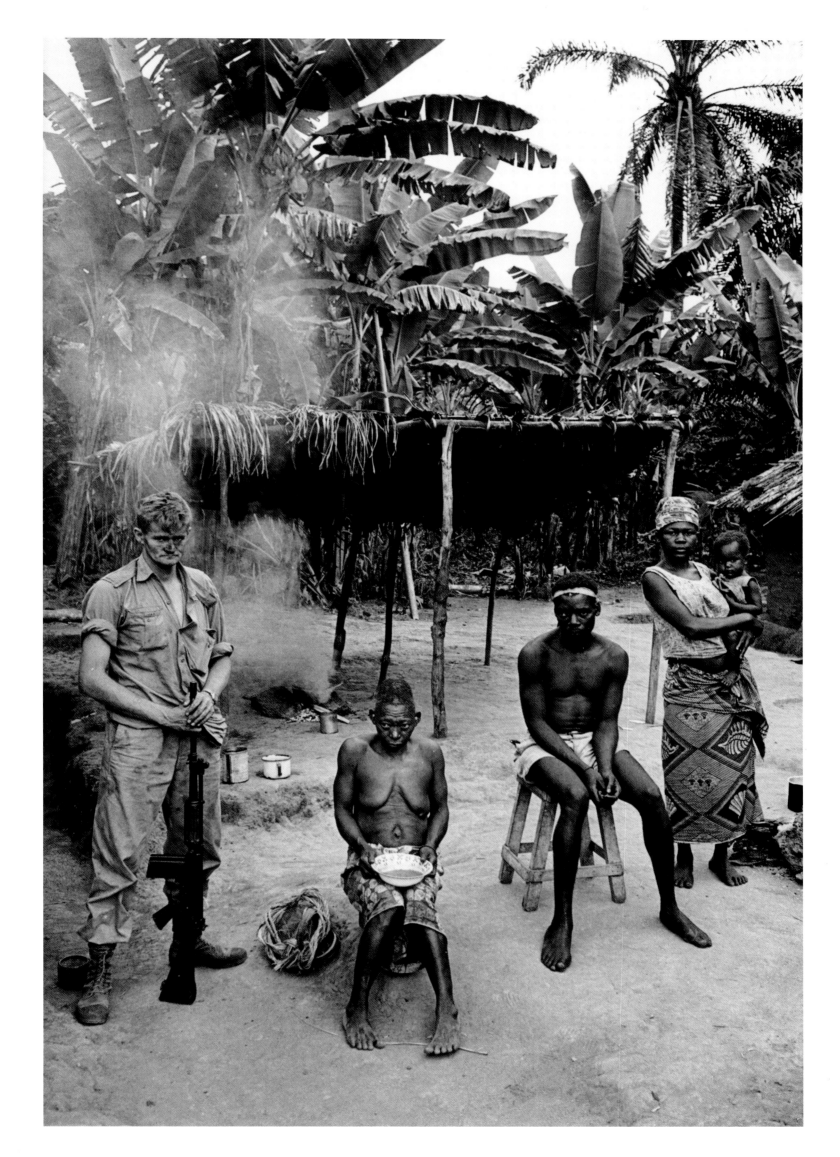

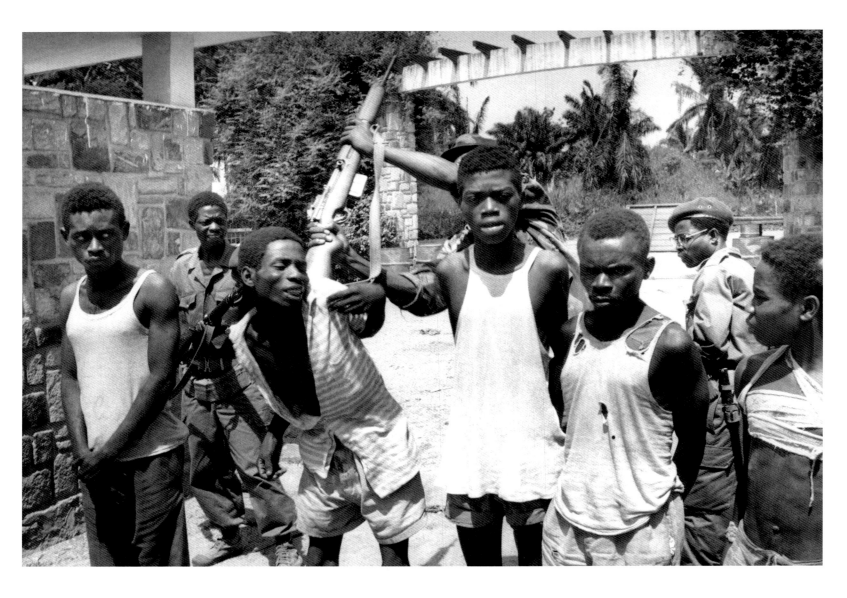

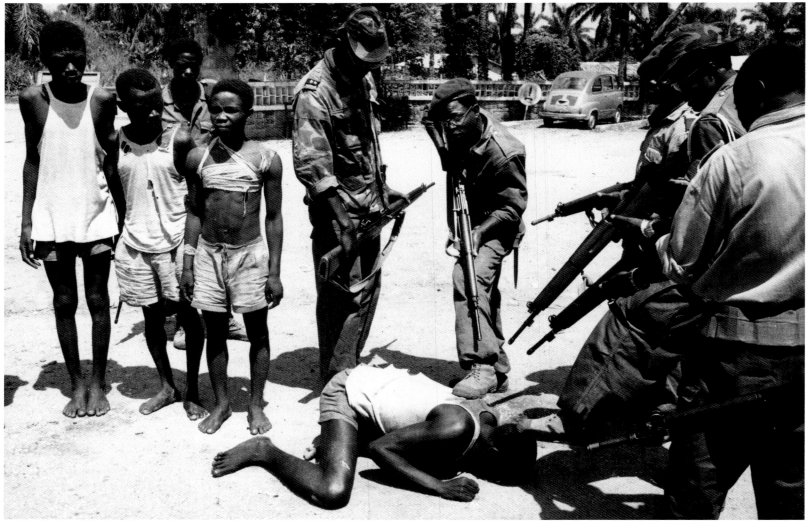

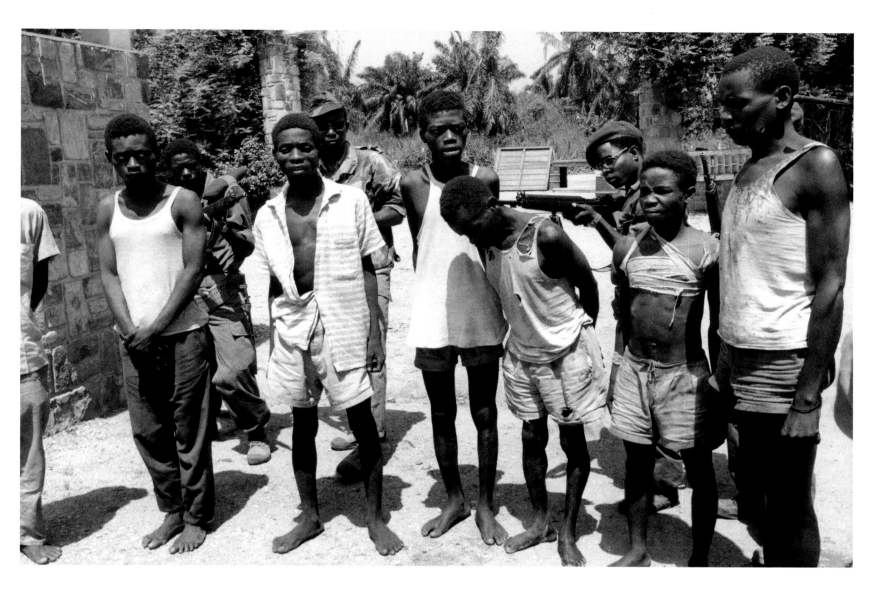
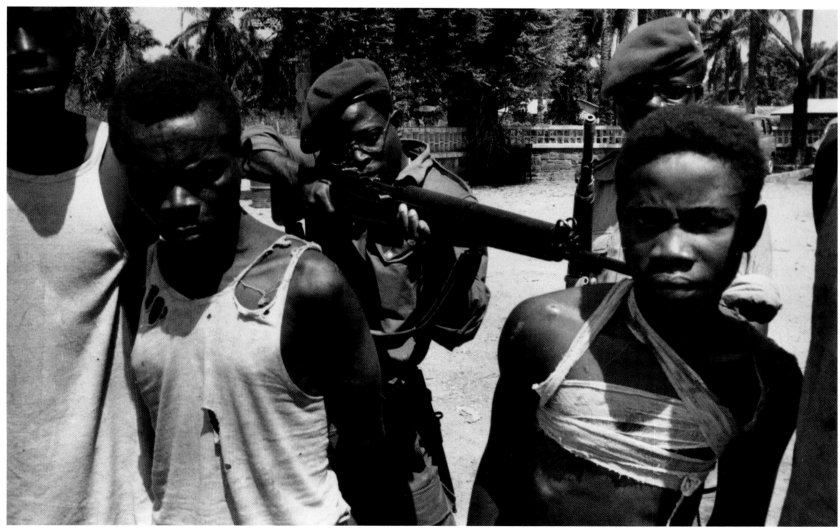

THE ILLUSTRATED LONDON NEWS

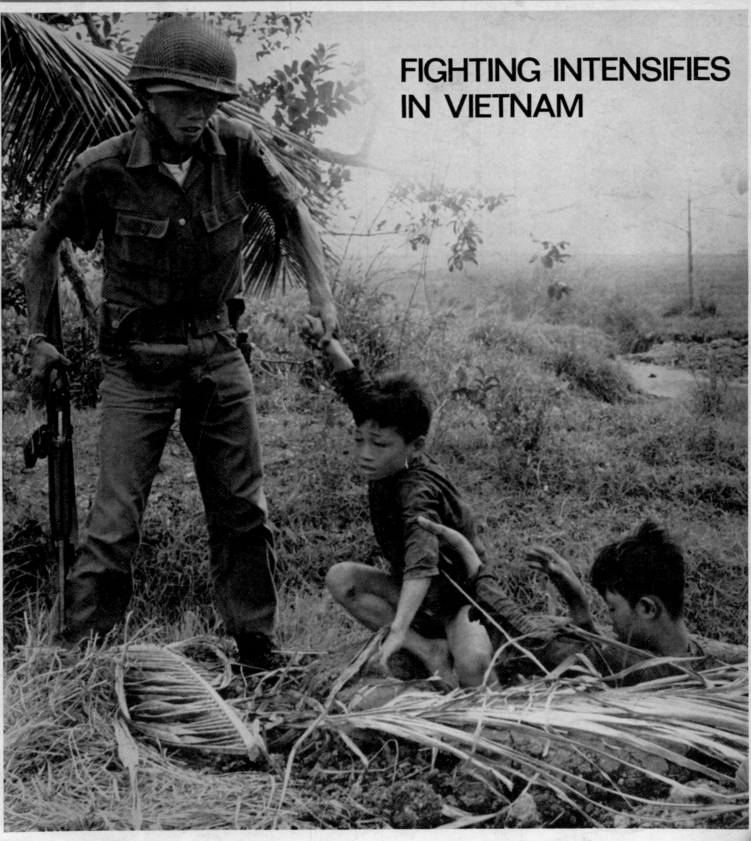

FIGHTING INTENSIFIES IN VIETNAM

THE ILLUSTRATED LONDON NEWS.

© 1965. THE ILLUSTRATED LONDON NEWS & SKETCH LTD. *The World Copyright of all the Editorial Matter, both Illustrations and Letterpress, is Strictly Reserved.* No. 6553—Volume 246

SATURDAY, MARCH 6, 1965

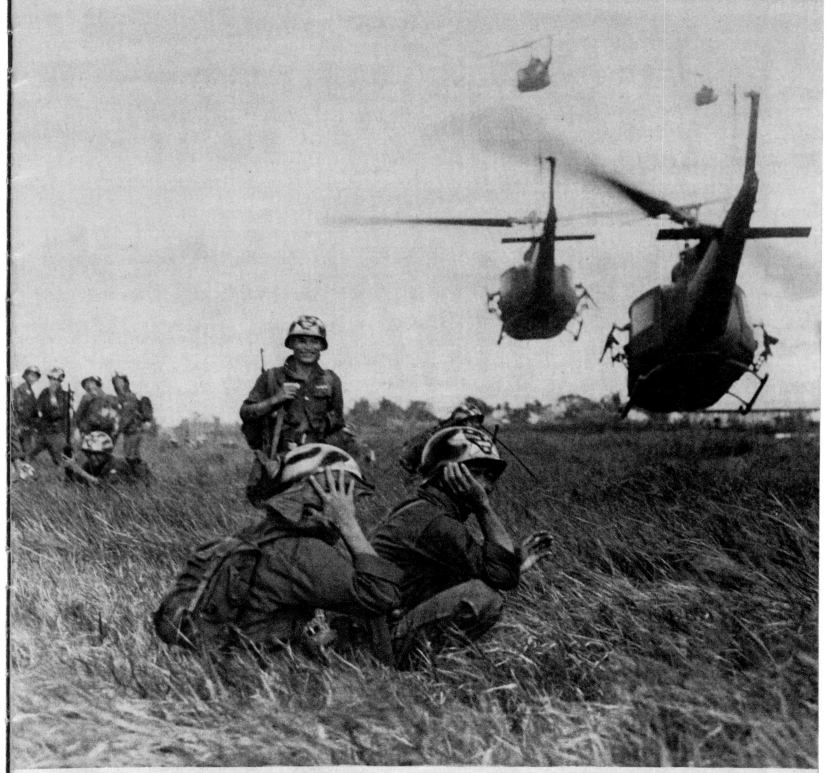

SOUTH VIETNAM STEPS UP ATTACKS ON VIET CONG

CHÚNG THƯ TẠM

Số : 396 /BTT/LLBC/CT

TRUNG TÂM LIÊN LẠC BÁO CHÍ

Chứng nhận : D.MC.CULLIN

Quốc tịch : Anh ...

Thông tín viên của : Illustrated London News

Thông hành số 984244 cấp tại : London

ngày : Ngày 13 tháng 12 năm 1965

Đang làm phóng sự tại Việt Nam Cộng Hòa. Đương sự đã đệ đơn xin cấp thẻ hành nghề tại Bộ Thông Tin ngày : 15 tháng 2 nam 1965

Trong khi chờ đợi thẻ hành nghề chính thức, Trung Tâm Liên Lạc Báo Chí cấp chứng thư tạm này để đương sự tiện dụng.

Saigon, ngày 15 tháng 2 năm 1965

Phụ Tá
Quản Đốc Trung Tâm Liên Lạc Báo Chí

Phan Thị Hạnh

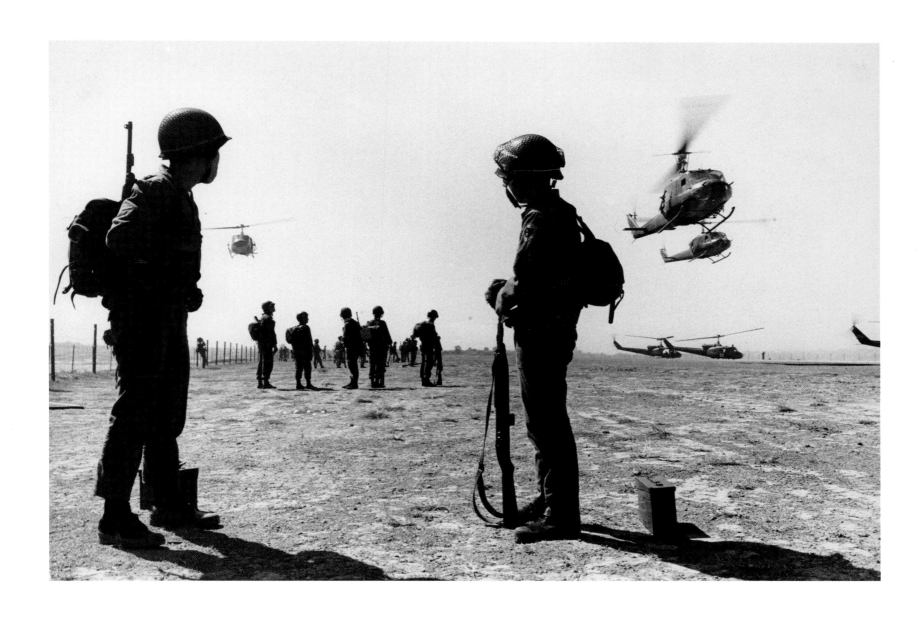

Left
Accreditation document,
Vietnam, 1965

Above
Landing zone, Mekong
Delta, Vietnam, 1965
(Don McCullin's first
photograph of the war
in Vietnam)

3

THE *SUNDAY TIMES*

1967–1978

Pages 69-71
Sunday Times magazine,
June 26, 1966, featuring
Don McCullin's colour
photographs from
Mississippi and the Deep
South, his first
assignment for the
magazine

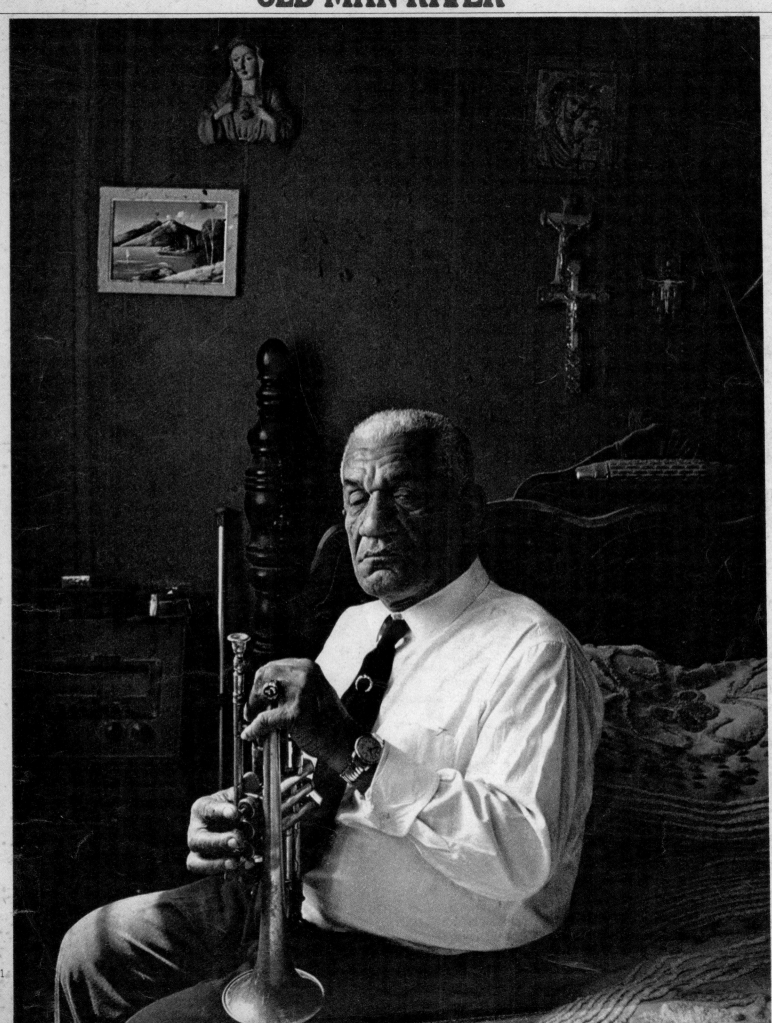

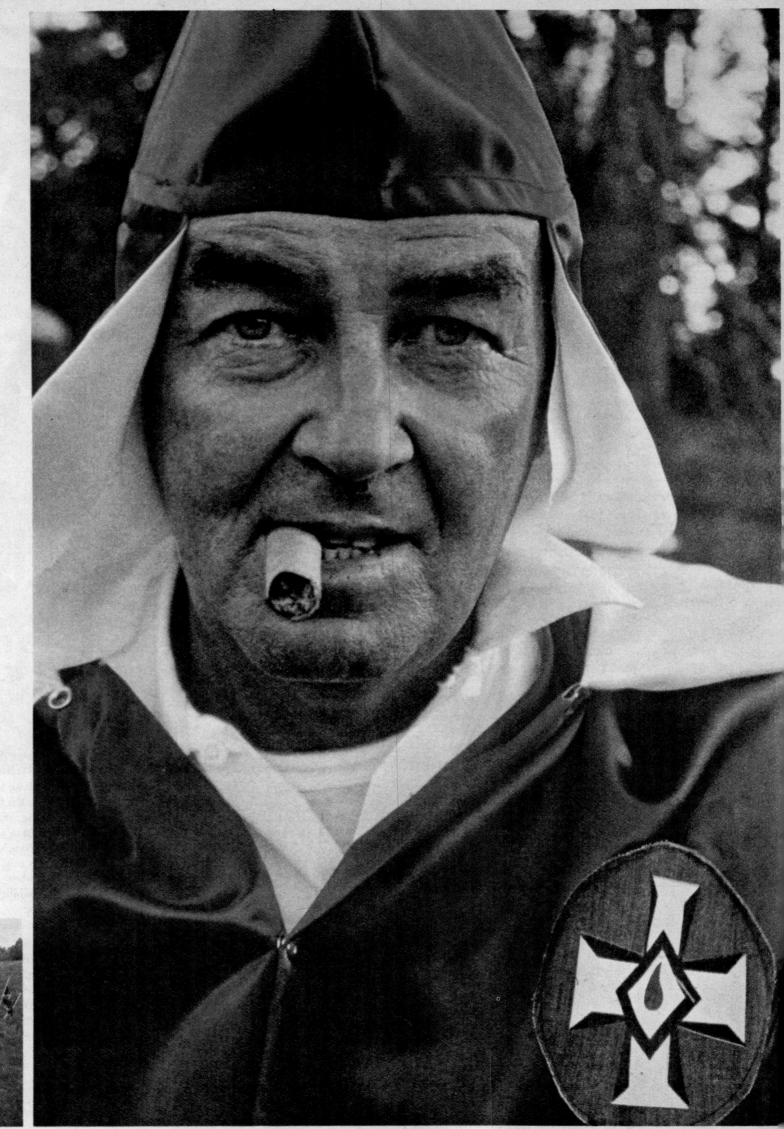

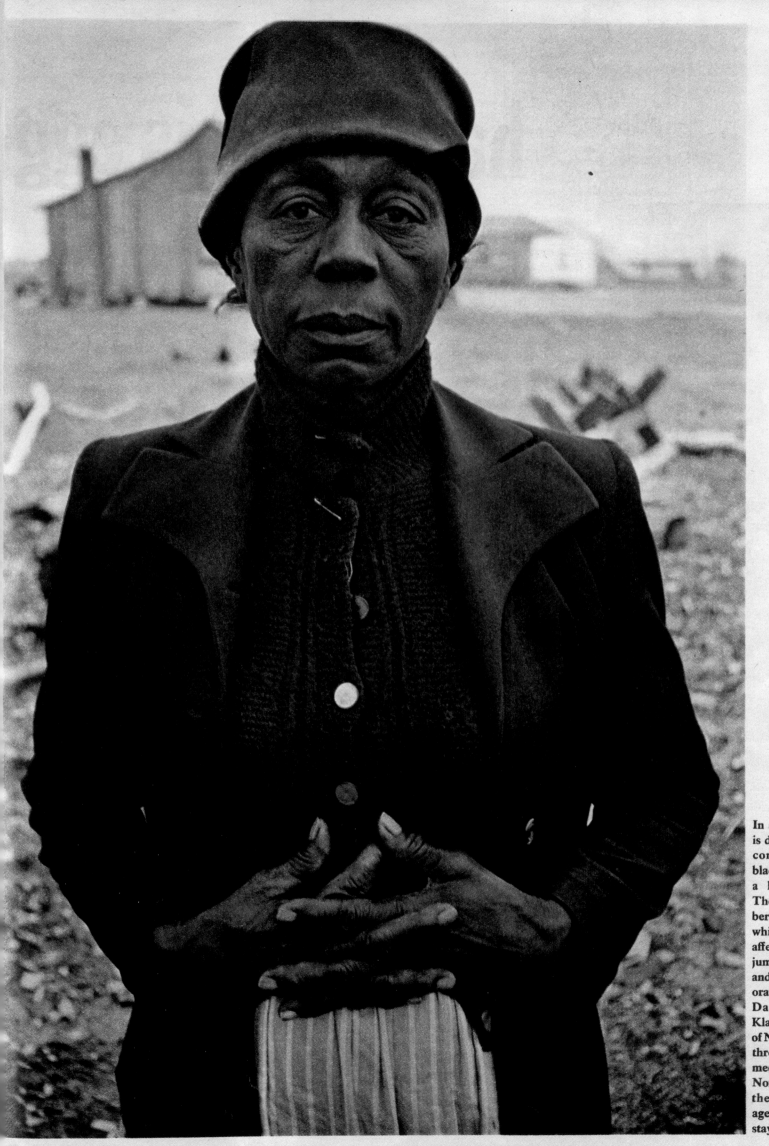

In a land where poverty is despised in whites and considered natural in blacks, dignity can be a kind of consolation. The Klan, whose members are known as 'poor white trash', attempt to affect it by the mumbo-jumbo of their ceremonies and the ludicrously elaborate robes as worn by Dan Dwyer (left), a Klan Titan. Thousands of Negro cotton workers, thrown out of work by mechanised farming, go North to try to better themselves. But this ageing cotton worker stays impassively behind 23

To: Donald McCullin
in memory of our
visit together to the
battlefield of Alamein —
hard work indeed, but we
had much interesting
conversation and we both
learnt a great deal from
each other.

Montgomery of Alamein
F.M
May 1967

In 1962 the *Sunday Times* established the first colour magazine. The newspaper itself was in its heyday during the sixties. Harold Evans was the best editor you could ever work under. There was a great team of graphic designers and picture editors. I was enticed to go there by my friend from the *Observer*, the designer David King, the authority on Soviet graphics and design. In 1966 I followed him to the *Sunday Times*. I was sent to do a story about the Mississippi River. I took an old tramp steamer from Glasgow and two weeks later I was in Charleston. The boat went down to Miami, where I disembarked and went up to New Orleans. I wasn't familiar with photographing in colour so I was worried. We integrated the colour work with some other black-and-white pictures about the Chicago Police. I filled my coffers over and over with this experience. I would go back to England and they would lay out a story and then suddenly I would be off somewhere else. I actually had the nerve to ask why we weren't covering certain things and they'd tell me to go out and do them. I had carte blanche to do what I wanted. It was extraordinary. For a journalist it was the most exciting place in the world to be. I'd always thought colour magazines were a form of fruit salad after the main course. I never imagined we'd get much recognition. On the contrary, we started challenging the newspaper. We started doing really hard stories.

If you were a picture editor and you were sending someone to a war, you could be sending that person to his death. I asked to go to places rather than wait to be sent. I used to go into the offices and say, 'Shouldn't we be taking an interest in such-and-such?' Michael Rand, the art director, would say, 'Well, what are you standing around for? Get going!'

In the Six Day War, everything happened so fast. Before the war started, I had gone to the Alamein Desert with Field Marshal Montgomery, who was reliving his experience. The *Sunday Times* arranged this because at the same time they were trying to acquire the loan

of the Tutankhamen treasures for the British Museum. Then the Six Day War kicked off. I returned to Cairo to see if we could liaise with some of the Egyptian generals that we'd met during the Montgomery visit, but it didn't happen. I came back to London and then the next day we went to Cyprus – we had heard that the Israelis were going to bring a plane into Cyprus and transport the journalists back to Tel Aviv. I got that flight and was accredited by the Israeli authorities.

I decided to go to the Battle of Jerusalem with the correspondent Colin Simpson. Many of the correspondents went south to the Sinai Desert, but the Israelis were overwhelming the Egyptian forces at such speed, the journalists couldn't keep up. At the Tomb of David in Jerusalem the Israeli paratroopers were assembling for their assault. They passed through the Lion's Gate and I followed. Colin was on the back of a tank, which I think he fell off and he didn't make it with me through the gate. We immediately received sniper fire and started taking casualties. The Israelis quickly overwhelmed the resistance. An Israeli was yelling at me, and I thought he was angry for some reason. I couldn't understand what he was saying. An Israeli soldier said, 'He wanted to know if you had a knife. He wanted to cut the webbing off a wounded soldier who was screaming with a bullet wound.' Before I knew where I was, the battle seemed to have been won. I was sitting down and someone brought a tray of Cokes. Then a man came up and said, 'Why are you sitting down? You should be where history is being made! The Wailing Wall, you fool!' I walked through the alleyways, which had been cleared, until I came to the Wall, where I saw people banging their heads against the stone. My bewilderment betrayed my ignorance. The Israelis had reclaimed the Wall and were praying in what was a highly emotional scene, which I failed to photograph.

Later, I returned to the King David Hotel and actually got into bed with all my clothes on. I remember

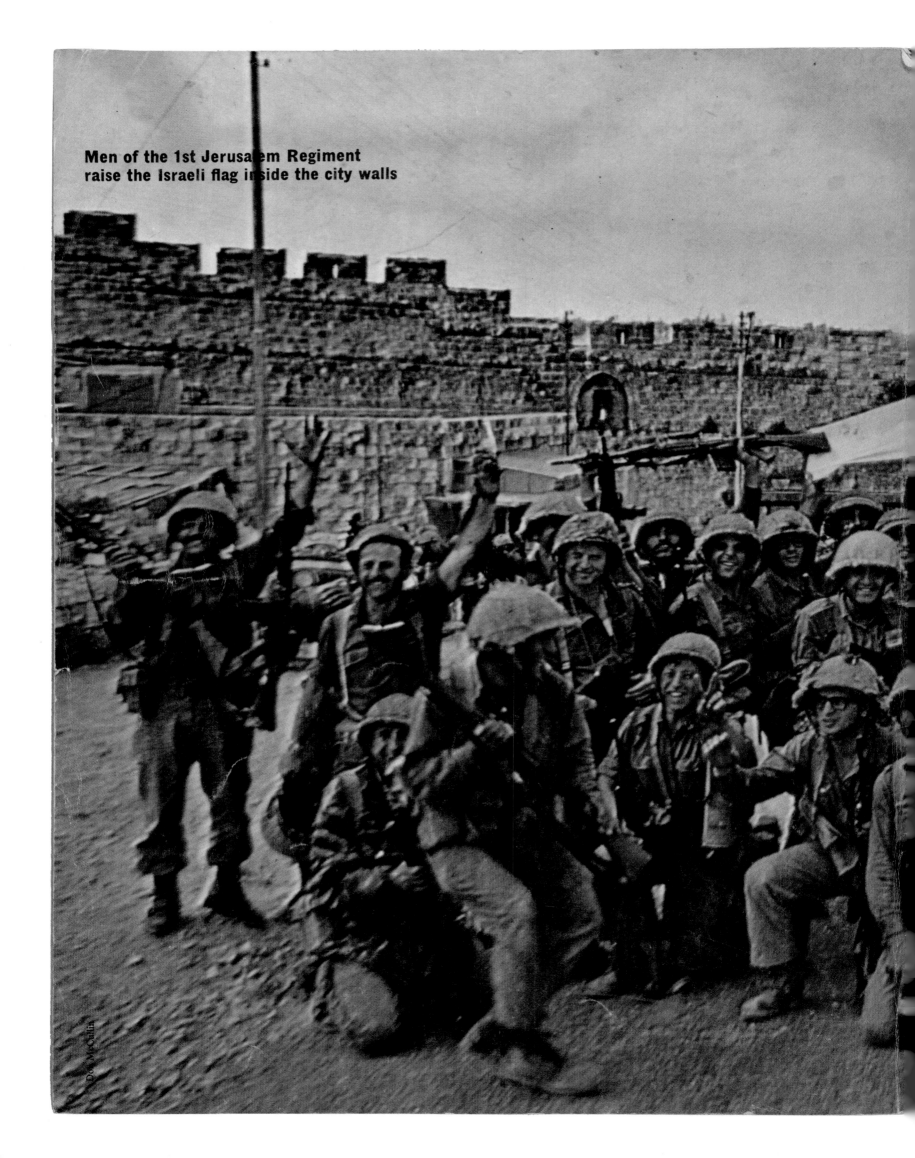

Men of the 1st Jerusalem Regiment
raise the Israeli flag inside the city walls

THE HOLY WAR JUNE 67

Compiled by the foreign staff of the London Sunday Times and a team of international photographers, with full maps and diagrams. Proceeds to refugee relief and the Israeli 'Red Cross' (MDA) 10s. $1.75

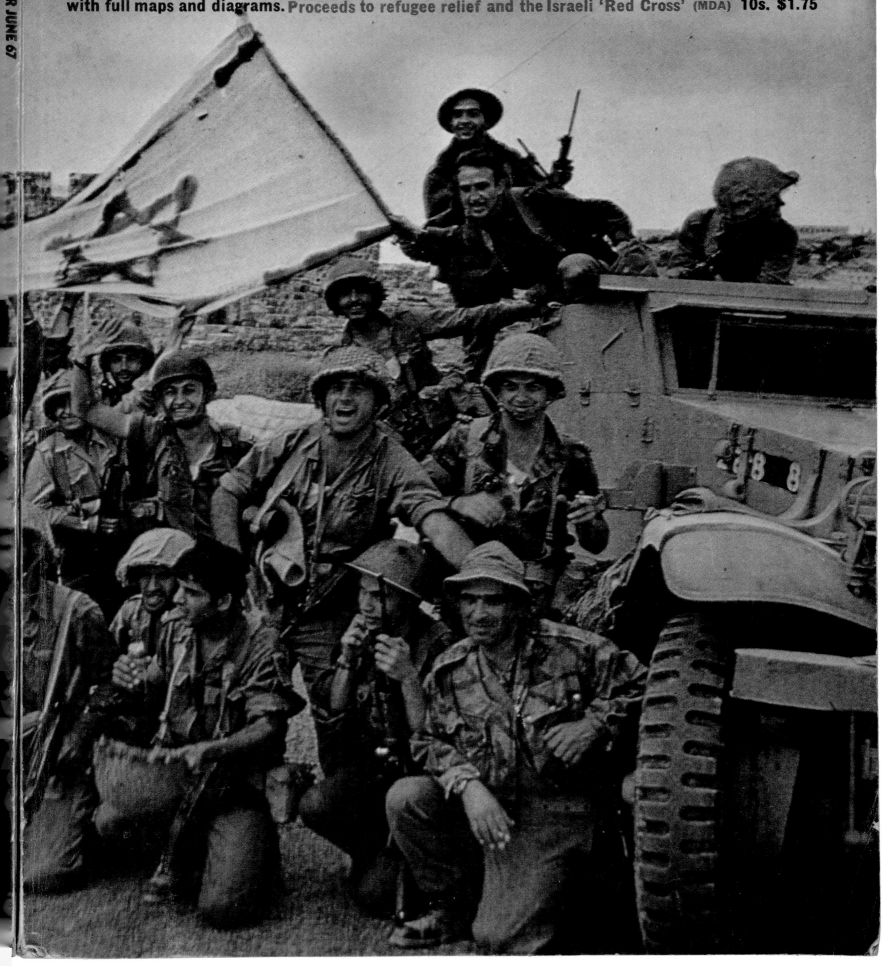

THE HOLY WAR JUNE 67

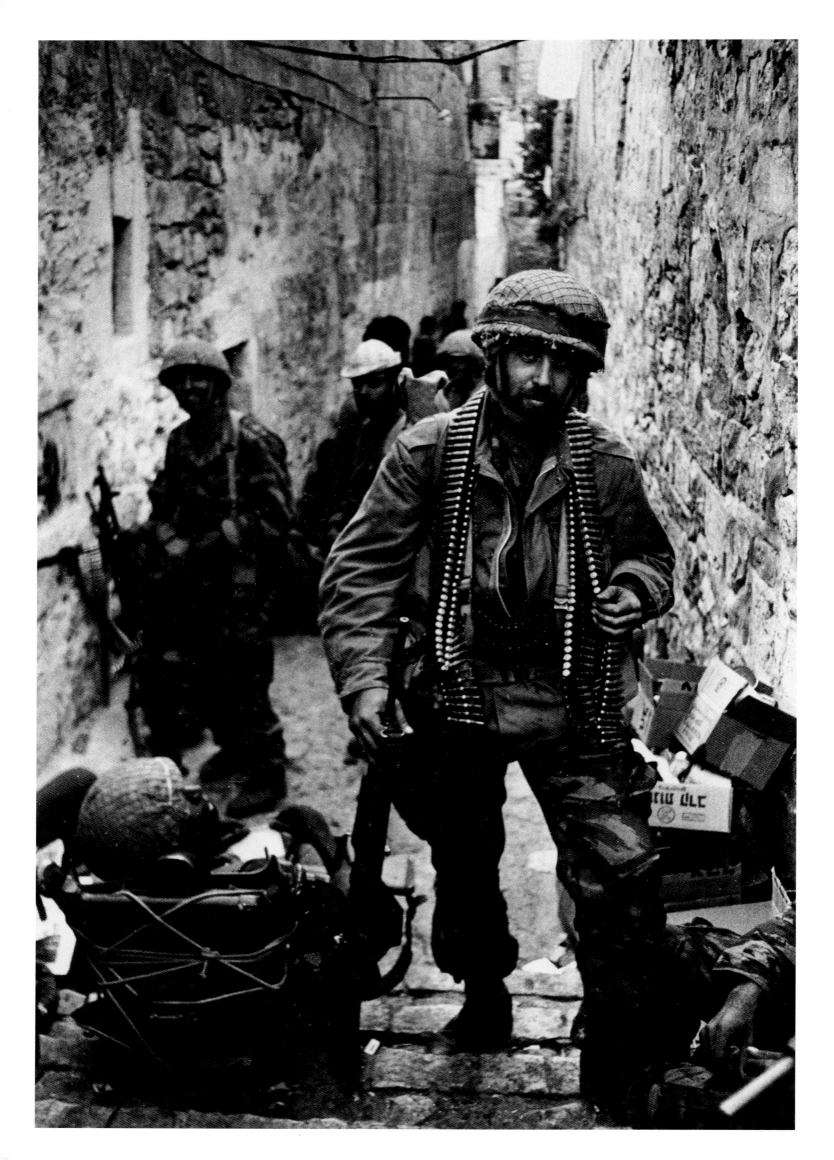

waking in the early morning. There was a knock on the door and a man said, 'Are you Don McCullin? There's a man down the hallway who wants you to come and meet him. His name's Cornell Capa.' He was the brother of the legendary photographer Robert Capa. I sat up in my bed and I could see all the dust on the sheets. I felt very embarrassed. When you've been in a battle and it's a historical battle and you've survived, and you've slept the night, which is difficult because your mind is too high, you think, 'I've just been involved in the most amazing piece of history and I'm still alive.' I went down the hall and met Cornell Capa, who became a friend. He was to be an important figure in the photography world in America and founded the International Center of Photography in New York. His brother had stepped on a mine in Indo-China in 1954. There seemed to be an empty seat. I thought it had my name on it. But I never wanted to be described as a 'war photographer'. It's like saying you work in an abattoir.

I left Jerusalem that same day. I went back to Tel Aviv and got a night flight to London. A huge mistake. The Israelis had expected me, like everybody else, to hand in my film for censorship. The next time I went back to Israel, I was strip-searched, because they were still angry that I had not gone through the censors. I did get the first pictures of the fighting in Jerusalem, but I don't think they were that good. I still lacked the experience. If I'd been in that battle today, I would have really eaten it up. I was very naive and a bit slow off the mark. Even though I did well in the Cyprus war, I wasn't very proud of what I did in Jerusalem. I made a lot of mistakes. I feel slightly ashamed of my lack of professionalism. I should have done better.

That was in 1967. The next year, when the Americans were coming under huge pressure at the start of the Tet Offensive in Vietnam, I begged to be sent there, to no avail and the days were going by. I finally got on the last Air France flight that tried to land in Saigon when the Vietcong had already attacked the American Embassy. I went to Vietnam to cover the Khe Sanh situation. The North Vietnamese were doing exactly what they did to the French at Dien Bien Phu in 1954, when they dragged hundreds of artillery pieces and surrounded the French, eventually overwhelming them. Of course, unlike the French, the Americans had the opportunity to pound the North Vietnamese with air power. After the Air France flight overflew to Hong Kong, I eventually got to Saigon and then reached the press centre in Da Nang. I said I wanted to go to Khe Sanh and was told that one of the most famous photographers had just come out of Khe Sanh. It was David Douglas Duncan, who had covered the Korean War brilliantly. There was no way, I thought, I was going to follow Duncan. One of the press officers said, 'Listen, you wouldn't do yourself any harm if you went with the 5th Marines. They're going to relieve Hue.' I jumped on a truck and made my way with the 5th Marine Regiment to the Imperial Citadel in Hue. Having switched my assignment, I was on the ground and I knew what to do, and I was with the marines when they made their assault.

I think what followed at Hue is considered strategically to be one of the most important battles of the war. The North Vietnamese had bottled up the elite Marine Corps in Khe Sanh because their real intention was to capture the city of Hue, which they did. There, they executed two and a half thousand people associated with the South Vietnamese regime, including scholars from the university, then buried them in pits. I was on my own there which suited me fine. I didn't have much equipment – a pair of boots and fatigues, no helmet, no flak jacket, no water bottles or food. I was carrying just my usual three Nikon cameras, thirty rolls of film and two light meters. I had to scavenge. I had no idea that the battle was going to last so long. A North Vietnamese regiment was dug in and determined to hold the city, so the battle went on for nearly two

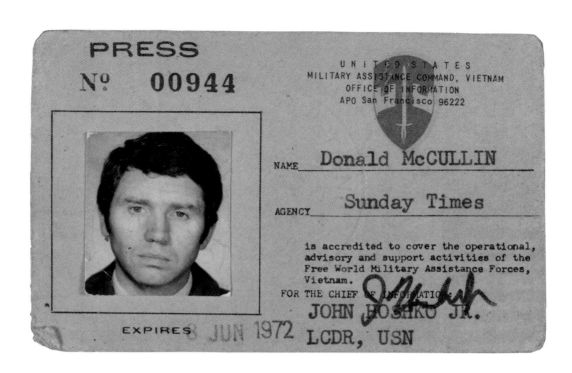

weeks. As the days went by, the marines were taking huge casualties. I went to the casualty clearing area and acquired my equipment – the helmet and flak jacket – from mountains of discarded stuff. I was kitted out as an American marine, which was dangerous because I was open to sniper fire. Most of the casualties were from snipers, who are the most feared people of all, because you don't see them, you don't hear them, and then you're dead.

I was on the walls of the Citadel, which was strangely semi-medieval for the site of a modern battle with twentieth-century armaments and ordnance flying around. Phantom bombers were dropping napalm behind us, which was meant to land in front. You had the anxiety of seeing these great canisters of death coming towards you. CS gas was being fired to winkle the North Vietnamese out of the foxholes. They were using offshore naval bombardments in grid patterns just ahead of our lines. These people, the Americans, were not *my* people. It wasn't *my* war. The enemy was not *my* enemy. I was an observer in their uniform. I was accredited to the US Army as a correspondent and they gave you the generous rank of major, which was a way of allowing you to get from A to B with a certain amount of authority. As the days went on, they were fighting hand to hand. Grenades were being thrown, which means the forces were only about twenty yards apart at the most. Suddenly you'd look down and see a Chinese grenade between you and the man next to you. You'd dive for cover and discover he was the one that got it. This went on day after day after day. Tanks ran over bodies on the road and flattened them like oriental carpets. One day you'd run one way and the next day you'd run the other and see a man that you'd been sleeping beside almost head to head now lying dead. I remember coming under attack and

jumping into a foxhole and sitting on the stomach of a dead North Vietnamese soldier. War is a nightmare experience. Madness. Whatever happens, one shouldn't be surprised.

I made up for my shortcomings in Jerusalem. For me to take those pictures, I had to stand up. I offered myself. I believe to this day that a sniper must have seen me, but seen me not carrying a weapon or not *wearing* a weapon. The truth is I could have been the victim of a sniper on so many occasions in Hue. It seems uncanny that I got away with it. The man or woman who was aiming must have known I was a correspondent not a soldier. The North Vietnamese had a certain discipline, which was not the same with the Khmer Rouge in Cambodia.

After the twelfth or thirteenth day I left. I know I was slightly insane on the helicopter to Da Nang. I had thirty rolls of the most powerful film I've ever taken in my life. I lost two rolls, which I never stop thinking about. I was lying down and a sniper was killing men around me so easily. I was under duress. The rolls of film must have fallen out of my combat jacket as I was crawling. I was actually trying to photograph with my mouth flat on the ground and taking in dirt. I photographed a man who was hit in the throat and the leg. I saw two other men killed right next to me and I thought, 'This is what you are. This is what you do. Do it.' When you're afraid, doing what you do best takes your mind off your fear. I would be a liar if I said I wasn't afraid. There was always fear in my make-up.

Back in Da Nang I took off all my clothes, which I'd been living and sleeping in for two weeks. I'd been surviving solely on Army C rations. My body was somebody else's body. My face was somebody else's. I think this was combat fatigue. It went way

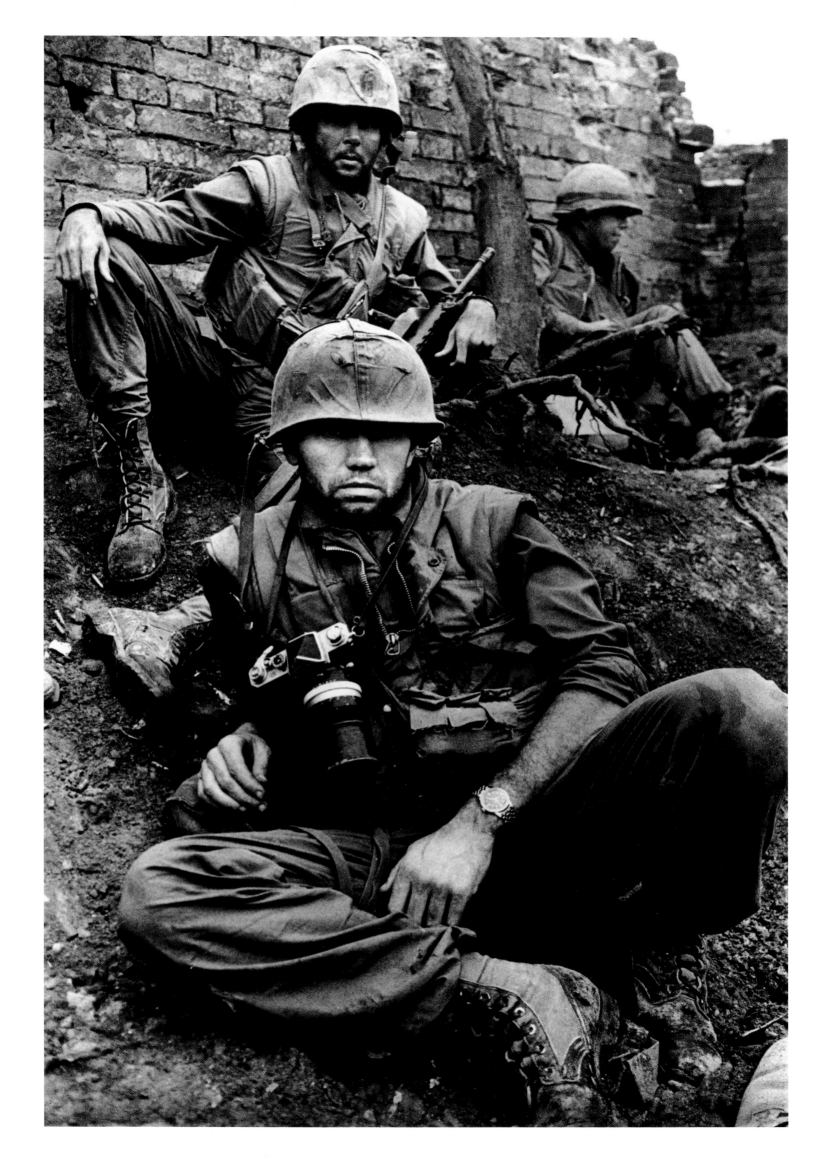

The cover of the *Sunday Times* magazine, March 24, 1968, featuring Don McCullin's coverage of Hue, Vietnam (the soldier in the photograph was later killed)

Pages 84–85
Paris Match, March 9, 1968, featuring Don McCullin's coverage of the battle in Hue, Vietnam, 1968

Pages 86–87
Contact sheets showing Don McCullin's selection of photographs from Hue, Vietnam, 1968, for publication by the *Sunday Times* magazine

beyond madness. I threw all the clothes in a waste bin. The Americans are very generous when they know you've been in those circumstances. People gave me things.

I flew south to Saigon, caught the Air France flight back to Paris and went straight to the Magnum office, where I was a member for a year. I took the plane to London the following morning with my film and contact prints and went straight to the *Sunday Times*. Michael Rand sent me back home to Hertfordshire to edit and I made the prints in my little darkroom. The *New York Times* ran a story about an Englishman who was in the battle. The *Sunday Times* ran it. Everybody ran this story. For the first time in my life I felt like a professional. I had started at the Berlin Wall in 1961 and seven years later I'd graduated. For the first time in my life I felt I was capable of being 'The Man'.

I edited the pictures. I thought that it should be my choice. I was the one who was there. I knew best. But I made the biggest mistake. The picture that has been used more than any other photograph I took in Vietnam wasn't one that I had included for the *Sunday Times*. I'd photographed a shell-shocked American soldier sitting in the yard where this battle was going on. That's the picture that everybody remembers. They don't remember the picture of the man throwing the grenade, the man dying with blood coming out of his mouth, the man who was hit with the Chinese grenade that I managed to miss. I didn't choose the staring soldier, and of course it's the perfect cover picture. There's an iconic look about it and you have to be careful of icons, because they can border on art. I have to be mindful about playing that card because I don't want to be associated with art. I'm a photographer. I'm a photojournalist, or whatever you

want to call me. But I don't belong to the world of art. Today, I am free to wander the English countryside in Somerset where I live, away from wars and revolutions. Now I can indulge myself. I can call myself what I want. But an artist I'm not. I'm a photographer.

I took a photograph in Hue of a soldier who was shot terribly and was being pinned against the wall. It reminded me of Jesus Christ being brought down from the Cross. It's the most iconic religious image that I have taken. I recognised it immediately. I photographed the man and then I told the soldiers to bring him over. They had to cross the gap, which was the killing zone. They ran with him, and they fell with him. They stumbled and he fell. He had the most awful wound in the upper part of his hip. There were screams and howls, but they got him over to me. I thought this was my chance to repay them. I owed them something. I put my cameras down and told one of the soldiers to look after them and I took this wounded soldier on my shoulders and carried him away from the battle. It was tricky because I didn't want to stumble with him on my back. It was only about fifty yards and I carried him back to the compound where his colonel was, a very nice man called Myron Harrington. Many years later I met Myron at the American Embassy and we had lunch just off Grosvenor Square. We looked at each other with the thousand-yard stare. 'I can't believe we're here', he said. I thought at the time that I'd been taking all these pictures of these people that I had a debt. And it was good for me. It had happened once before in Cyprus when I'd photographed an old woman who was incapable of walking, let alone running. I gave my camera to my friend John Bulmer and carried her. Ironically, he photographed me, and with my own camera!

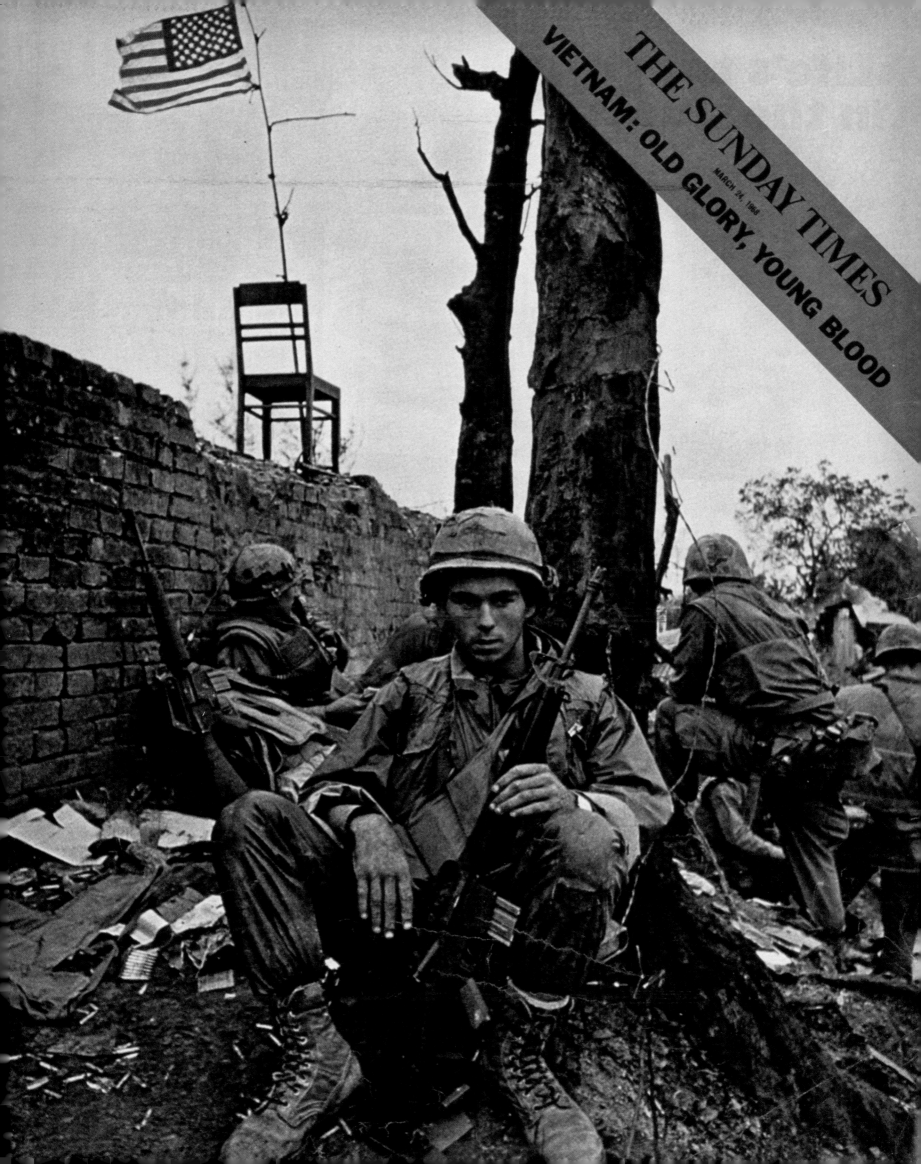

VIETNAM: L'EN

500 000 Américains jetés dans une bataille au corps à corps (ici, les « Marines » dans Hué) : c'est le Vietnam 1968. En 1963, à la mort de Kennedy, des cen

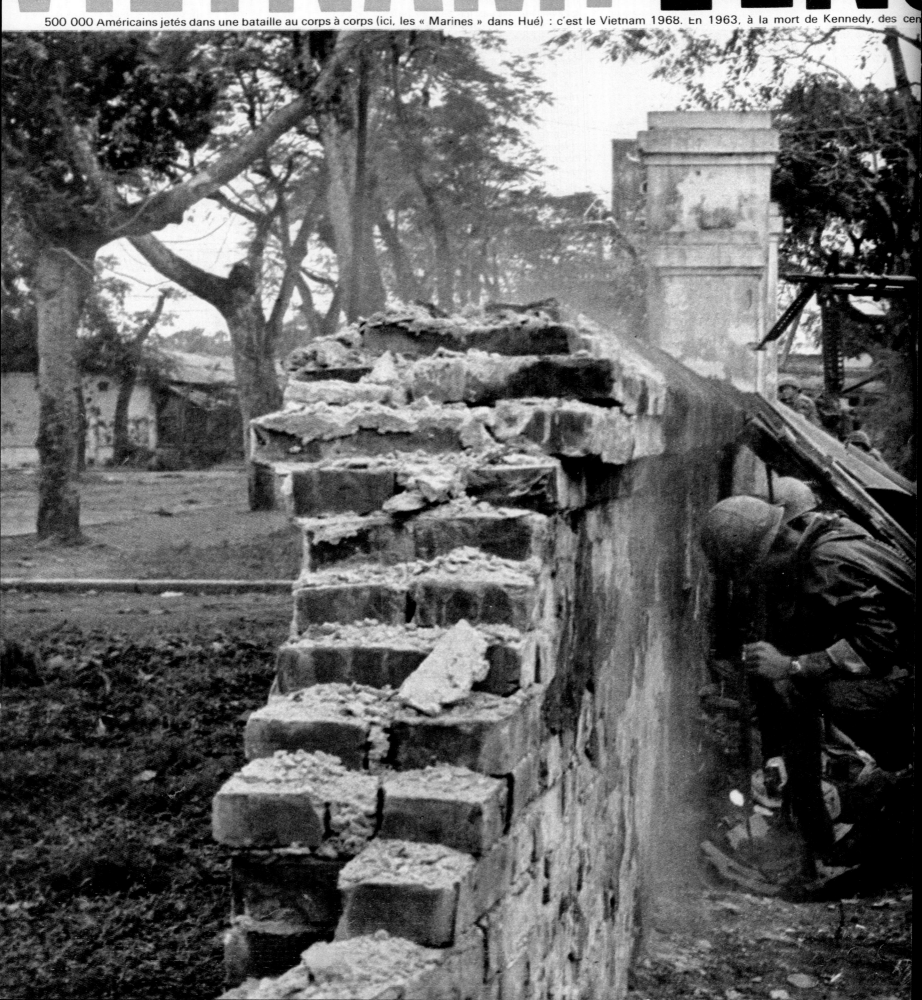

GRENAGE

PAR RAYMOND CARTIER

taines de « conseillers » U.S. assistaient l'armée sud-vietnamienne. Aujourd'hui, après 4 ans et 3 mois de pouvoir, Johnson promet 700 000 soldats à ses généraux.

© Donald McCullin / Magnum

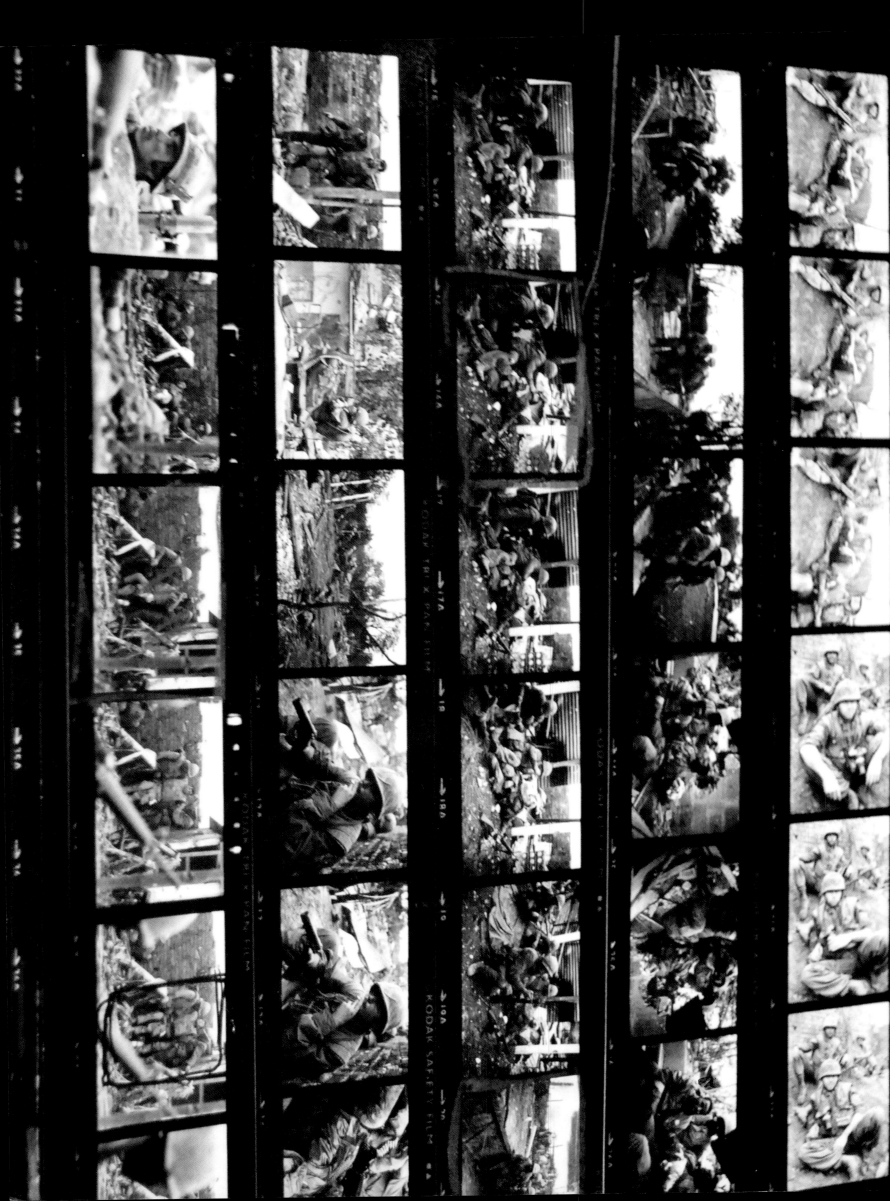

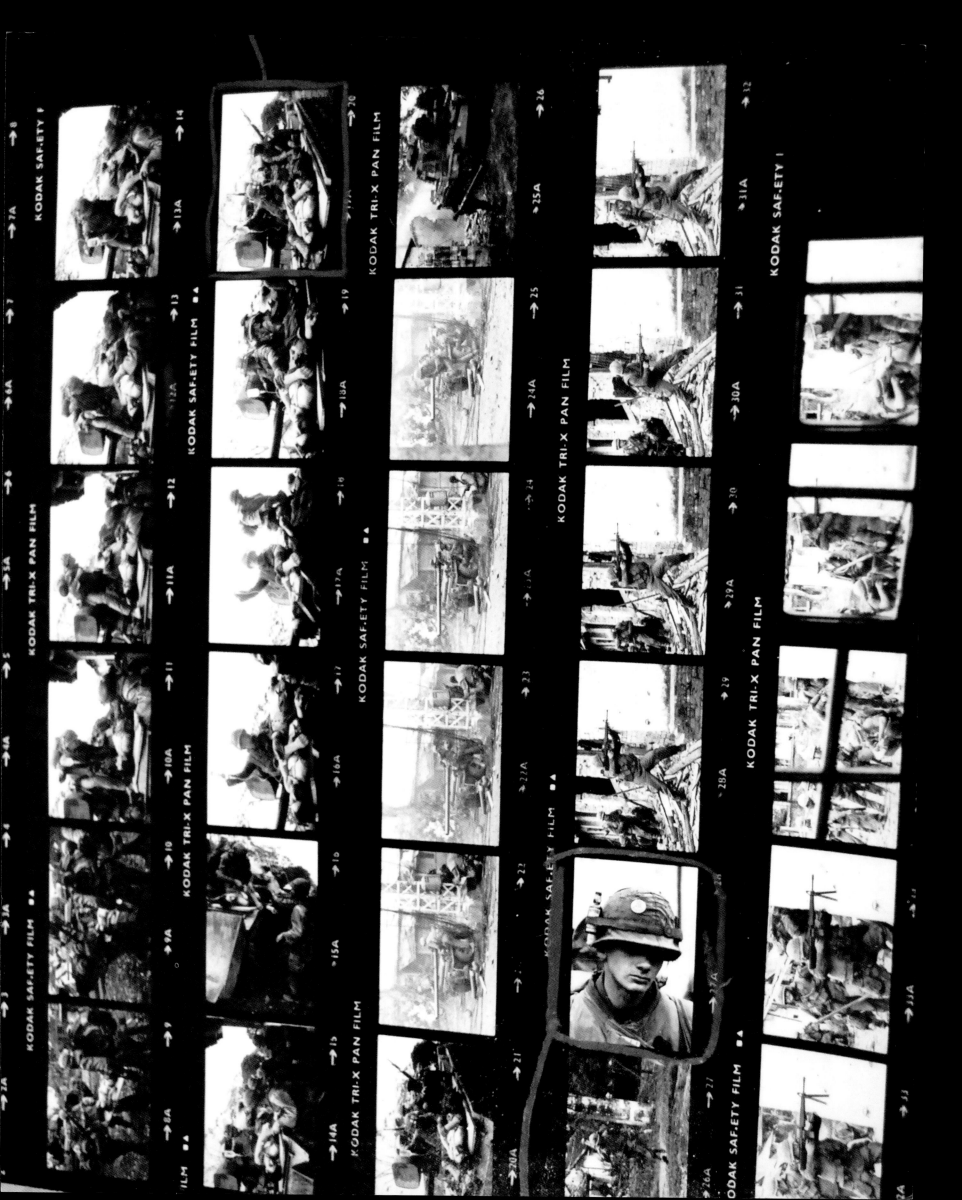

Shell-shocked US marine,
Hue, Vietnam, 1968

Pages 90-91
US marine throwing
grenade towards a sniper,
Hue, Vietnam, 1968
(moments later he was
shot through the hand)

Page 92
US marine shot through
the hand after throwing
grenade, Hue, Vietnam,
1968

Page 93
US marine with captured
North Vietnamese soldier,
Hue, Vietnam, 1968

Pages 94-95
US medical orderlies
evacuating a wounded
Viet Cong, Hue, Vietnam,
1968

Page 96
Refugee, Hue, Vietnam,
1968

Page 97
US marine, Hue, Vietnam,
1968

Pages 98-99
Vietnamese family after
the destruction of their
home by US Phantom
bombers, Hue, Vietnam,
1968

Pages 100-101
US marine shot in the
thigh by a sniper, Hue,
Vietnam, 1968

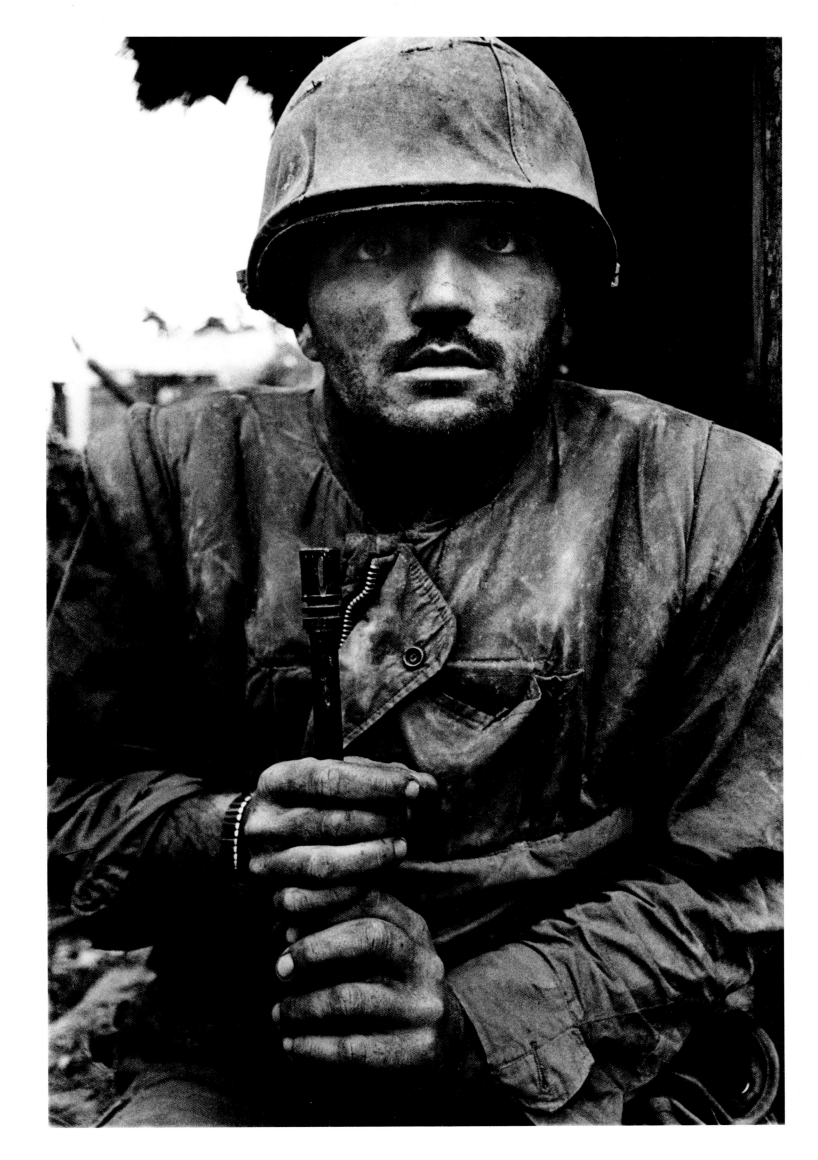

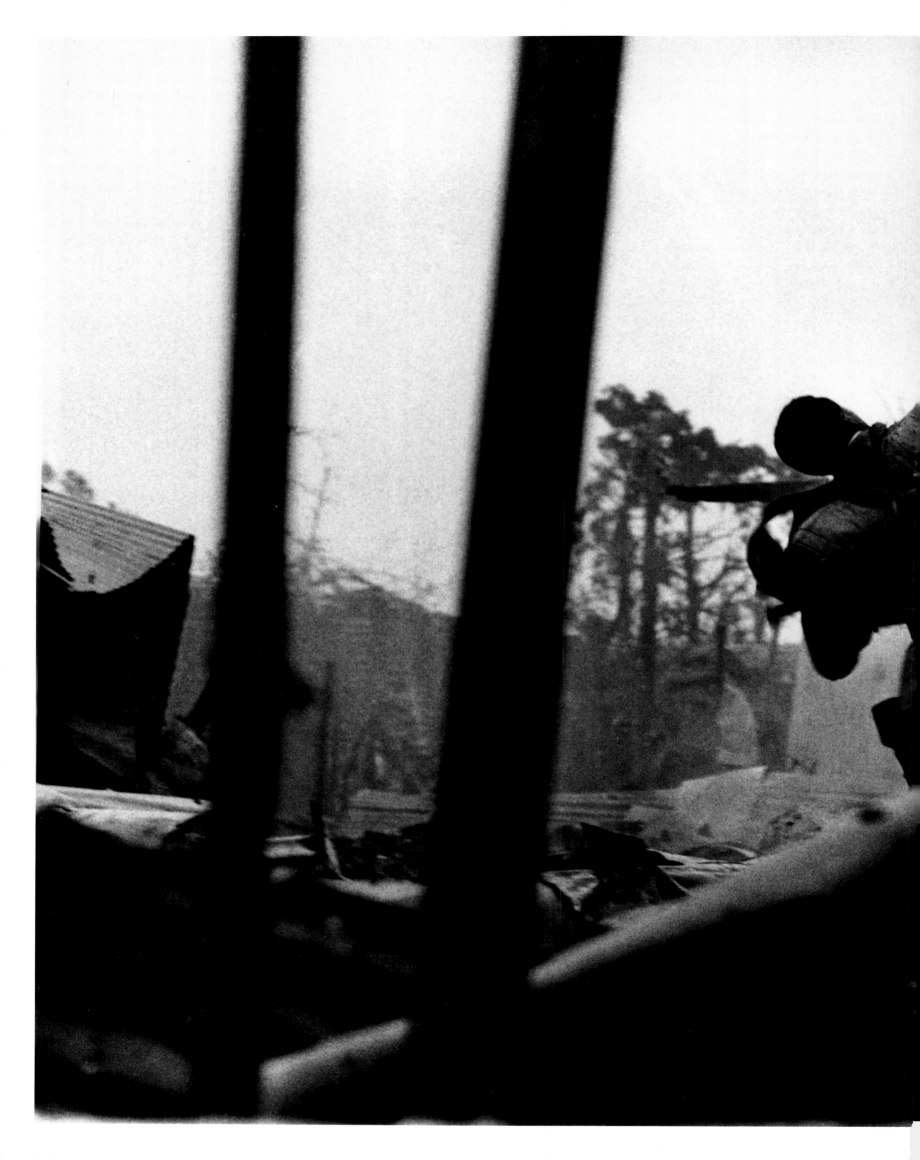

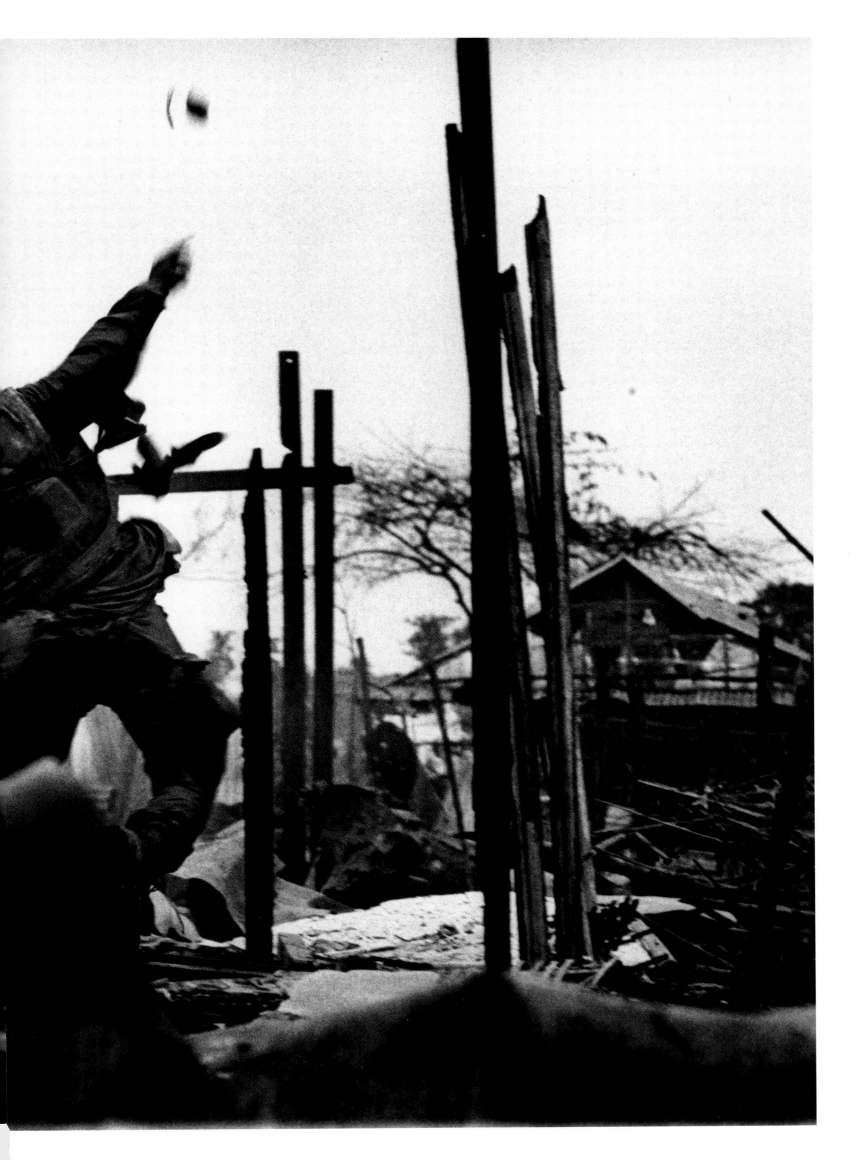

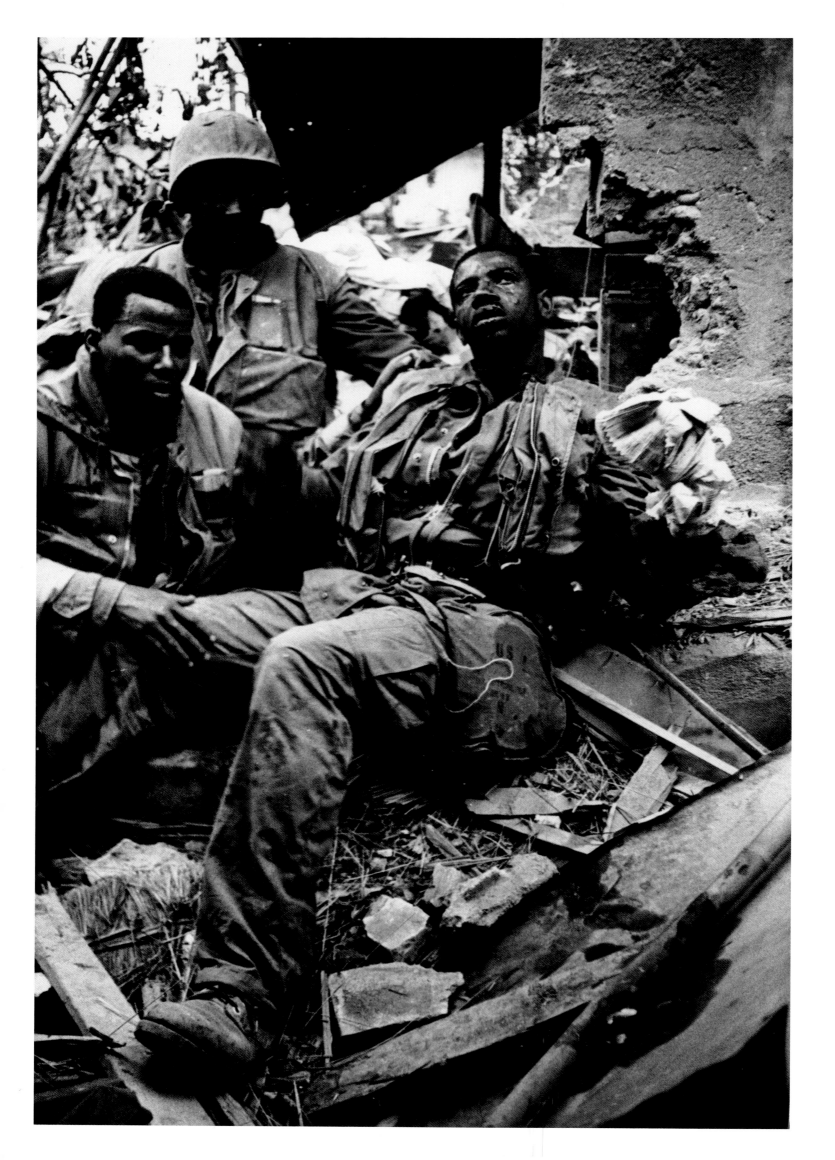

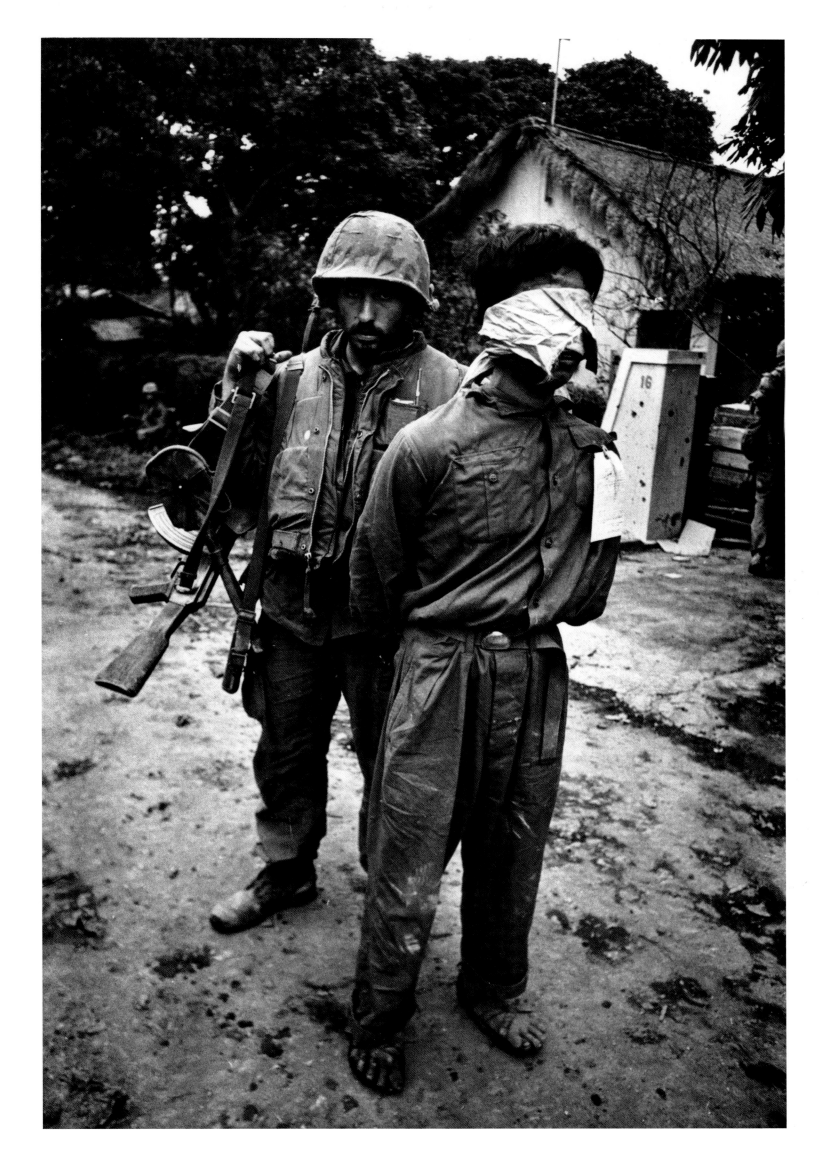

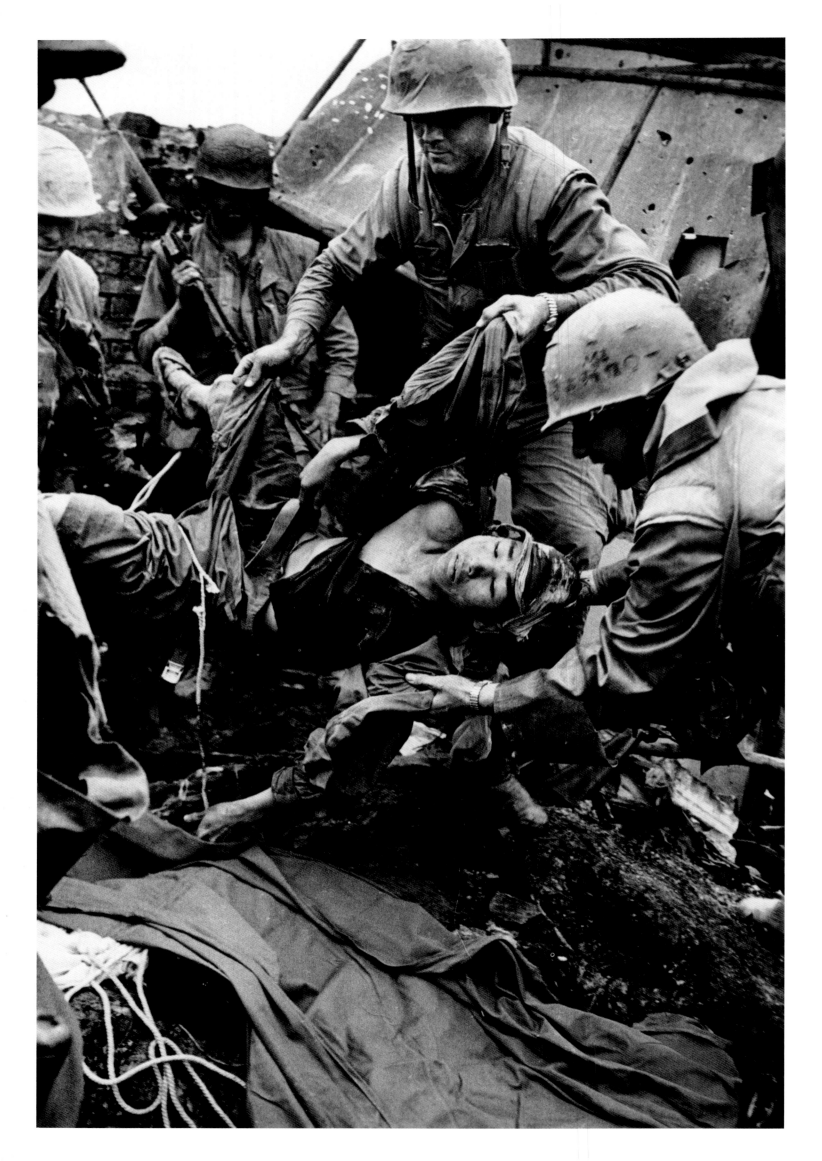

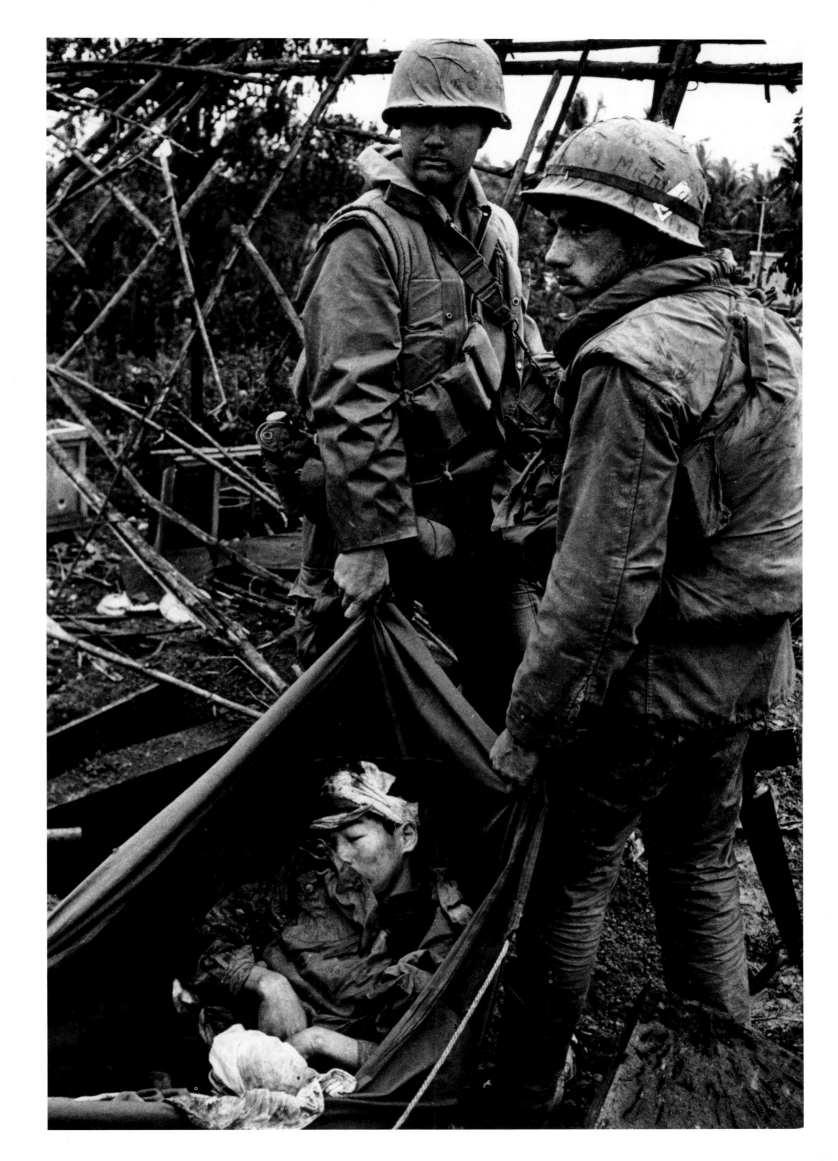

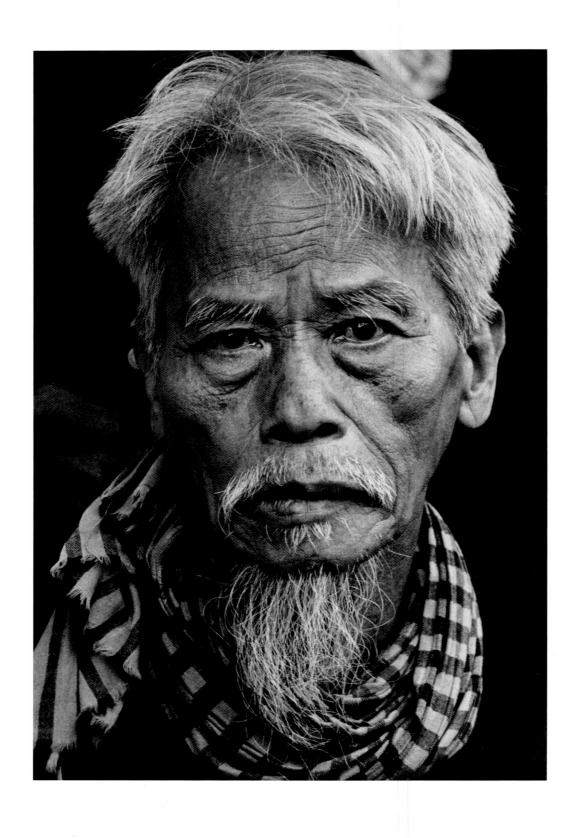

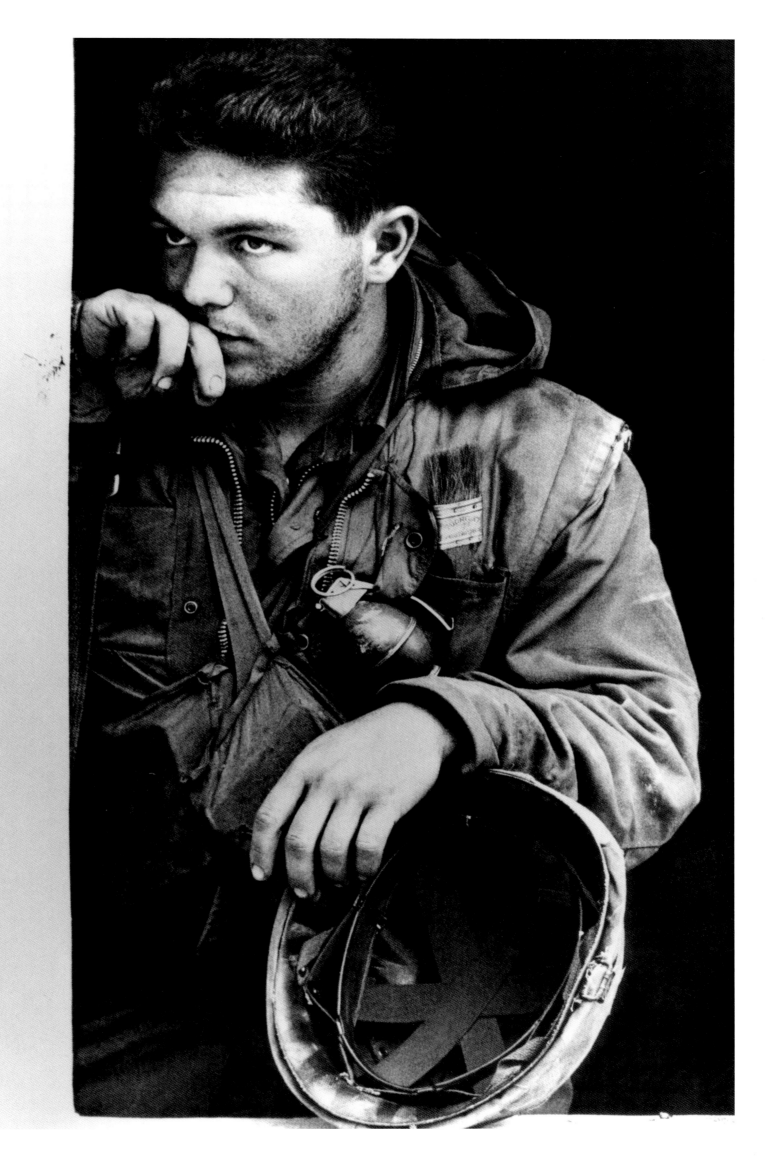

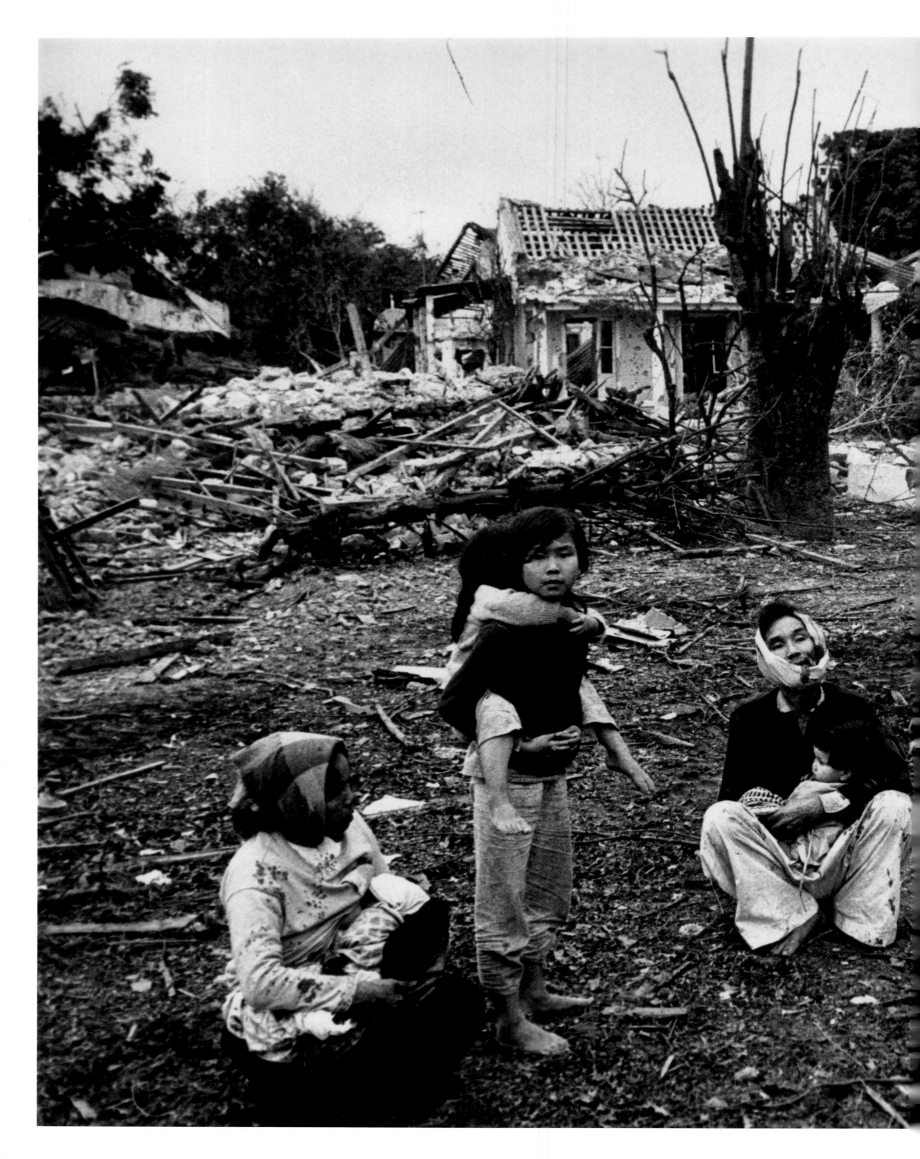

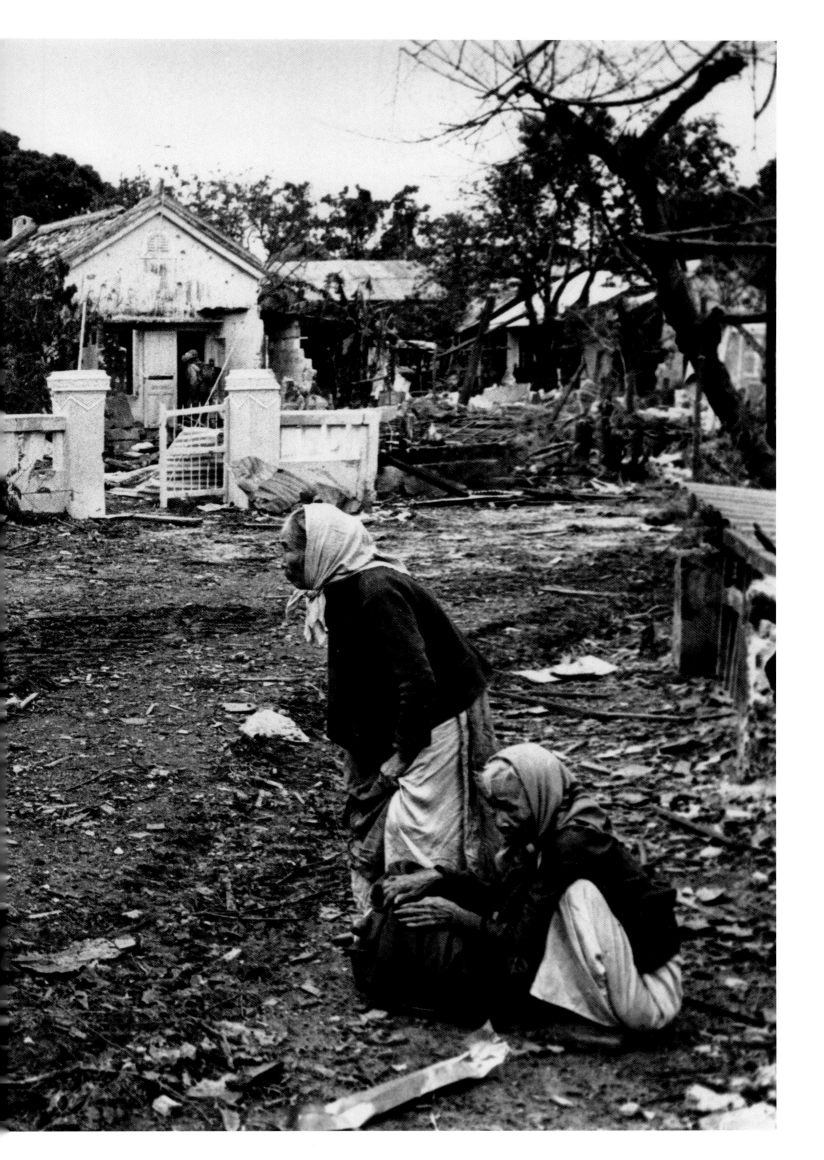

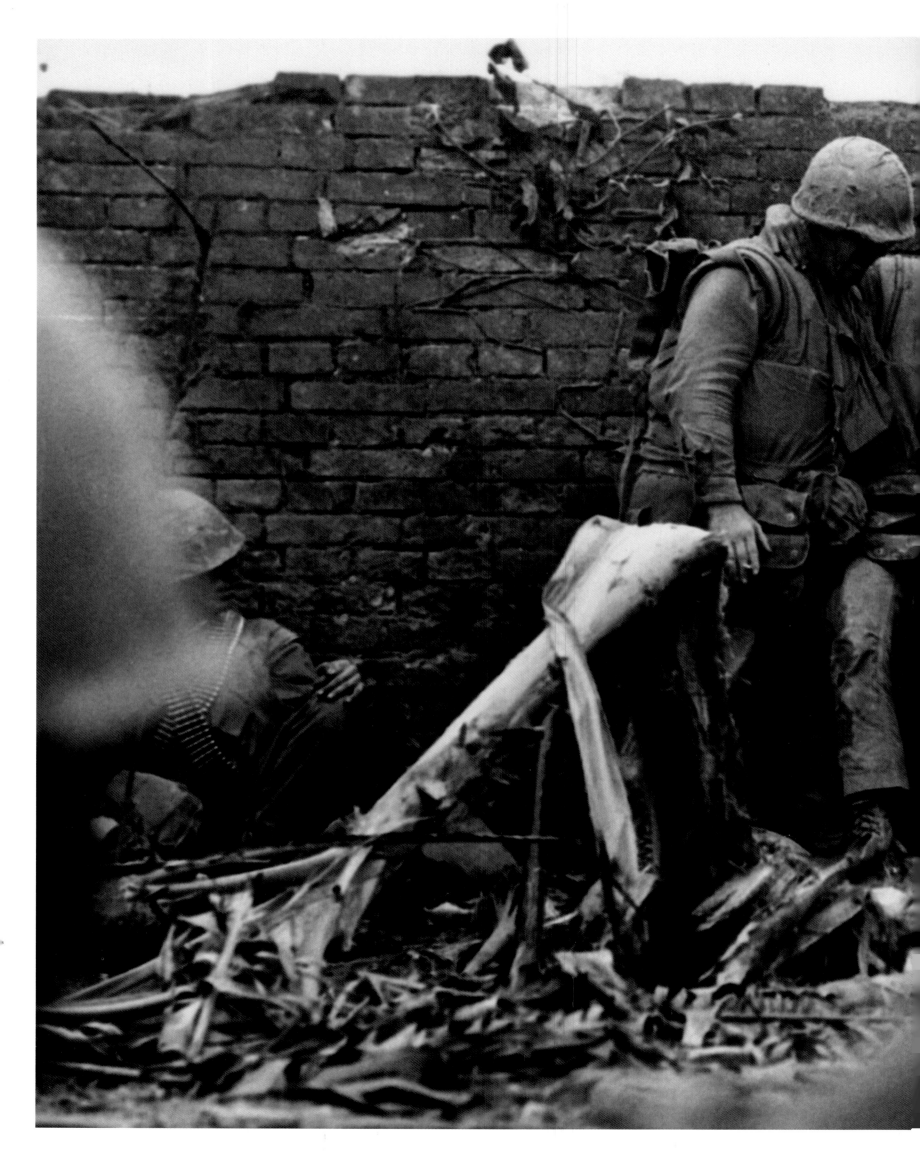

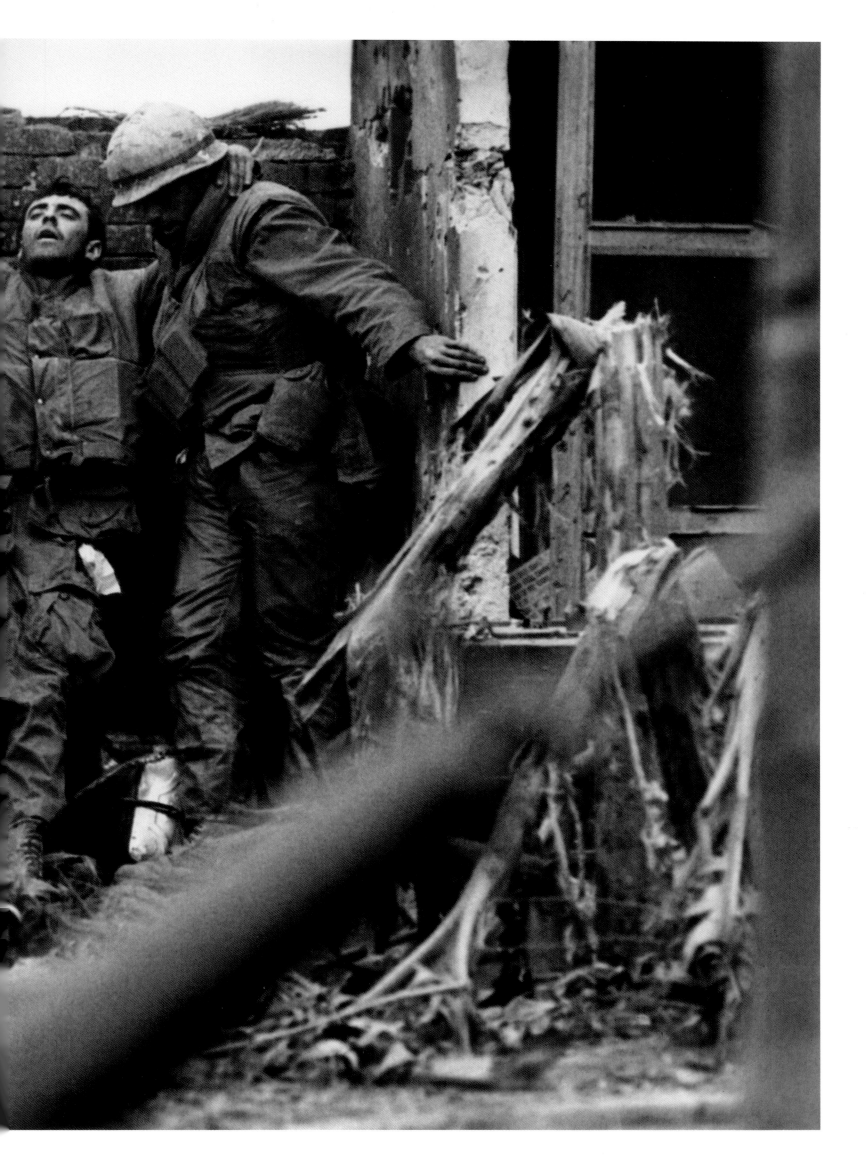

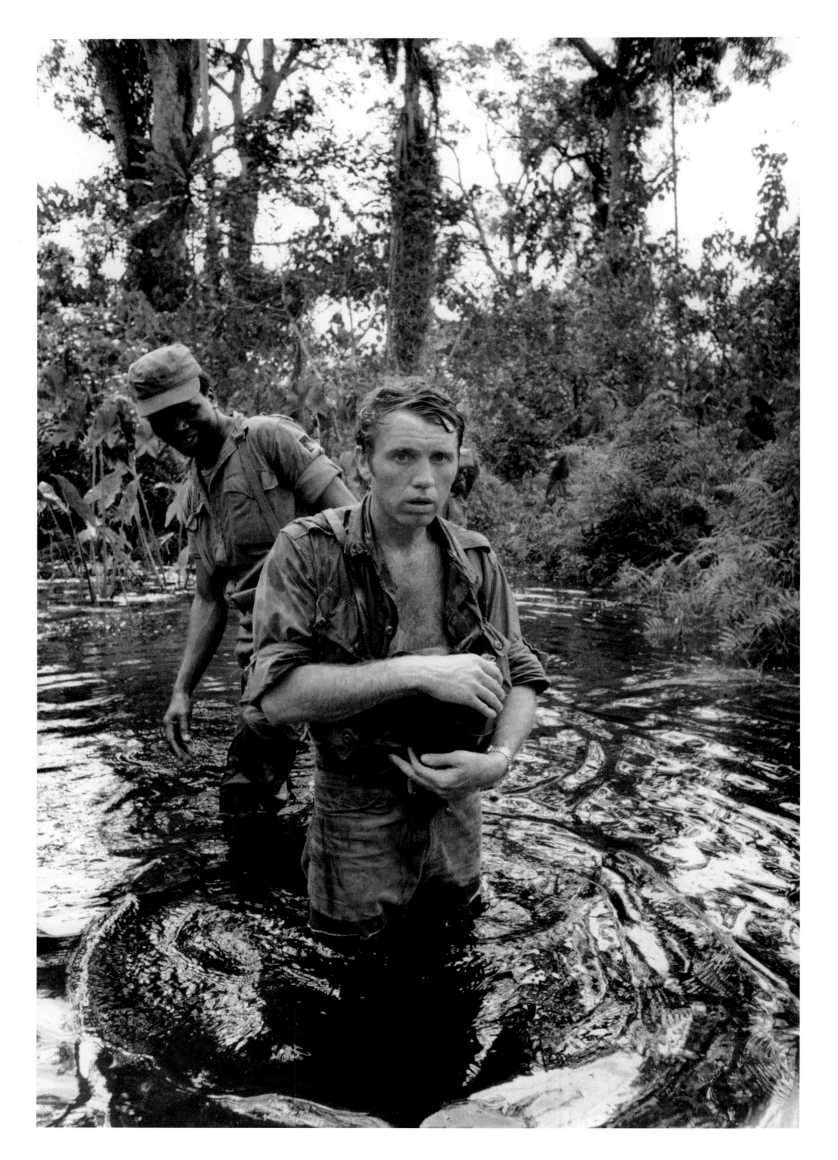

Don McCullin, Biafra,
1968, photograph by
Gilles Caron, who was
killed in Cambodia by the
Khmer Rouge in 1970

Pages 104–09
Sunday Times magazine,
June 1, 1969, featuring
Don McCullin's
photographs from Biafra

I feel guilty about the people I photograph. It's true, I do. Why should I be celebrated at the cost of other people's suffering and lives? I don't sit comfortably with laurels on my head. I had young children in those days. My wife was very loyal and stood by me. Every time I said goodbye and looked back at that little family waving to me, I often wondered if this could be the last time they would see me and I them. I had a very good friend who was murdered by the Khmer Rouge. He and I were a bit competitive. He worked for a French agency and when the Cambodian War started in 1970, he was quick off the mark to get to a former French colony. He arrived there a week before me and disappeared. He was never seen again. I'm still in contact with his wife and family. His elder daughter is forty-five now. She recently told me, 'I loved my father. I understand it was his work. But my sister, who was only two years old when he disappeared, can't forgive him, because she never had a father.' There were other conflicts that went on in parallel to the ones you were covering. Sometimes you clouded your imagination selfishly. These other conflicts were taking place in your own home. One of my children nearly died one day on the kitchen floor in a simple accident after swallowing something. We happened to live in a street full of doctors and they rushed over and saved him. When I was in the battle in Hue, another friend of mine, Philip Jones Griffiths, spent the night talking with me. 'Take it easy here. Be careful', he said. 'You know, people at home are thinking about you.' He knew about my son, but he didn't tell me. I learned what had happened when I came home.

At that time, during 1968, the Biafran War was still going on. My French friend and I went on a special mission with the Biafran Army, who were crossing the Niger River to attack the Onitsha Bridge, which was held by the Nigerians. The Biafrans captured some prisoners and executed them in front of us, and then we had to flee from the battle. The Nigerians were hard on our heels and firing hundreds of mortar bombs in our direction. We were crashing through the jungle with thirty miles to clear to get back to the Niger River. It was a very bad day for us. Had the Nigerian Army caught up with us in our Vietnam camouflage jackets, they would have thought of us as mercenaries. Undoubtedly they would have shot us. There were good days and bad days.

I didn't photograph the prisoners who were blindfolded and tied up. The commander, a really bad man, ordered them to be killed. I looked at my French friend and we just stood and watched it happen. It was terrible. I'd seen men executed before, and since, many times. It's not a nice thing to have to remember. I have never photographed such a killing. The first public execution I witnessed was in Cholon, the Chinese quarter of Saigon, in 1965. I could hear the journalists shouting excitedly as they were hanging off different vantage points. The condemned man was tied to a stake, screaming anti-American slogans. There were headlights on him from parked vehicles. It was stage-managed like some macabre Gilbert and Sullivan. I thought I didn't have the right to photograph another man's death. He hadn't given me his permission. I shouldn't be part of the theatre. I actually heard a correspondent saying, 'God! That was amazing!' I've never forgotten that voice. He was a famous television journalist. It was a chilling thing to say. They shot the victim and then someone stepped forward, held the victim's head and put a 9mm bullet through it. This was the French way of doing things. The fire brigade hosed down the stake when the body had been cut down.

In the end, the story of the war in Biafra became the story of the terrible famine. There's no worse death than death by starvation. I walked into a school complex in Biafra and found eight hundred children standing on their dying legs. It was one of the most shocking things I've ever seen. Back in England there was a little, healthy McCullin family. I had my own

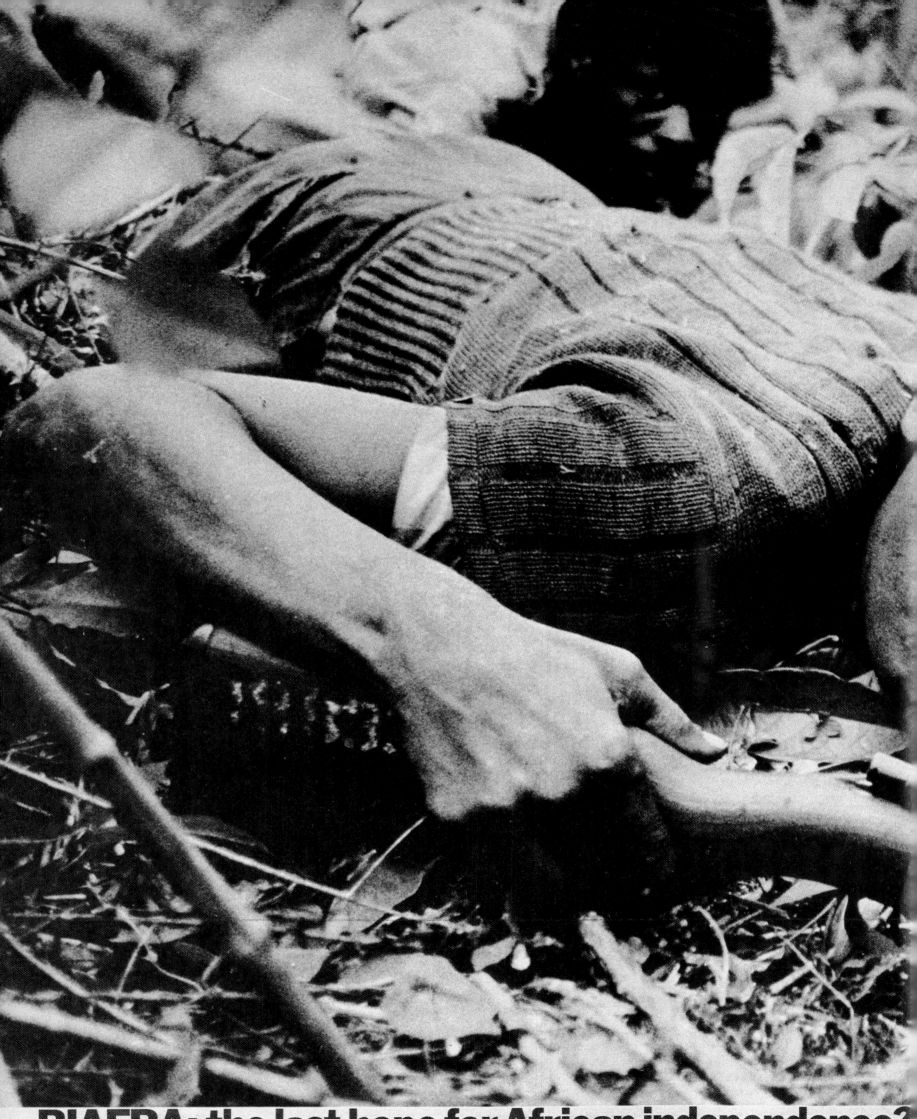

BIAFRA: the last hope for African independence?

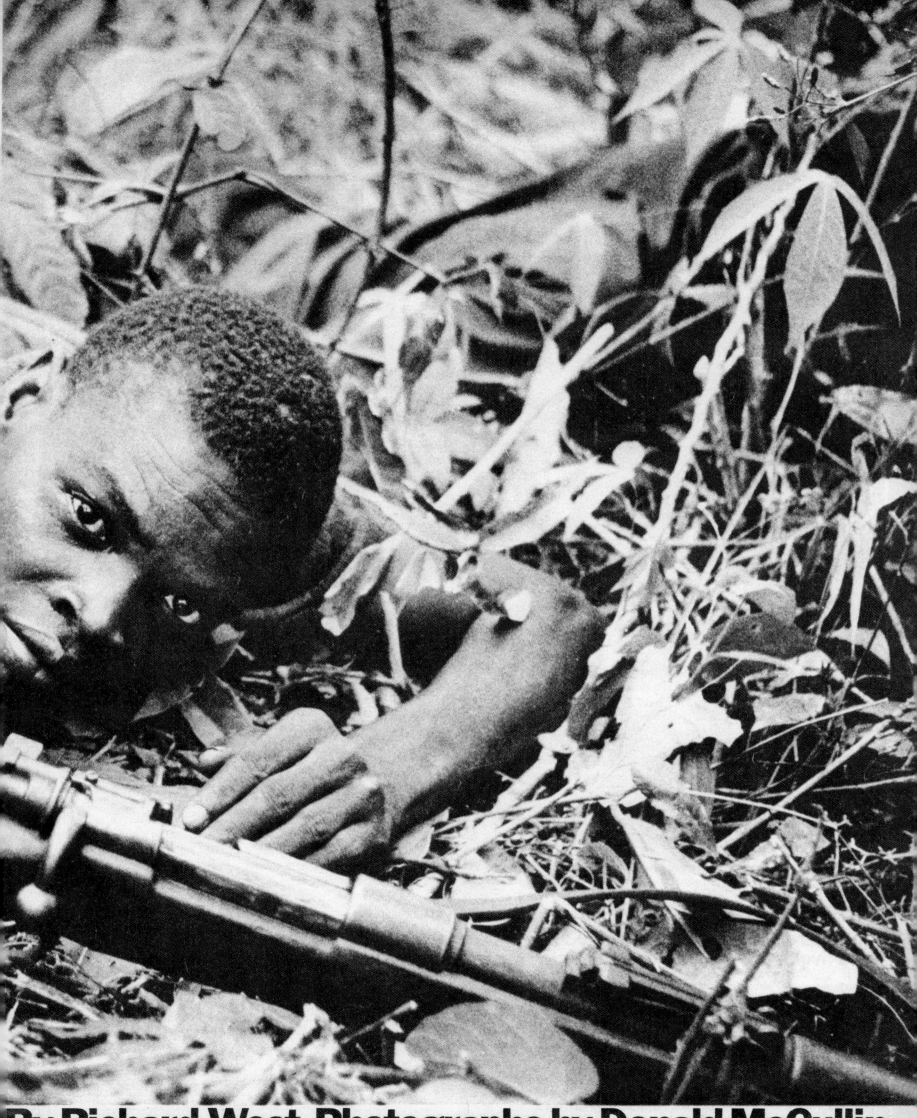

By Richard West. Photographs by Donald McCullin

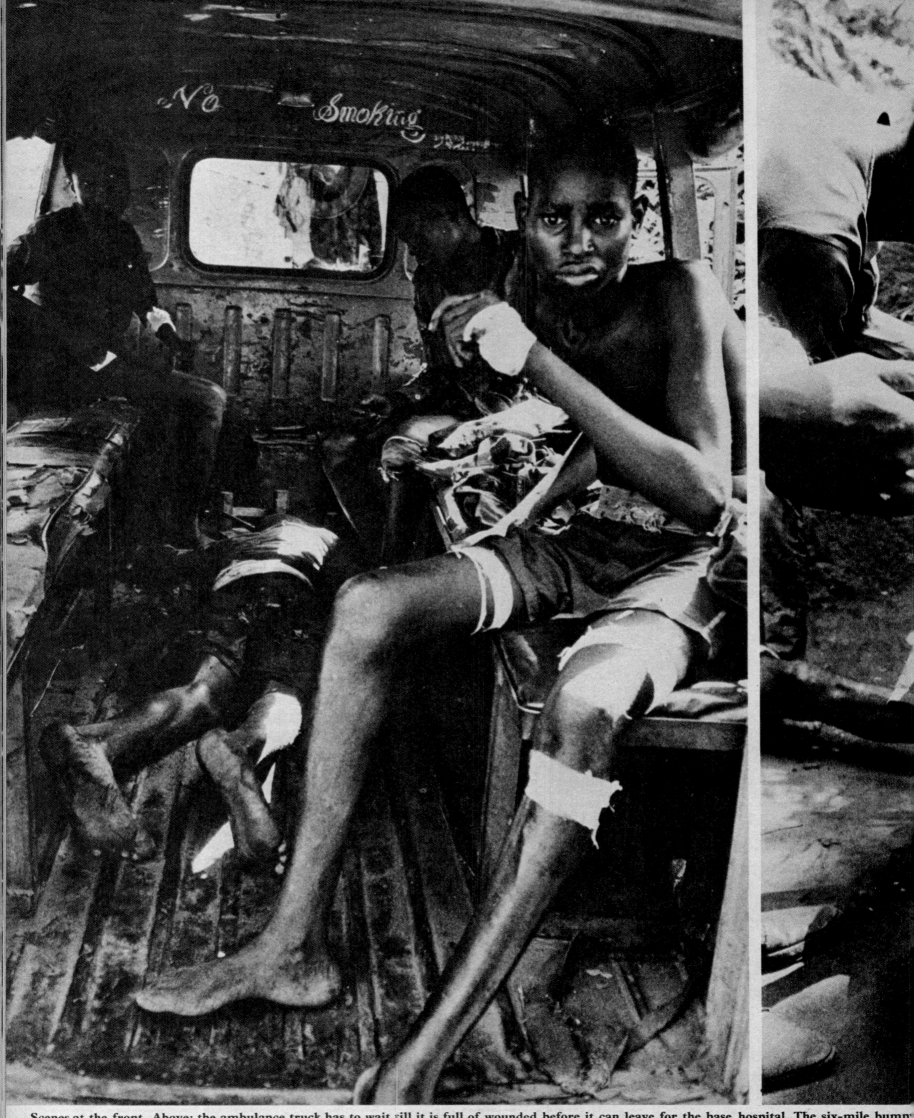

Scenes at the front. Above: the ambulance truck has to wait till it is full of wounded before it can leave for the base hospital. The six-mile bump
44 in the face by mortar fragmentation is treated at the First Field Dressing Centre. Top right: the wounded are expected to find their own way bac

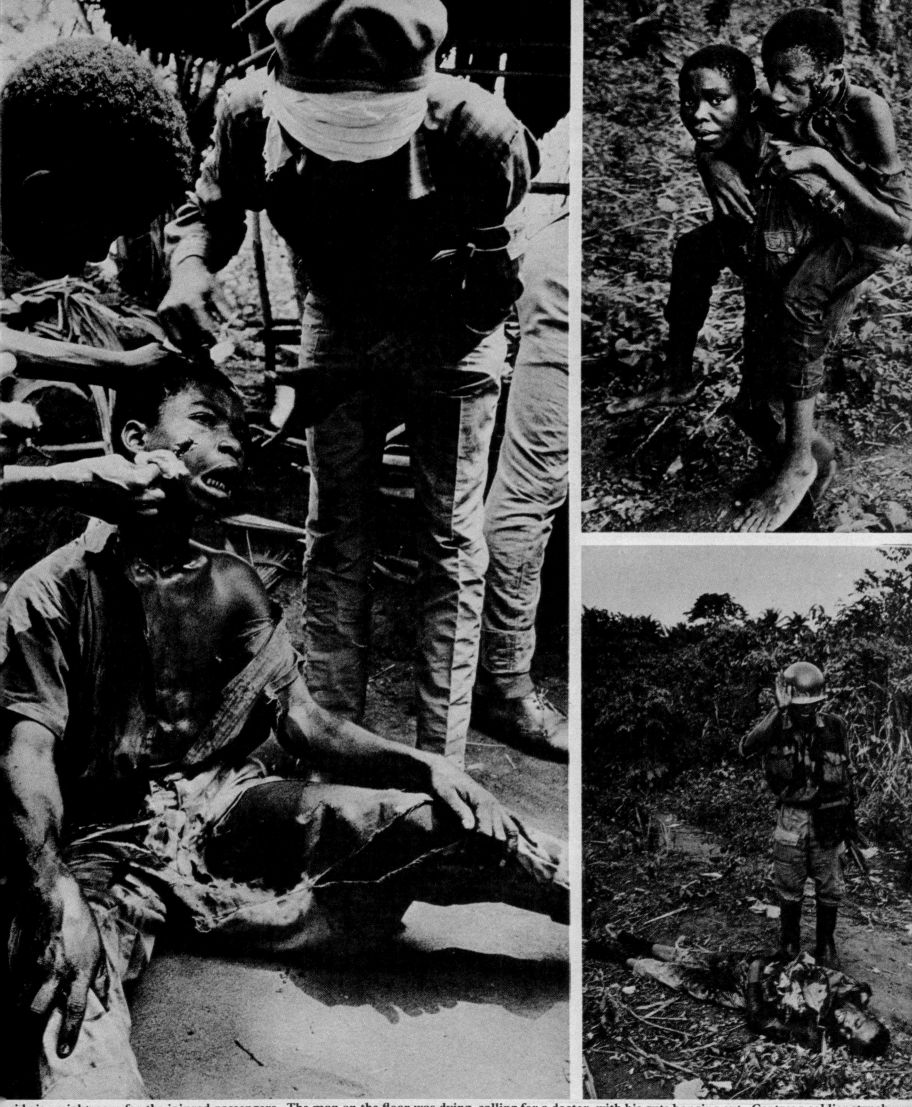

ride is a nightmare for the injured passengers. The man on the floor was dying, calling for a doctor, with his guts hanging out. Centre: a soldier struck. This casualty was carried there by a friend. Bottom right: Capt. Steven Osadebe salutes the body of a dead soldier; he was wounded himself soon after 45

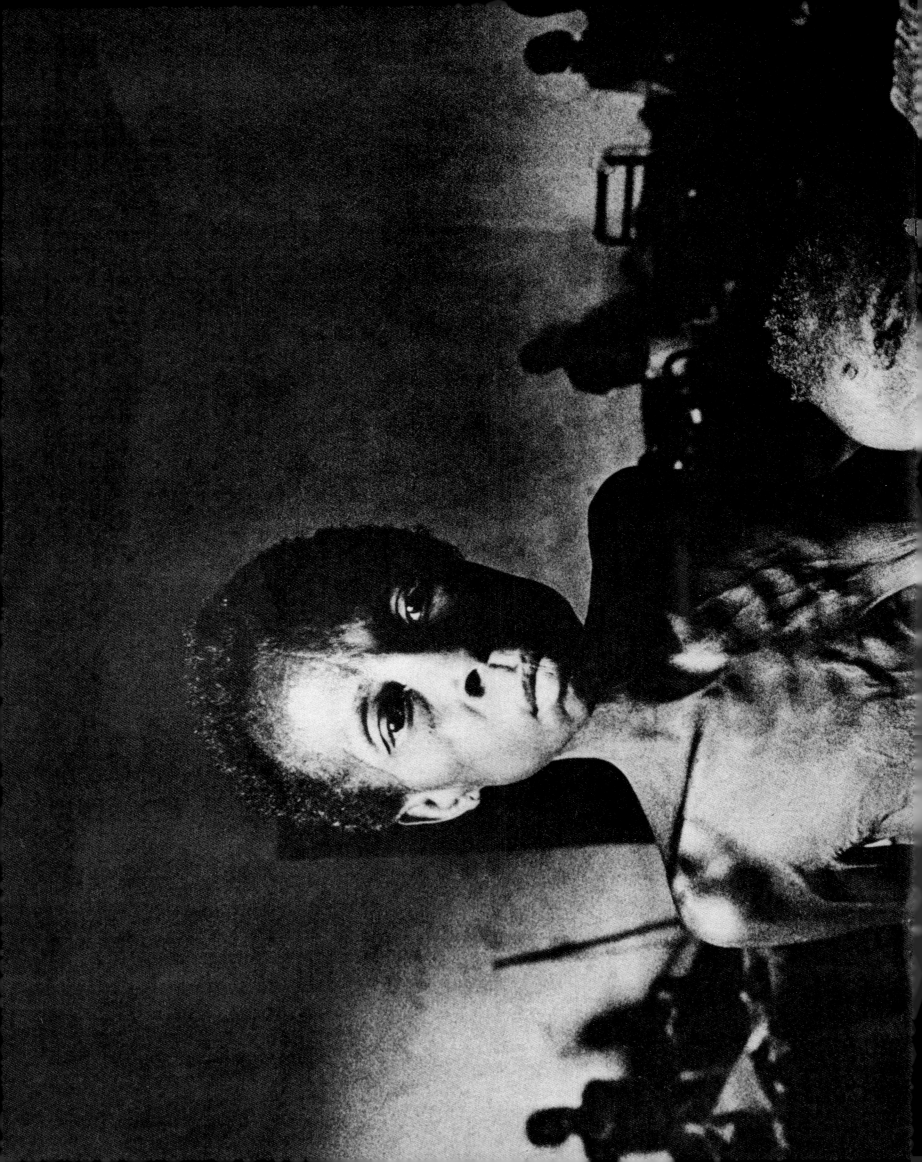

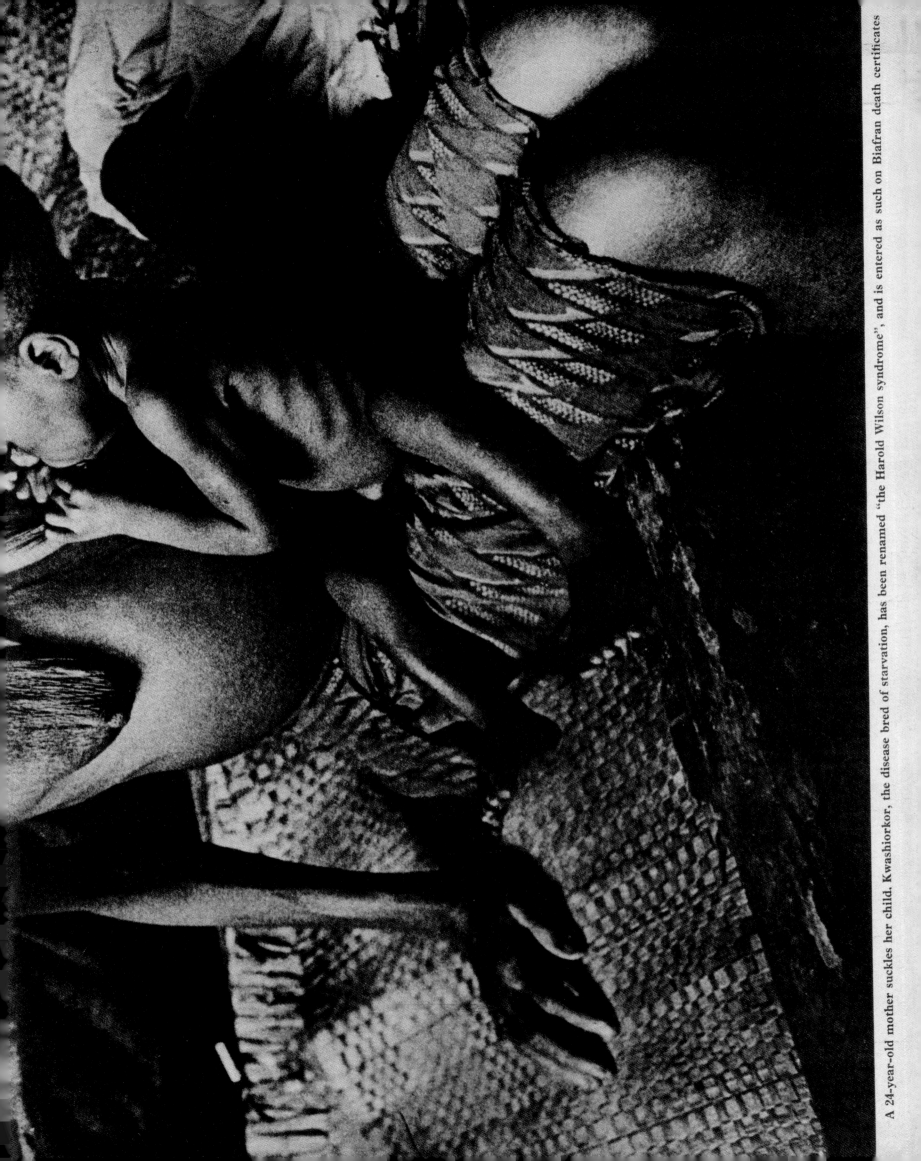

A 24-year-old mother suckles her child. Kwashiorkor, the disease bred of starvation, has been renamed "the Harold Wilson syndrome", and is entered as such on Biafran death certificates

psychology to deal with as I was standing in front of eight hundred dying children. A girl dropped dead in front of me. They rushed her into a grubby room and were pumping adrenalin into her throat, but it was a total waste of time. I saw scenes in that place you couldn't imagine. It was very difficult for me. In such a place people are thinking you're bringing them something. In fact, you're bringing them nothing when you have a Nikon F with some 35mm film in it. You're bringing them no hope whatsoever. One particular child was an albino. He fixed his eyes on me and I will never in a million years forget those eyes. I thought, 'Don't look at him, go somewhere else.' I went around, and around, very distressed. Somebody touched my hand and I looked down and there he was, holding onto me. I thought I had to get away from him, but that I had to do it with some dignity. I put my hand in my pocket and found a barley sugar. I gave him the sweet. He went a short distance away and unwrapped it and was licking it. He was just licking it, looking at me. The other boys were trying to steal it from him. He was clutching an old discarded French corned beef tin and he'd completely eaten every last gram in that tin. I haven't printed the picture of him for many years. When I'm in the darkroom and that image is coming up, it's as if he's saying to you, 'Hello! Hello, I'm back!' I think it's one of the worst pictures I've ever taken.

In 1971 I went to Bangladesh. Again I was pleading with the *Sunday Times* to let me go. It was the beginning of the monsoon season and there were a million people on the move, crossing the border with what was then East Pakistan. I wound up in Calcutta and went north. After a terrible night in a rat-infested place I came the next day to a place called West Dineshpur and went to the Catholic church and asked if I could spend the night there. I slept in a cot bed and

in the morning the man who looked after the church loaned me his bicycle. I cycled down the road to a refugee camp about a mile away, where there were ten thousand people. It was a beautiful, sunny day with no sign of the forthcoming monsoon.

On the fourth morning I started cycling and suddenly the first patter of rain was striking my face and my clothes. It was coming – torrential rain. Every day, ten thousand people came to that camp, left the old, the sick, the lame and the dead, and moved on. Then another ten thousand came. This traffic went on for nearly two weeks. Once the monsoon was in full swing, the place started to flood. People then began to contract typhoid. There were the most tragic scenes. People were trying to take refuge while babies were being born. Sick children were dying and were being washed in contaminated water. A colossal human drama and tragedy was all around me.

I was exhausted, tired and hungry and took refuge in a little tea shop made of sticks with a lattice covering. I drank my tea from a little clay vessels and ate bananas. A boy came up to me and he said, 'Mister! Mister! Mister, look!' and I saw behind him a man who was carrying his dying wife, the most beautiful woman, in the throes of typhoid. I grabbed my Nikons, which were starting to be swamped with water. I lost one camera then I lost an exposure meter. The monsoon was gradually destroying my equipment. When I finally left with the statutory thirty rolls of film, I had one Nikon just working but water was still in the prism. I had two destroyed cameras and one destroyed exposure meter. I had figured that there was going to be monsoon rain and a million people and that there would be some awful scenes, but in those first few days, when the rains weren't coming, I was actually slightly disappointed. I don't feel comfortable saying this. Nevertheless, one of the most damning pictures I

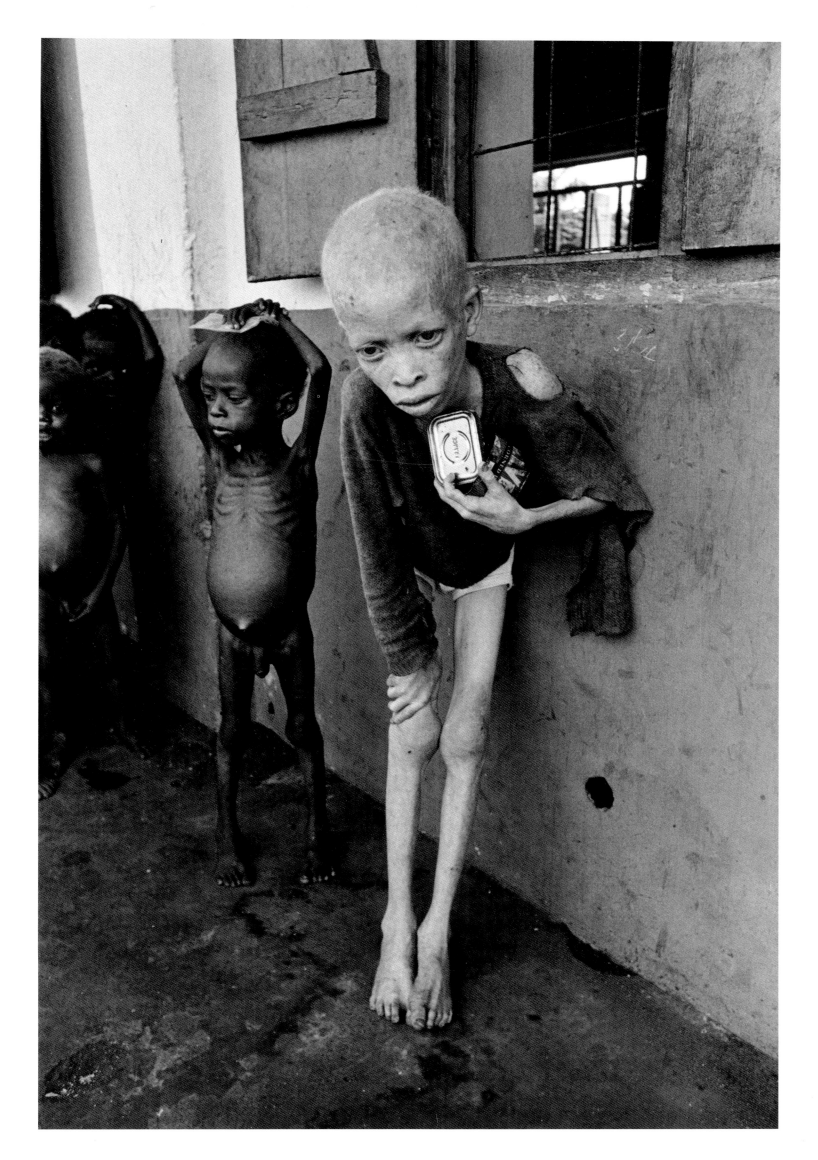

Sunday Times magazine,
September 5, 1971,
featuring Don McCullin's
coverage of Bangladesh

took *before* the rains came was that of a man carrying his dead nine-year-old son to what they called 'The Dead Body Area'. They had used some rattan to create a semicircular space. The boy had died in the night. The father put the body down and knelt there while I photographed him. Next to his son was the body of a one-year-old boy. I could have got equally powerful and damning images of this tragedy without the rain.

Once the rain came I went to a flooded schoolroom they had designated as a hospital. I went in very quietly. I trod very carefully. Being in those situations is like a high-wire act. I could hear crying before I got into the building. A girl was sitting at the foot of her mother's bed. They'd propped her mother up and she was frothing from the nose and mouth. She was dying because someone had given her the wrong medication. She was in her last throes. Her daughter was screaming and then I took a picture. You can't hide in such a situation. It's impossible to hide behind a 35mm camera. But you do hide emotionally. You tell yourself, 'Do the job. Don't think. Do the job.'

They took the body outside on a stretcher. The woman's children came outside too. Their father was holding a baby. There was a lot of panic and confusion. One of the Little Sisters of Mercy, from Mother Teresa's charity, was trying to calm them before they carried the body to the area for the dead. But the children threw themselves on the ground. They were banging their faces and punching the ground. I photographed the woman lying there, her children crying over her and the peasant farmer father holding their baby, which was biting its knuckles from hunger. When it was all over, I think I was crying. The father asked me what he should do, as if I could tell him his future. I put my hand in my pocket and did something that could be regarded as despicable. Whatever you do at this stage wouldn't be right. I gave him a bundle of filthy old Indian money and said a stupid thing. I told

him to go to Calcutta, by which I meant he should get away from there and just go somewhere. I said the first thing that had come to mind. It was so stupid. I was buying him off in a way, in my own emotional way. You are expected to be the diplomat and the compassionate person who does the right thing at the right time. It's almost impossible. I felt so two-faced and bad. I knew I had an amazing picture, but what a terrible way of earning a living. However you cut it, it doesn't come out good.

You constantly have to analyse your role in these situations. You can't think you've got immunity from proper reactions because of your many responsibilities to yourself and to the people you're working for, or just because you represent some newspaper or other. The position you're in *demands* that you conduct yourself correctly. It is not an everyday occurrence to see people die in front of you. You have to be careful how you react. In Bangladesh I was working with the added pressure of knowing I was there because of my judgement back in London and that judgement would come under question if I didn't pull off what I promised I could bring back.

I could photograph that family in Bangladesh because I knew that there would be no hostility. By then I knew enough of what was possible or acceptable in different cultures. If I had been present at the Aberfan Disaster and had tried to take my camera out, can you imagine what would have happened? I have always tried not to take liberties with other people's situations. But a lot of people do. I've seen appalling behaviour. Normally in the Middle East people want to show you their grief. That's probably the mistake I made one day in Beirut. I was assumed without thinking that that's what I was allowed to do, that I could simply photograph their appalling grief. In Vietnam I saw some dead South Vietnamese soldiers wrapped up in ponchos. Vietnamese troops carried one of the bodies

THE SUNDAY TIMES *magazine*

SEPTEMBER 5, 1971

A LAND
BEYOND COMFORT

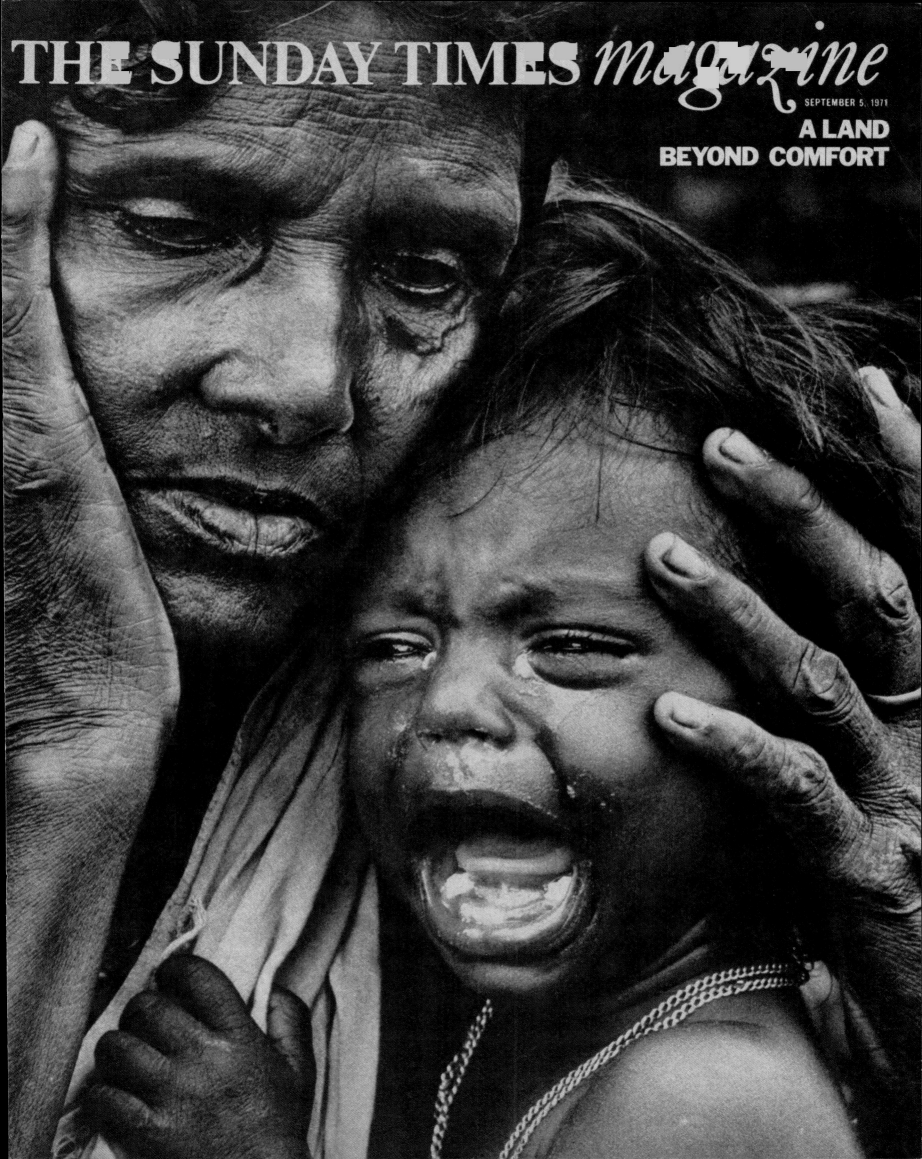

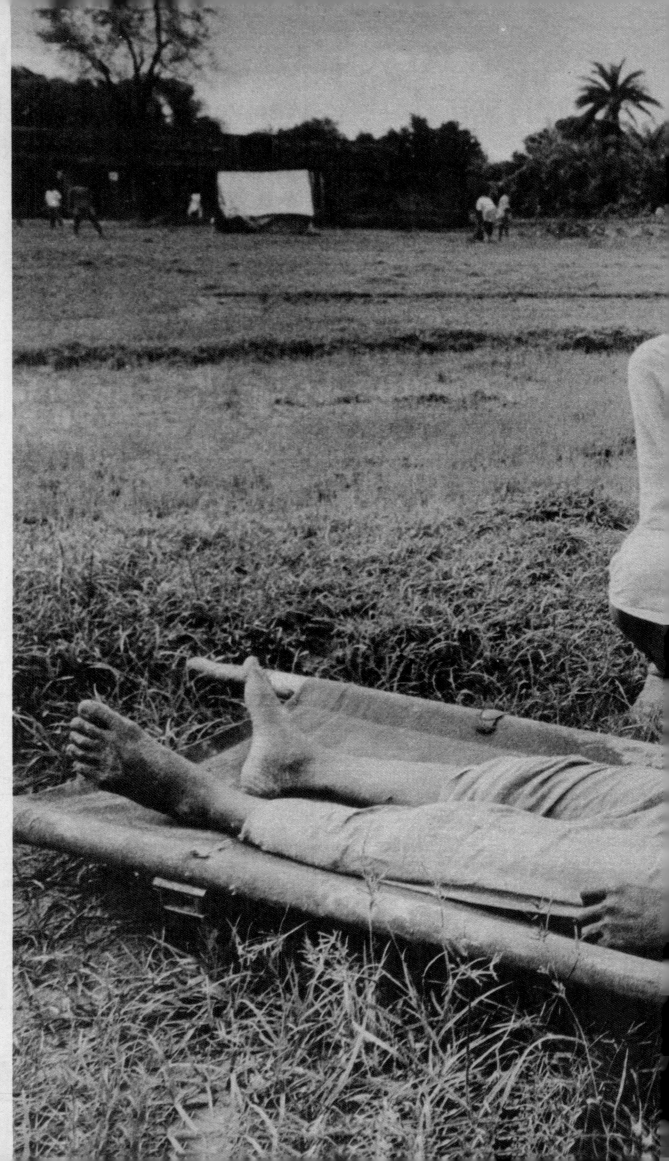

AND STILL THEY RUN

The unabated misery
of West Bengal photographed
by Donald McCullin

This family had been walking for sixteen days from their home in East Pakistan to escape the army of Yahya Khan. Within a day of crossing the border into India, the wife and mother had been admitted to the cholera ward of Helencha hospital – an unfinished brick building by the side of the road, completely surrounded by flood water. While she was nursed by Indian nuns they had hopelessly waited, knowing she was going to die. They had witnessed her death and now, before the corpse is finally removed for cremation, they are paying it their last respects. The weeping widower is praying for the future of the son in his arms, while the baby sucks his father's fingers for nourishment. Then, the bereaved family will wander on aimlessly down the road to Calcutta 60 miles away

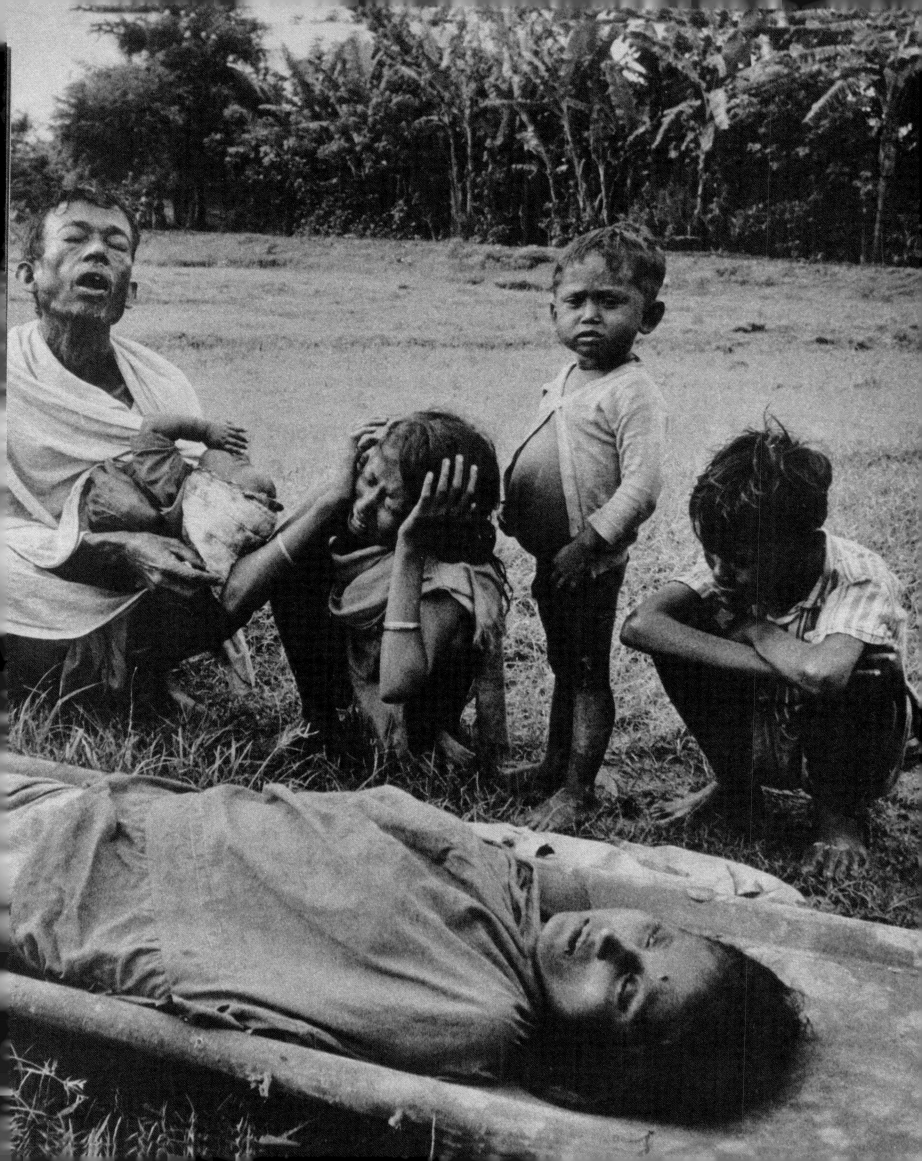

Right: a dead baby
lies in that part of the
compound at
Helencha where the
'dead body squad'
daily leaves the
corpses until the local
rickshaw boys can be
persuaded to take
them to be burnt in the
Government ghats.
It is not uncommon to
see dead babies
thrown on rubbish
dumps in similar
refugee camps. Far
right: an ox-cart
had travelled a mile
down the road
from the Pakistan
border, axle-deep
in thick mud, but could
make no progress
beyond Banaswar Pur
because of the
teeming crowds on
foot. This man had
been forced to
abandon the cart
and was himself
carrying his dying
wife the last
three miles to
36 Helencha hospital

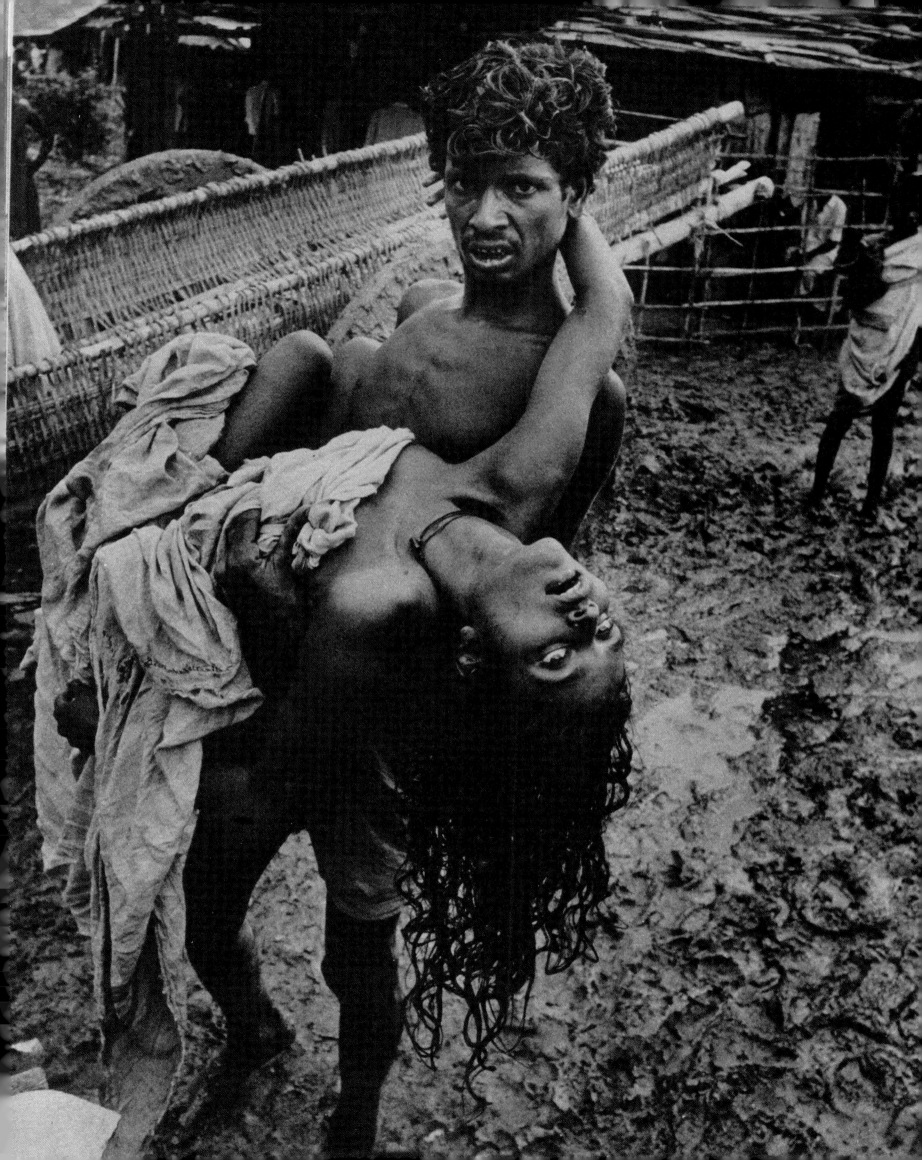

Pages 119-21
Sunday Times magazine, July 12, 1970, featuring a report on the ambush at Prey Vang, Cambodia, in which Don McCullin was wounded

Pages 122-23
Seriously wounded Cambodian soldier being transported from a Khmer Rouge ambush in which Don McCullin was also wounded, Prey Veng, Cambodia, 1970

and put it down. One of these soldiers thought that it was a good opportunity to urinate, which he did right by the dead soldier. I was angry at this insensitivity, but maybe their Eastern attitude to death means that, after the spirit has left the body, they have no obligation to respect the corpse. We come from profoundly different cultures.

I've seen massive earthquakes in Iran where they've buried twenty thousand people. I've seen the bulldozers digging the pits for the bodies. I don't want to become an expert on death. I can hardly speak the Queen's English properly, let alone master another person's language. I'd have to be the greatest linguist in the world to be fully equipped to cross the minefields of problems that confront you on such assignments.

By the time I arrived to cover the war in Cambodia in 1970, I was chasing my French friend who was ahead of me and I thought I was too late. There was something particularly spooky about Cambodia. At first it was almost delightful for many of the journalists who'd spilled over from Vietnam. There was a different pace. The culture of village life had not been shattered. It was described as a sideshow compared to Vietnam, which had been at war for decades. Cambodia seemed like R & R. But I could feel something very sinister.

I had bought myself a brand-new pair of desert boots from Marks & Spencer. The last thing I wanted was to wear military uniform and be captured by the Khmer Rouge. I was accredited in Phnom Penh and got on a helicopter to Prey Veng, which was especially dangerous because it was where the Khmer Rouge attacked the ships bringing ammunition and supplies to Phnom Penh. As there was a battle in progress the helicopter didn't land, but hovered over a paddy field. The pilot shouted, 'Now!' and I jumped straight into the mud in my new shoes.

I got a briefing from a commander with some Vietnamese forces. They were going to capture a village

believed to be occupied by the Khmer Rouge. I was told to wait but, instead, I rushed off with a probing force of Cambodian troops. We reached halfway across the rice fields and came under heavy fire. A young boy carrying the Cambodian flag was killed immediately. Bullets started spitting in the water all around me. I panicked and got behind the radio operator so I could get my head covered by something safe. Then the men broke up and ran in all directions. They were taking heavy casualties. I managed to crawl away down the side of a field, dragging my Nikon cameras, keeping them out of the water. I think it was at this stage that one of my Nikons was struck by a bullet. An AK-47 round hit the side of the prism and it was right by my face. Now was the time to escape from this terrible place. There were dead bodies lying face down in the water and I managed to get past them. I zigzagged across this field and could hear mortar shells and small-arms fire coming my way but I managed to get away.

A week later, Jon Swain, a friend from the *Sunday Times*, told me there was some Khmer activity about twelve kilometres from the town. He had to attend a press conference, but said he'd pick me up later. I went down there. Some ordinary civilian trucks arrived with Cambodian paratroopers, and in those days they always used paratroopers or marines for tricky operations. The paratroopers didn't look very convincing. They had all kinds of fancy-coloured embellishments hanging off their uniforms. They started walking down the road, and I walked with them. In a few seconds we were caught in a hail of fire. I was in the middle of the road and bullets were striking all around me. My jungle hat flew off and was lying there but I thought I was not going to get killed for that stupid hat. I went down an embankment and lay there. The paratroopers decided to counter-attack and I had to go after them. I went up the bank and knelt by a jeep. The man next to me ran in front of the jeep and an 82mm mortar exploded right there. I was exposed to everything that came on to the

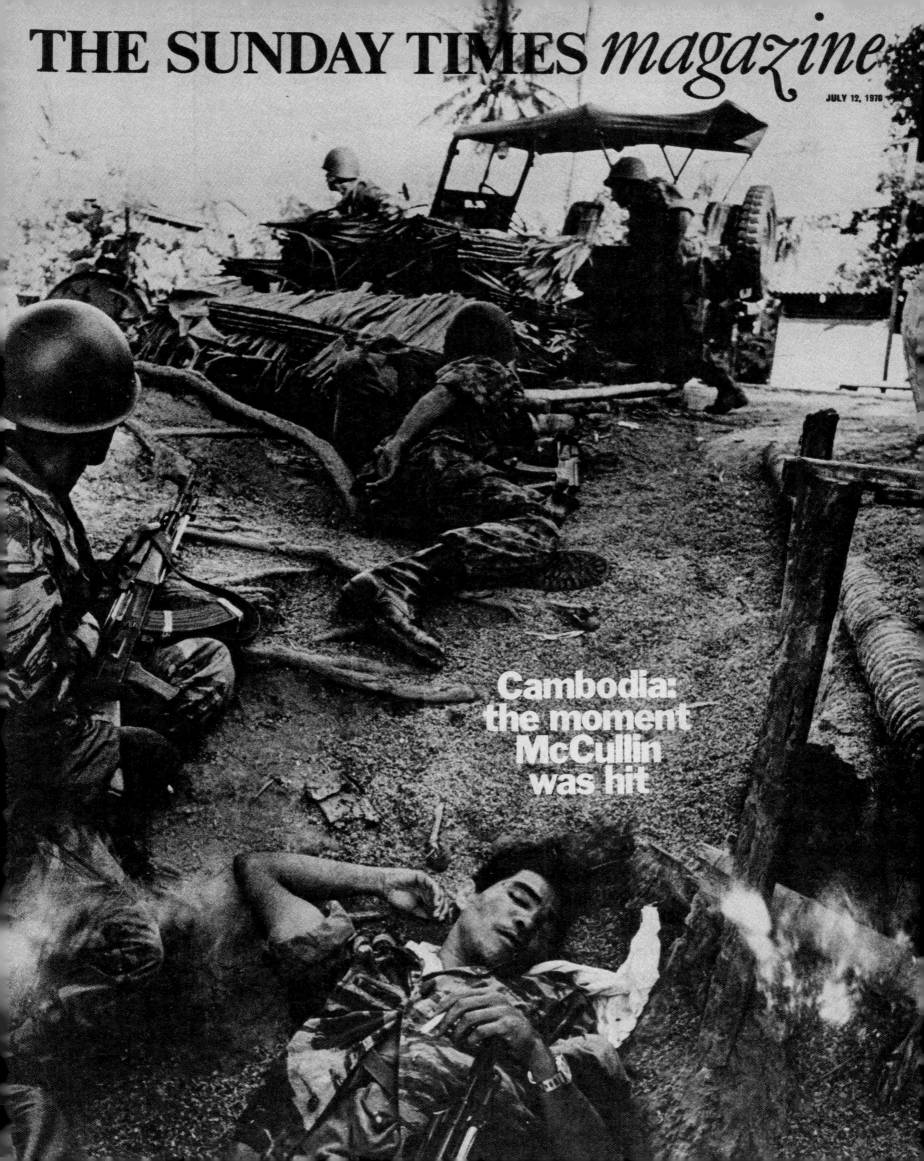

THE SUNDAY TIMES *magazine*

JULY 12, 1970

**Cambodia:
the moment
McCullin
was hit**

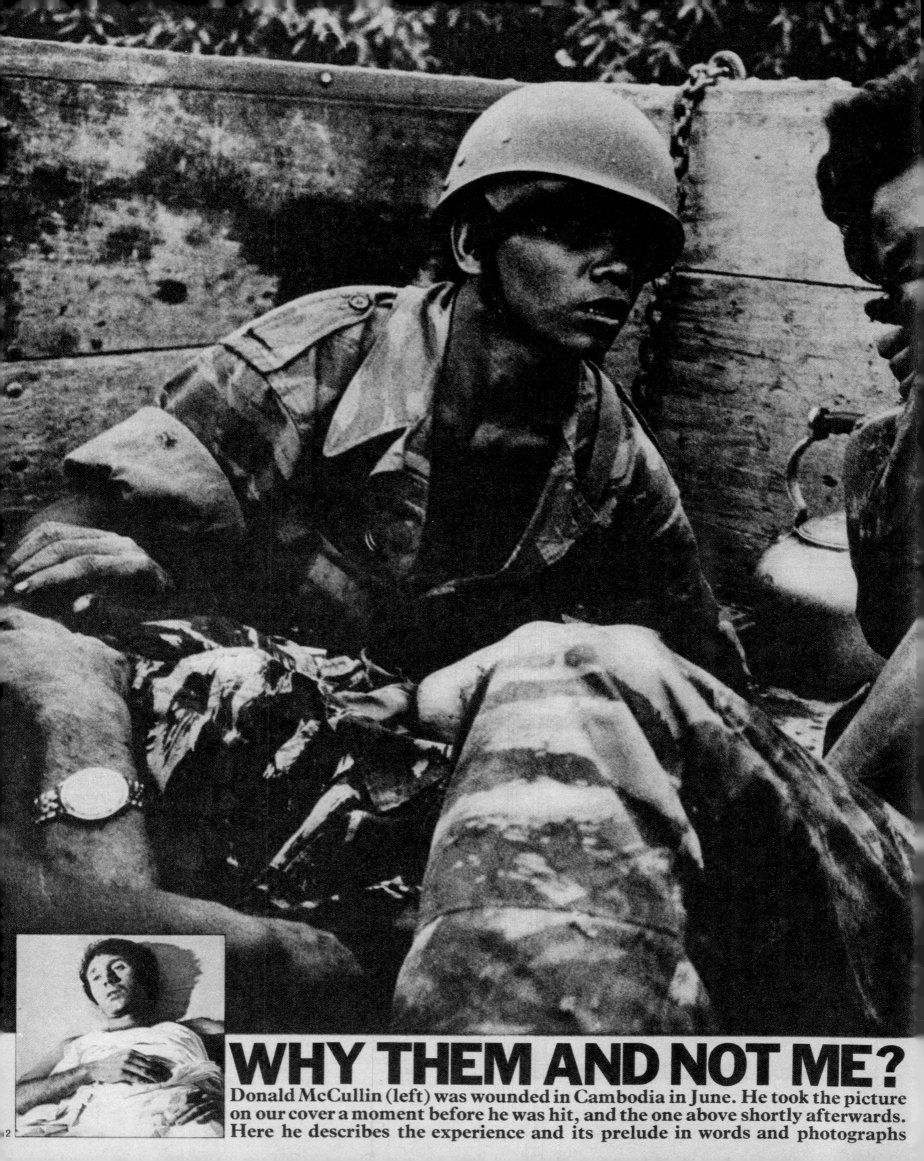

WHY THEM AND NOT ME?

Donald McCullin (left) was wounded in Cambodia in June. He took the picture on our cover a moment before he was hit, and the one above shortly afterwards. Here he describes the experience and its prelude in words and photographs

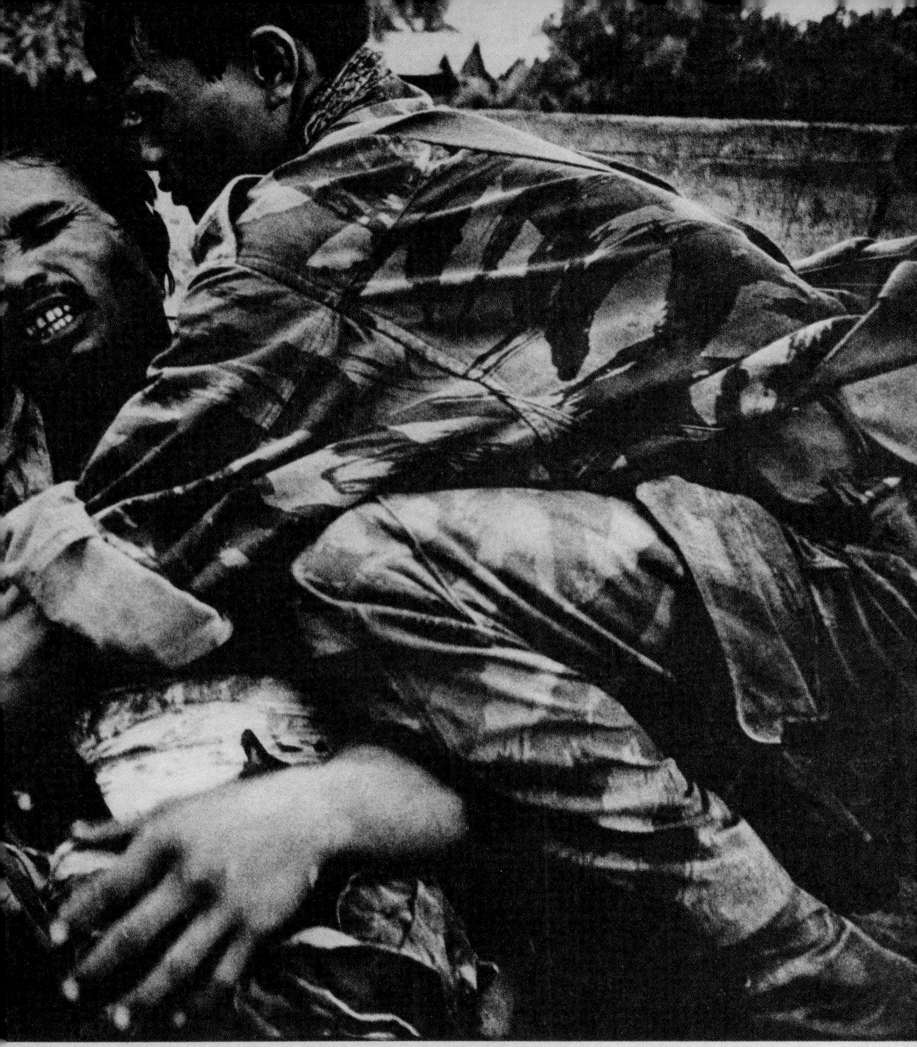

There was a big battle at Preyveng in Cambodia at the end of May. Preyveng was just outside Nixon's 30-mile limit, so the South Vietnamese went in with a sprinkling of Cambodians to relieve it from the Vietcong while the American marine advisers stayed behind. I hired a big white Mercedes Benz in Phnom Penh and drove to the front. (Hertz had lost three hired cars to the VC – their prices went up according to the fatality rate of journalists.) I had to cross the Mekong and reach a ferry over a tributary river about an hour's ride from Phnom Penh. It was a hot sticky day, with a monsoon approaching. I reached the ferry at 2 p.m. and asked a Cambodian captain under a smoking sausage-stall if I could cross. He said all the bridges were down, so I got on the crowded ferry. It was a pleasure to ride this stinking hole because of the breeze: the heat buffets you, the smell of dried fish seems to hum in the sultry air like the mosquitoes.

On the other side it was like a Hollywood scene: *Back to Bataan* played by little gold-teethed, ⟫⟫→ 19 13

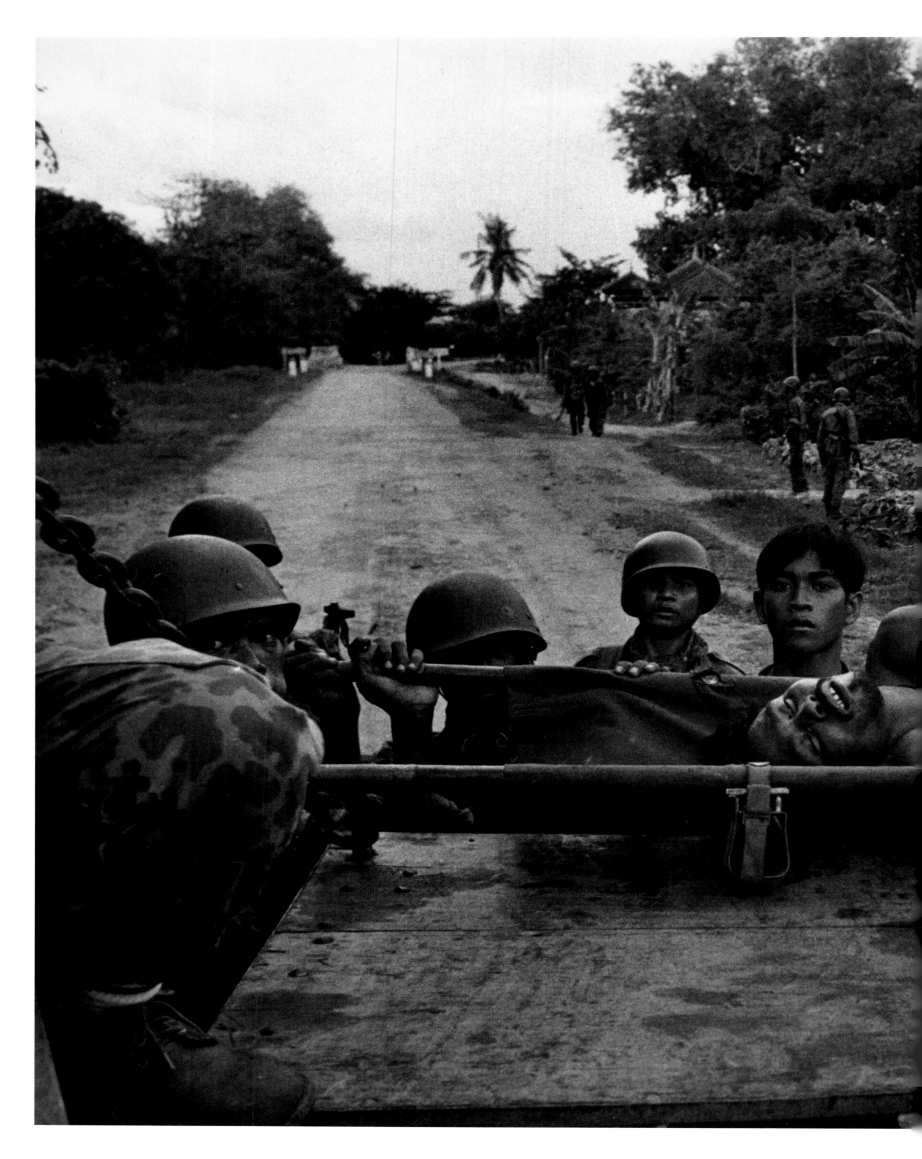

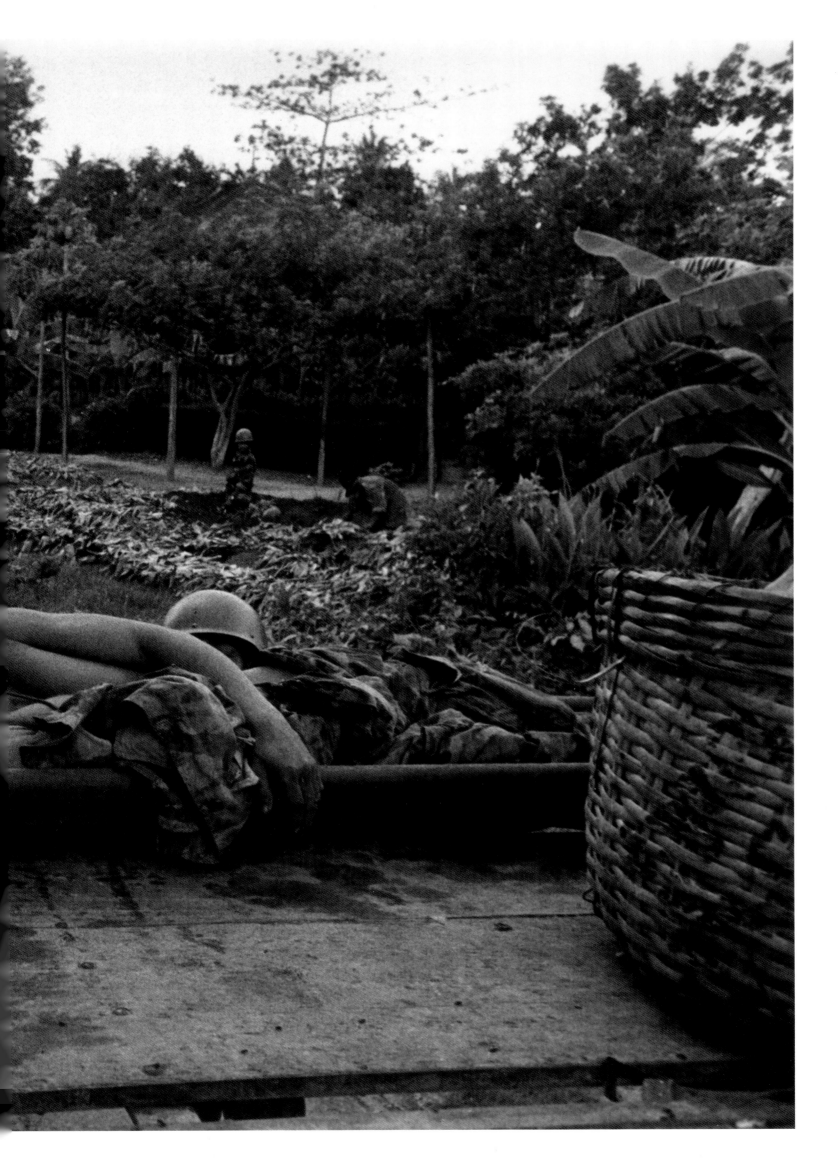

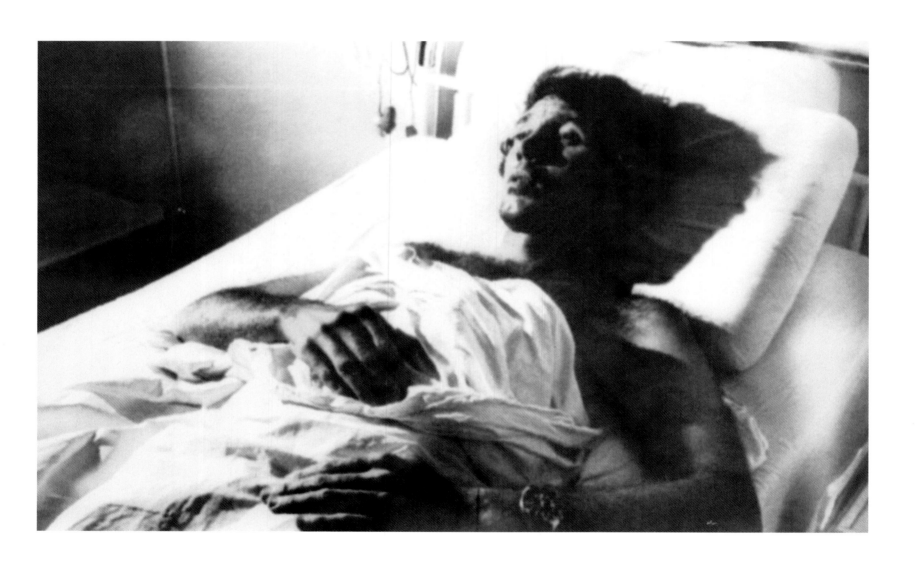

road. I was hit in the legs and the lower part of my body. I was bleeding, deaf, confused and in shock. I rolled back down the embankment and people who were trying to flee were treading on my legs. I was not going to be captured by the Khmer Rouge, so I crawled for about two hundred yards on my stomach, dragging my cameras. I thought that if the Khmers suddenly tried to move in, I was going to leave my cameras and make it into the river and swim. I passed a bridge under which the casualties with a lot of wounds and blood were being tended to. I kept going another hundred yards, then some Cambodian soldiers dragged me into a house, stuck morphine into my leg and bandaged me. I was bleeding from the crotch, so I was concerned about that.

I was put on a truck and taken back to the site of the ambush, which made me afraid. More shells came in. While they loaded the wounded I knew I had to take my mind off what had happened to me by photographing what was going on. My mind was all over the place from the morphine. The truck started back to the hospital at Phnom Penh. The man next to me was the man who had run in front of the jeep and had taken the brunt of the mortar shell. He was dying. He sat up screaming. His abdomen was covered in blood and full of holes. He was making his last pleas and I took a picture. The truck was bumping its way back and by then it was dusk so I was having a job with the exposures. I vividly remember arriving at the hospital and the man's head was down the other side of the truck and all I could see were his bare feet next to my head, shaking with the bumps of the road, and I knew he was dead.

Jon Swain had come to the ambush spot and followed me back in his Citroën. I lay in a bed and to my astonishment a chicken wandered in. The wards on the ground floor were full of running chickens. Jon said, 'He's not staying here. I'm taking him to the Calmet Hospital,' which was a hospital run by the French military. The French doctors took care of me for several

days. While I was recovering I read Laurie Lee's *As I Walked Out One Midsummer Morning*. I could hear the distant crunches of artillery and mortar shells. When you can't walk and you can't run and you can hear shelling on the outskirts of the city, you feel very insecure.

Eventually I was taken to the airport and I came back to England. I changed planes in Orly and had to get to the other side of the airport to catch the BEA flight to London. I struggled down a long walkway with all my cameras, and my legs bandaged up to the waist. When I got to Heathrow, my wife was there and she said to me, 'You stupid, bloody fool. Don't you realise what you're putting us through?' We went back home to Hampstead Garden Suburb. From Phnom Penh with its blood and death and misery to the Garden Suburb was a strange switch.

Back in London, I'd sometimes go out to someone's house and be asked what it was all like and I'd know I could never explain in a million years. But frankly, it would be an indulgence to go out for food and drink in abundance and then try to convince them of the details in answer to their question. It would be a complete waste of time and I sometimes just retreated into my own thoughts at those dinners. My background wasn't a dinner-party background. Suddenly I was coming into a world of educated and wealthy people. I have gone through this transition all my life. I'm still going through it. This was part of an identity crisis. If a car backfired as I was walking down the road in London, I'd want to hit the deck. There are things you take for granted in England, which you don't on a battlefield. You can't, otherwise you'd get killed.

Robert Capa said that if you weren't close enough, you weren't good enough. But journalists don't have to be next to the man who gets shot in the face. You can still write about a war from a thousand yards behind the line. There were always heavy restrictions on war reporting on the British side. We were always well and truly censored. Some journalists weren't

Detail of Don McCullin's Nikon F camera, hit by a bullet from an AK-47 in Cambodia in 1970, photograph by Richard Ash, Imperial War Museum

Pages 128-29
South Vietnamese troops in retreat from Dong Ha, Vietnam, during the North Vietnamese Easter Offensive, 1972

going to buy this. They would try to get to the front, as in the case of my friend Nicholas Tomalin, who was killed on the Golan Heights. He was actually in front of me when it happened and I eventually got to his body. The photographer has to be even closer than the writer.

By the time of Vietnam, having seen great images coming out of that war, journalists realised that the photographers were no longer people they could introduce as 'my photographer'. Once, in my company, a reporter asked, 'Have you met my photographer?' 'I'm not *his* photographer. I'm *my* photographer!' I said I wasn't going to be treated like some kind of valet. That possessive phrase was quickly wiped out. In the end nobody would ever say such a thing.

I had to learn how to develop my own sensitivities. Biafra was a particularly tricky place because you could hardly bring out a Fortnum & Mason's hamper in the midst of the starving. I was in the Sudan a few years ago with an aid agency. A terrible famine had developed because of the civil war in Sudan. When I was given my meal, I went round the back and ate it out of sight alone. Sometimes if they hovered around me, I'd give the kids something to eat. But then you'd really need to conjure the fishes and the loaves. You try to be discreet and not to indulge yourself in front of those who have nothing.

At one stage I used to take Ready Brek with me, because I dreaded waking up in the morning with hunger and nothing to eat. On my first Vietnam trip, I woke up starving and a nice American sergeant gave me what could only be described as a hamburger-cum-fritter. So I polished that off pretty quickly. Then he told me it was made from rat. The Vietnamese harvest their rice fields for rice, freshwater fish and rodents. There is an ecological balance in those green squares of flooded fields you see from the air. Food was never abundant in those cultures and almost anything that would move could be thought of as something to eat. I've seen dog restaurants in Phnom Penh.

The most important piece of kit you needed to sort out was footwear. In rugged terrain like parts of Afghanistan there isn't any footwear in the world that's going to be right. If you were going to monsoon areas, you would make sure you had a poncho, which you would get from the US Army. Malaria tablets were essential. In Vietnam you were constantly perspiring – the humidity was 100 per cent – so you would be losing salt from your body and you would need salt replenishment. You would need a kind of iodine tablet that killed off bacteria in the water. You were a working machine and needed to be in good health to do your job. Eventually I was brought down with malaria just prior to a big battle in Biafra. I just collapsed, fell on the floor and woke up in a tent. The doctor was warning me that he was going to give me an injection but it was not a virgin needle. There was always something to bring you down physically. If it wasn't the lack of food, it was illness. You had to keep yourself in shape for these occasions.

I carried three cameras all the time. Two were working cameras and one was a reserve. I had two meters, one being a spare, and thirty rolls of film. I thought that if you couldn't tell a story with thirty rolls of film with thirty-six frames to each film, you wouldn't get the story anyway. With motor drives your film would be used in no time. It was better that I stuck to a manual operation than burn into my film with winders. You had more discipline and I exercised that discipline to the limit because I was quite tight-fisted about film. I had too much respect to squander it.

As the *Sunday Times* magazine was a colour magazine, the editor used to beg me, 'Oh, Don, *please* take some colour!' Occasionally I used colour – I can use it quite well if it comes to it – but I thought that black-and-white images in war were much more powerful. If you see a black-and-white photograph held on a television screen for a couple of seconds, it's *so* powerful. But we live in a world that has the seven colours of the spectrum. We don't inhabit a black-and-white world.

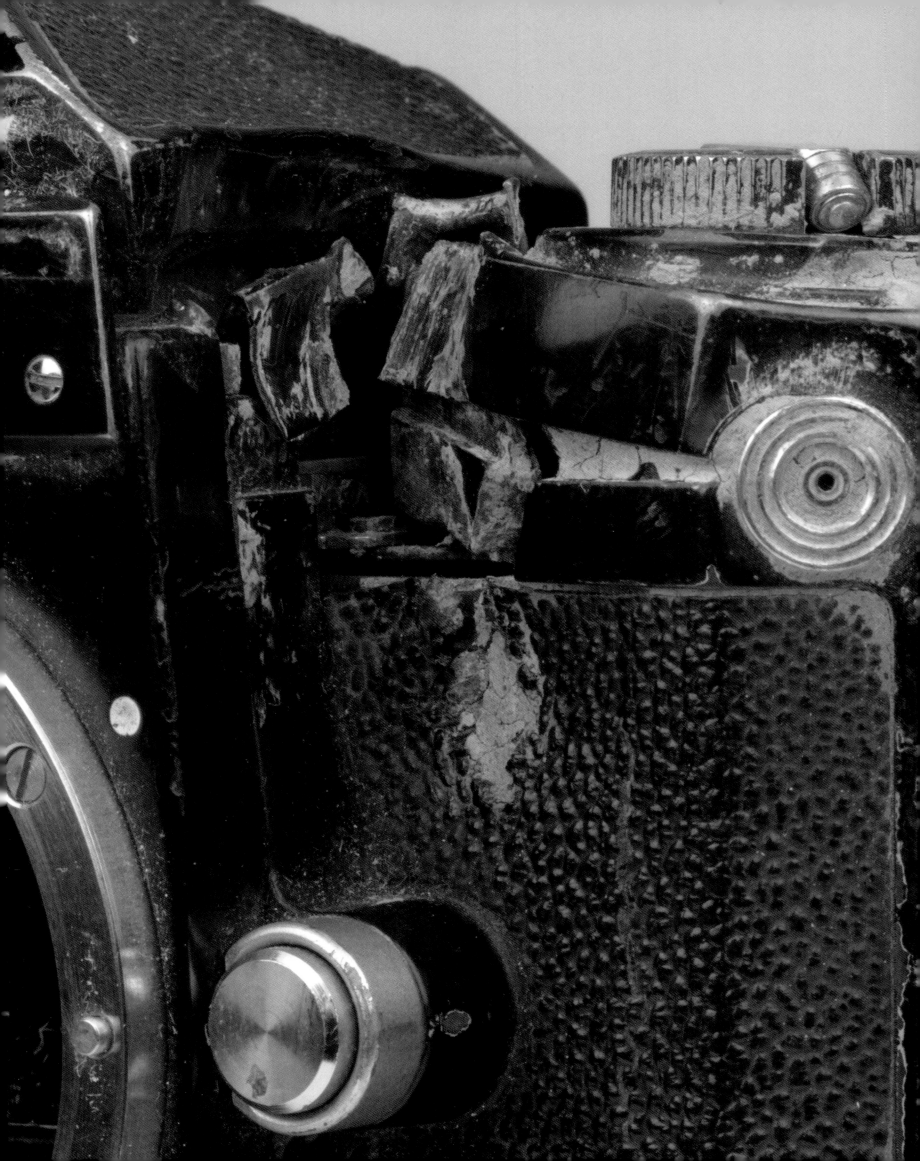

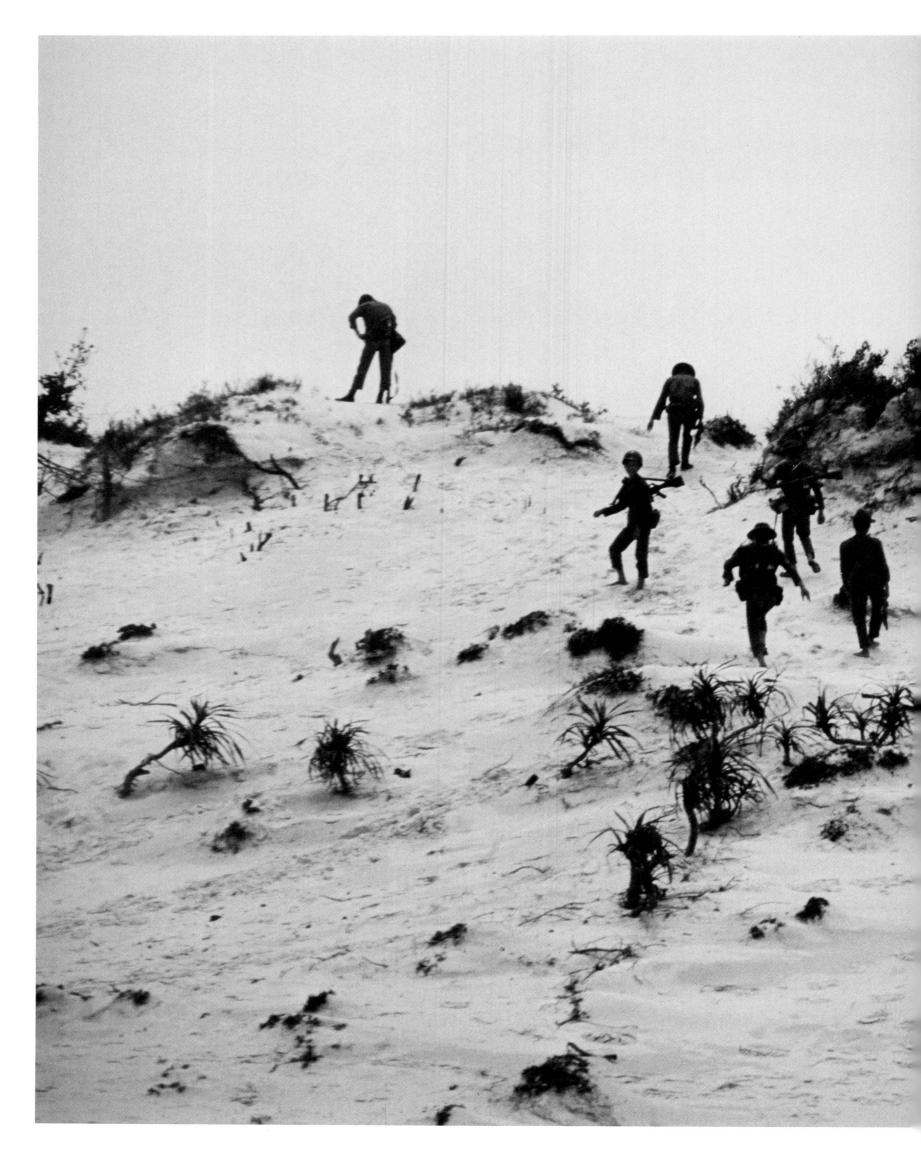

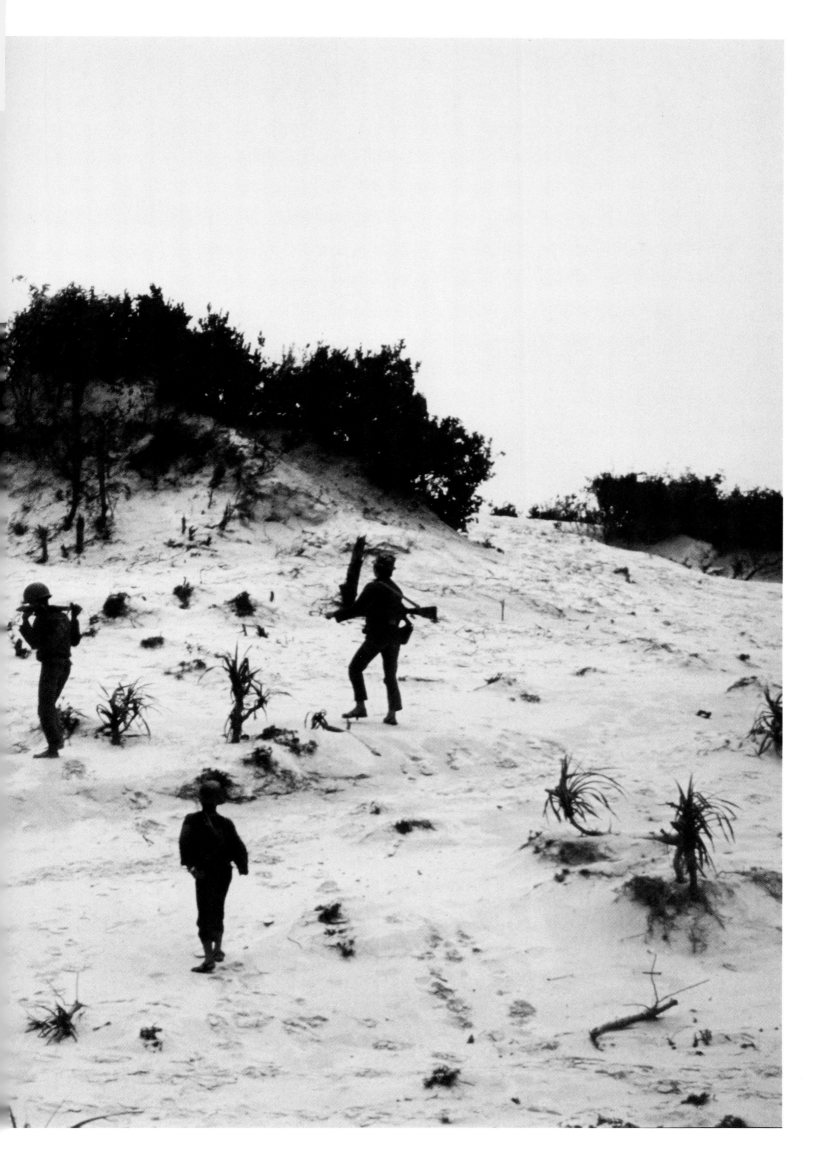

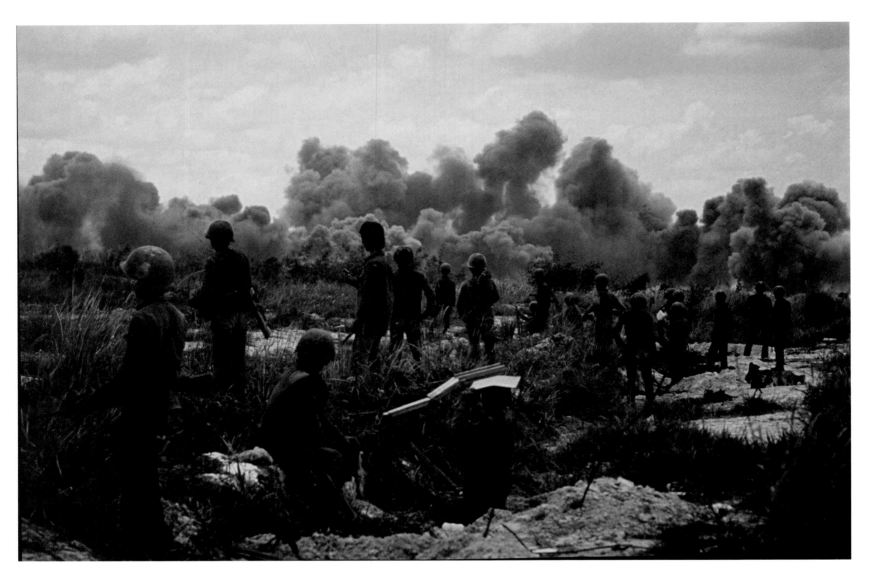
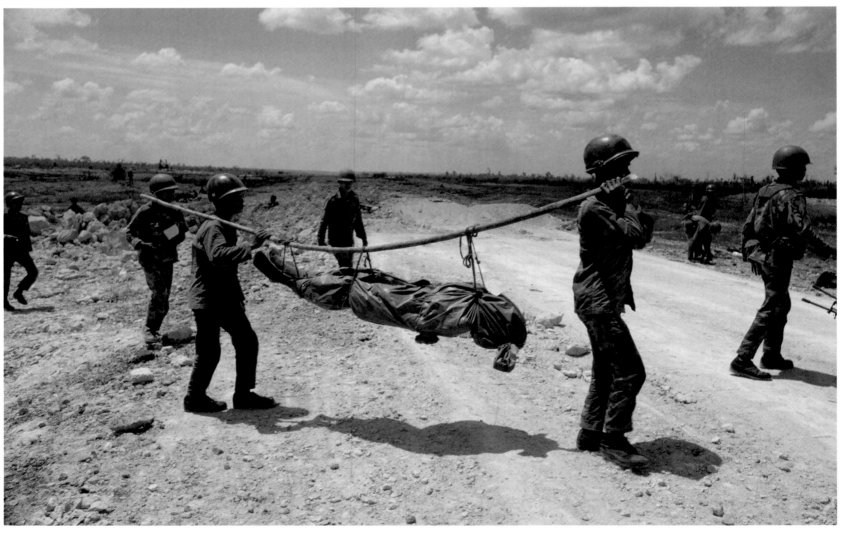

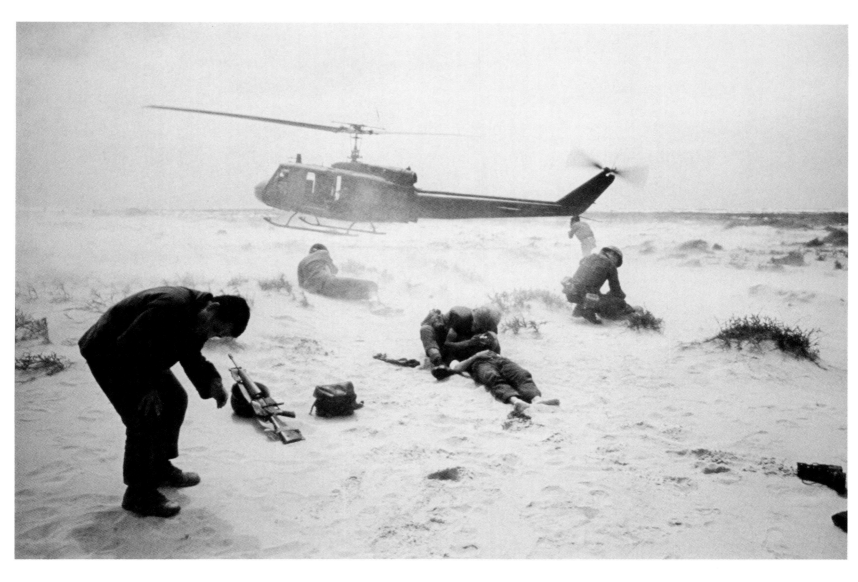

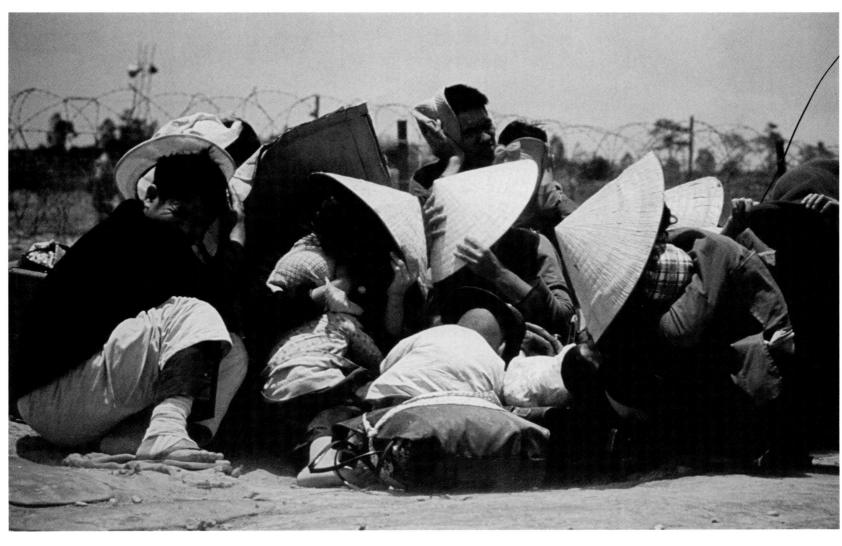

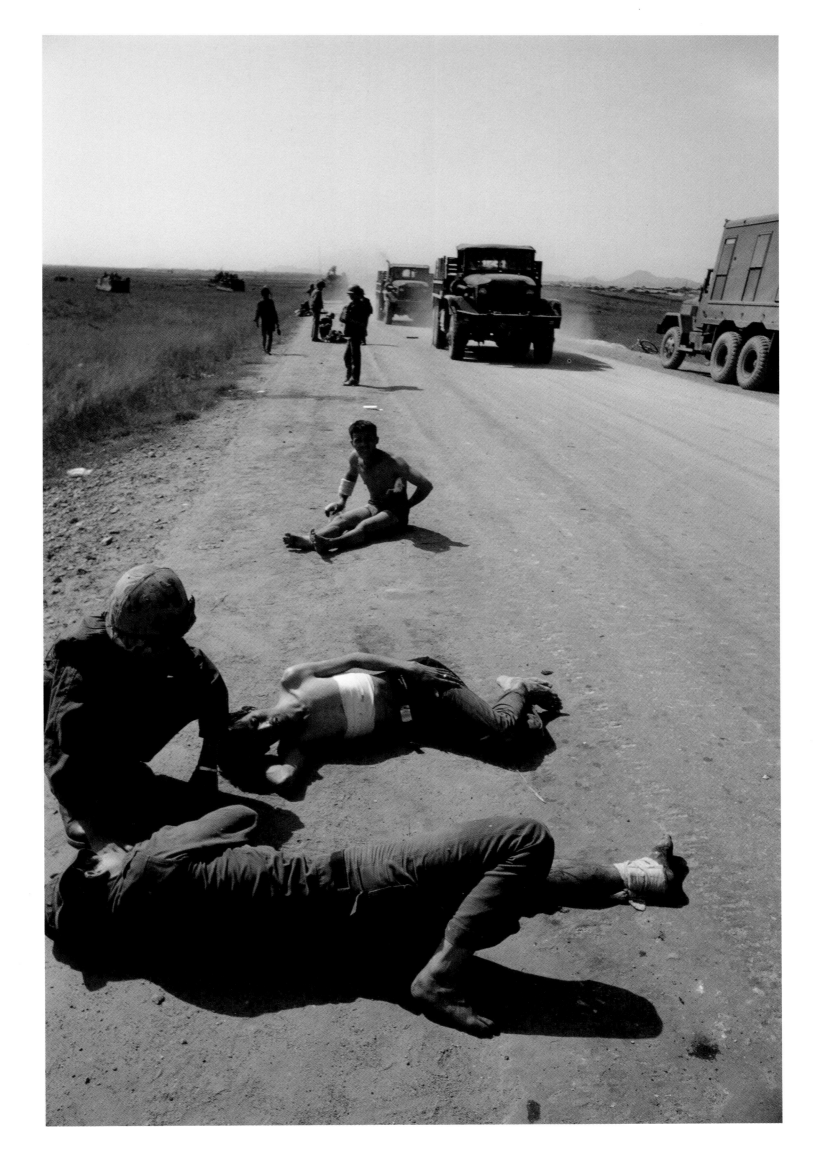

4

CHANGING TIMES
1976–1983

Couple fleeing from a
Phalangist massacre of
Palestinians, Karantina,
East Beirut, Lebanon, 1976

Pages 138-39
Beirut, Lebanon, 1982

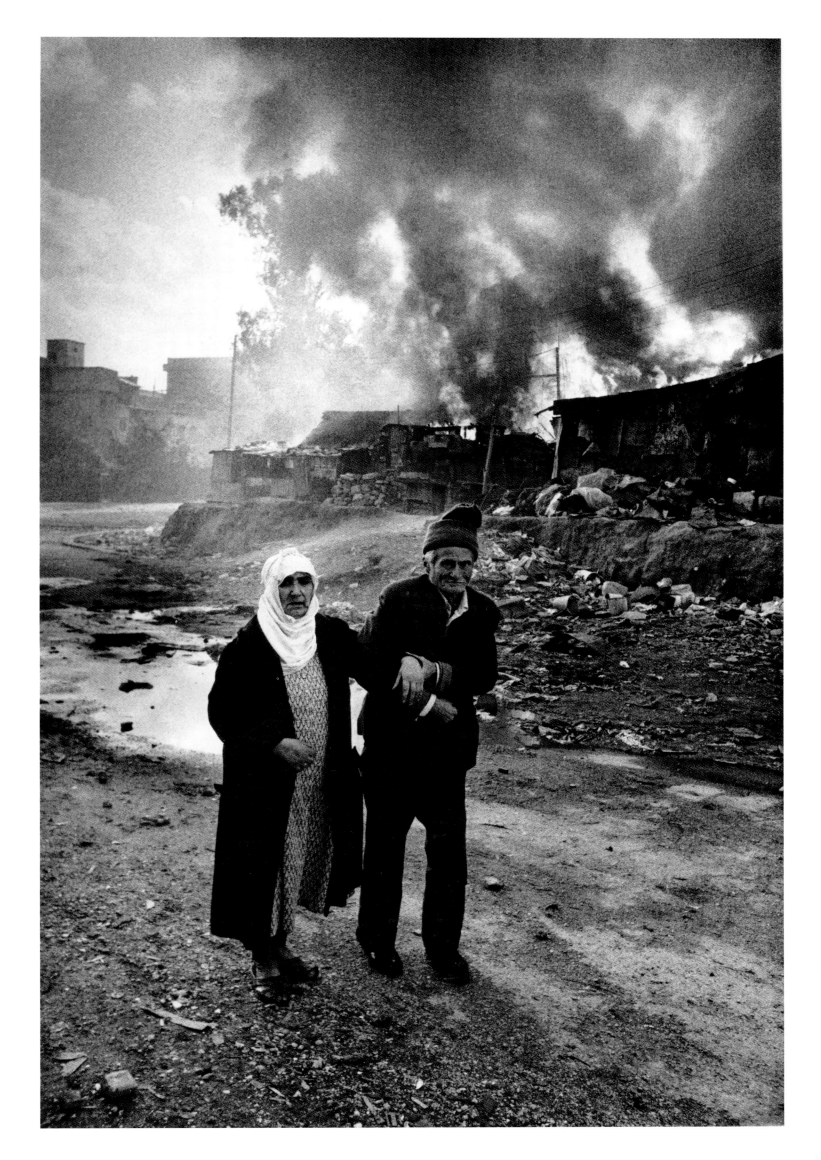

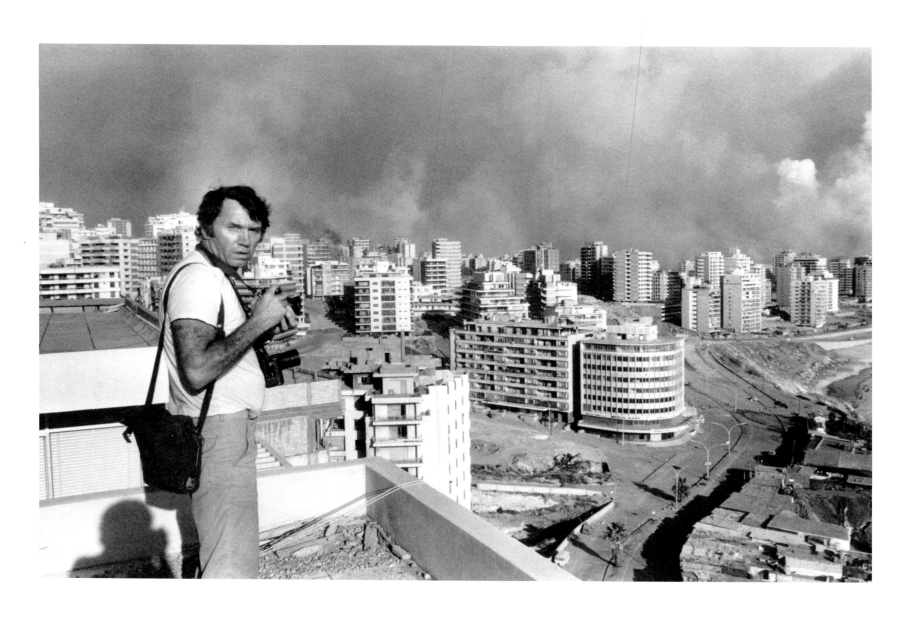

In 1976 I went to Beirut to cover the civil war in
Lebanon. I only knew Lebanon as a place where the
Arabs would come and act as playboys. They could
escape the summer heat of the Gulf, buy clothes and
probably do things they shouldn't do, like drink alcohol.
Beirut, a sophisticated city where everyone was dressed
in Gucci and displayed the trappings of the rich, became
a killing ground. The people who'd outstayed their
welcome, the Palestinian refugees, became a natural target.

I was told I couldn't work with the Mourabitoun
or on the Islamic side, but with the Christians who
would welcome me and get me accredited. I went up
to Ashrafieh, the Christian stronghold in east Beirut,
and told them I was from the *Sunday Times*. I was
sent down to the unfinished Hilton Hotel, where on
the eleventh floor the Christians had their gunmen
and snipers. After a couple of days I was told to go
back up to the headquarters, where they were planning
something big. It was winter, freezing, raining and
miserable. I remember sleeping under a table in a
derelict house where everything in the room was
destroyed except for a huge chandelier hanging from
the ceiling.

I was loitering around outside the headquarters
– it was in a printing works – and a man came up to me
and put a blue ribbon around my neck. They were all
putting these around each other's necks. Somebody
asked me to come across the road to see something.
On a telegraph pole was a dissected cat that had been
nailed together like a jigsaw puzzle. It was a sinister
introduction. There was something very unpleasant
about these people. When I asked what was about to
happen I was told, 'We're going to clean the rats out
of Karantina.' The rats were the Palestinians.

You have to avoid reacting in these situations. You
have to stay very calm. I found out that the Phalange
fighters were wearing the blue ribbons so as to be
identified when the fighting started. The attack got
under way. They began probing and immediately

received fire. The Palestinians knew they were coming
and must have been dreading it because they would
have realised that they would probably lose their lives
in the attack. The Christians had already perpetrated
some huge massacres, sparing nobody. They were
wicked and cruel and it was incredible that they were
calling themselves Christians. They were quite prepared
to annihilate another race.

We got bogged down and it was raining and
getting dark, so we took refuge in a hospital and I slept
in the corridor. In the morning after a fitful night, I woke
up very early to the sound of gunfire. Down the corridor
I opened a door and it was the mortuary. It sent a chill
down my spine. When I went outside I could see the
battle was really under way. It wasn't the kind of battle
where we were in much danger because I knew that
most of the firepower was coming from the Phalange.
I could hear all kinds of screams and shouts and saw
the smoke rising. I vividly remember eucalyptus trees
exploding because they were so inflammable.

Then people appeared, surrendering, crying and
screaming. More shots were fired. I saw a man shoot a
woman in the stomach close up in cold blood. Inside a
house I saw two Palestinian men standing with their
hands raised in surrender in the corner of a stairwell.
Coming down the stairs was a group of Palestinian
women and children looking at the two in the corner
who were part of their family. The moment the women
came out of the building, some Phalange came in and
shot these men at point-blank range. I remember one
of them falling and with his last breath uttering
'Allah!' even though he'd been hit in the face, throat
and chest. I was so shocked I ran round to another
stairwell. I was shaking and broken emotionally, but I
knew I had to get a grip. This was going to be a bad
day. When I went back out, a Phalange who was
there with the women and children said, 'If you take a
picture, I'm going to kill you!' I took him at his word,
because I'd just seen what these people were capable of.

Then a terrible day followed. I often think about the wicked people who act so brutally. They're cowards. To allow themselves to have the courage to kill somebody, they have to abuse them first in order to dislike them. When they hear people calling for mercy, it feeds the hatred even more. They hate them for begging for their lives. This is my own theory and I'm not far from the truth. I saw a man being kicked and brutalised along with two or three other Palestinians. All of a sudden he sprang to his feet and ran for it. I thought that's what I'd do. He flew past me. The Phalange started shooting at him and I was in their way. Bullets hit the wall above his head and he managed to get away. Sadly, he was trapped in an alleyway by an oncoming group and kicked down on the floor. Someone stepped forward and almost emptied a magazine into his head. I remember all that was left was the front of his forehead. The rest of his skull had been smashed like an egg.

I looked at a picture the other day and I saw two very beautiful-looking boys – they could only have been fourteen years of age. They were entwined with their father whose hands were raised in surrender. It only dawned on me then that I could have said, 'You're coming with me. I'm leaving and these boys are coming with me.' I didn't do that. These are the kinds of things I hate myself for, because those boys were murdered with their father. I saw one group murdered and then others being shot individually in doorways. They massacred every man over the age of fourteen and let the women, children and old men go. I was told to leave the area, and then the next morning I came back. The bodies had been torched in one big funeral pyre. All that was left were naked, black, burning corpses. Among them would have been those two boys. There are moments when I feel disgusted with myself, not just with the people who did these things I'm asked, 'Do you ever help anybody?' The answer is, 'Sometimes, but rarely, because my responses may bring more trouble than I can handle.'

One always hides behind the cloak of international journalism. Killing a journalist has always been a terrible crime, and it's never a good idea because you will bring the wrath of other journalists. So you imagine you have certain immunity. In a battle there's no immunity. It's the luck of the draw. If you are dealing with people with whom you are accredited, you assume they are not going to kill you. When I returned to see the burning bodies I was told to leave the area immediately and to take no more pictures. A few blocks away I could hear music and I looked down the street and there was a young boy playing a lute. Next to him was a boy with a Thompson machine gun and another nearby with a Kalashnikov. I heard someone say, 'Mister! Take this photo!' They were celebrating over the body of a dead Palestinian girl lying in the winter rain. She was on her back, dead. She could have been sleeping but she was on the road in all the filth. They were laughing. I thought, 'I can't do this, because I'm going to get killed. I've been told to leave and if they catch me, they'll give me a terrible time, but I can't *not* do it.' I took one frame. I still have the negative, but the negative is very thin as I didn't judge the exposure properly. I couldn't use a meter so I just snatched this one picture and ran for it.

That wasn't the end of my story. I came back on a third day and was stopped at a checkpoint by Muslims who asked for my pass. I put my hand in my pocket and I brought out a pass, which appeared to be in Arabic. They went completely crazy. I had given them the pass from the Phalange who had just committed the massacre. I was dragged from the car

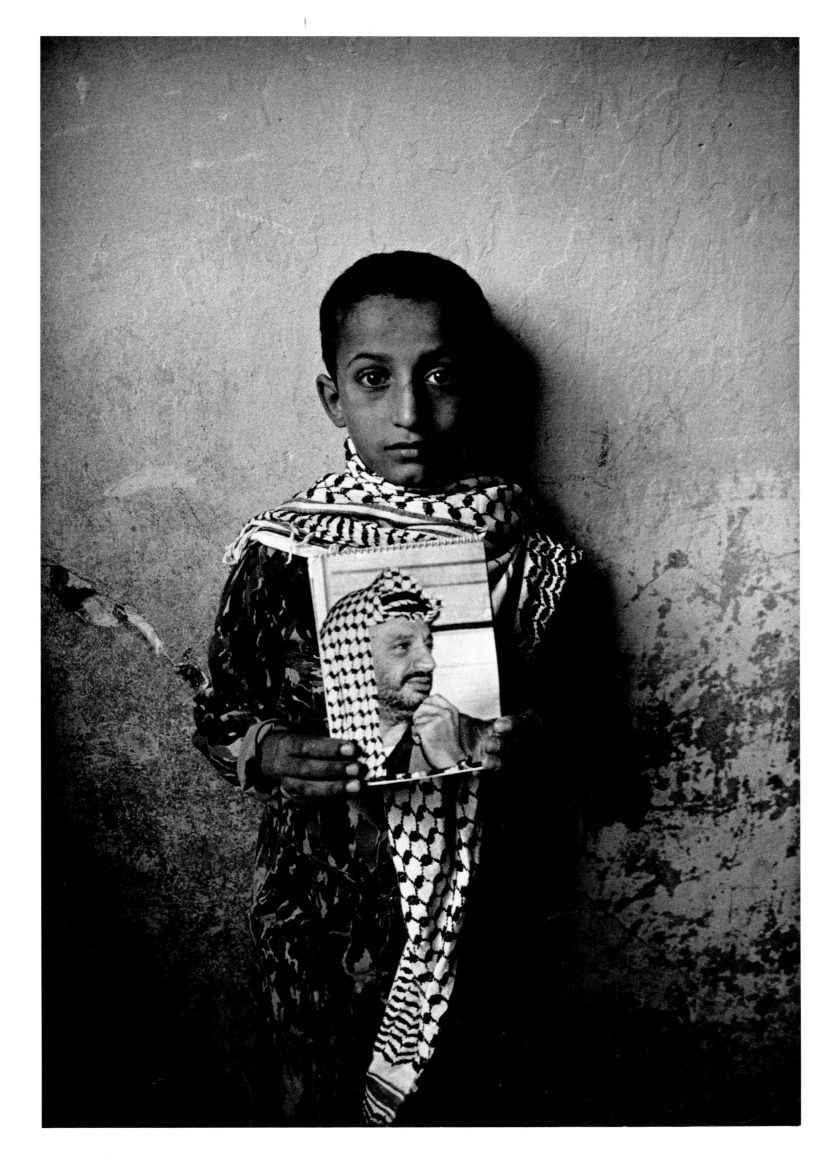

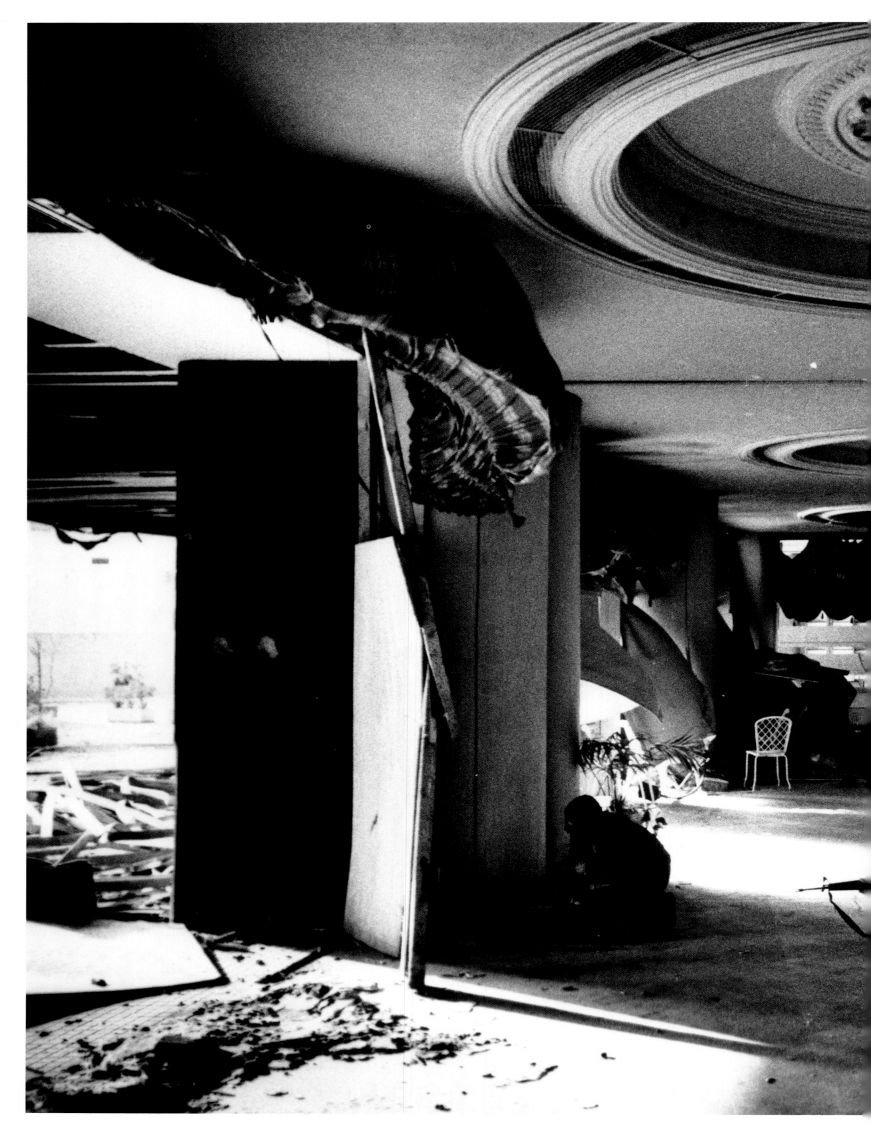

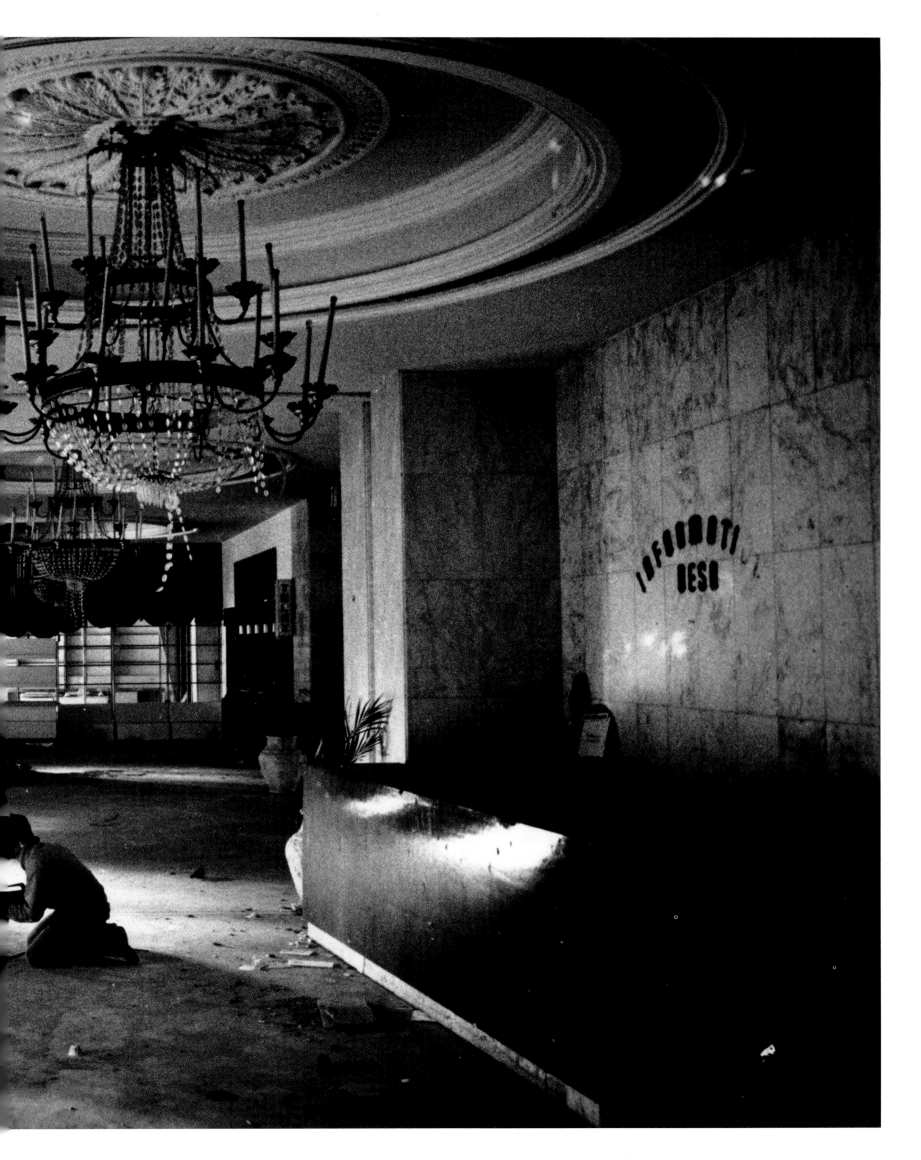

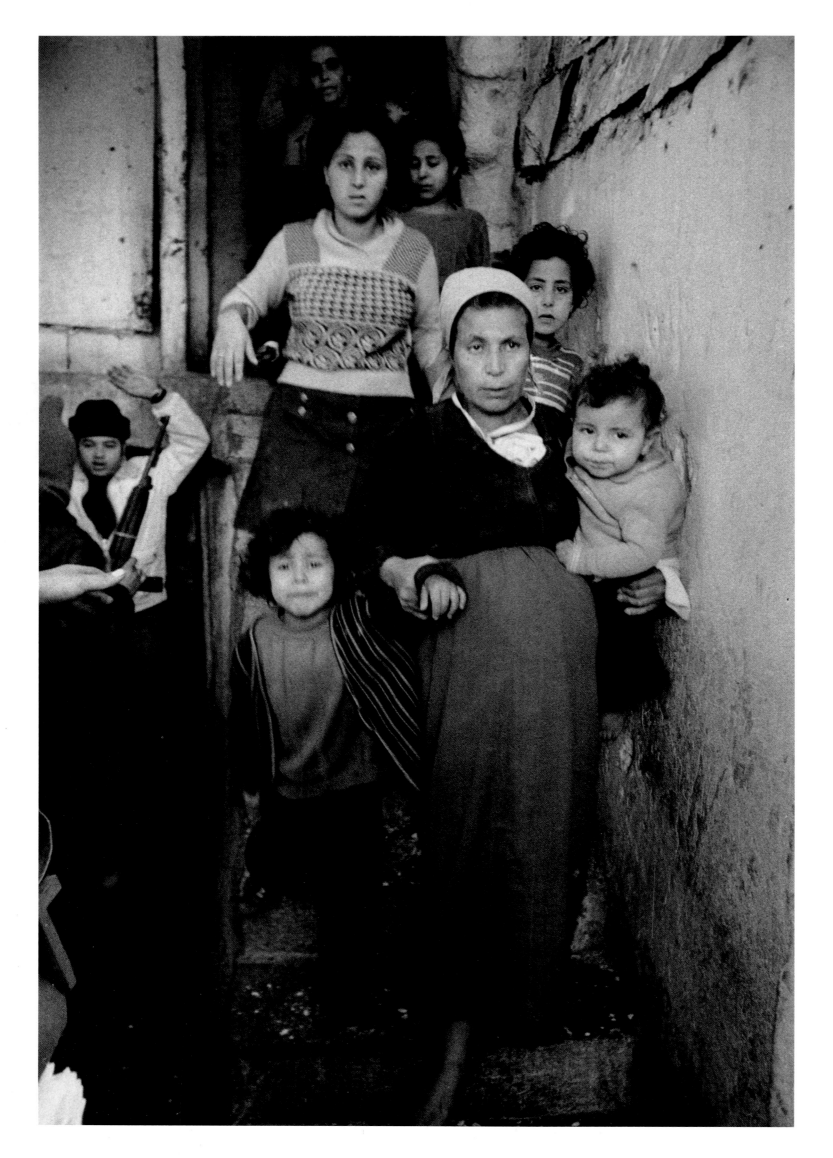

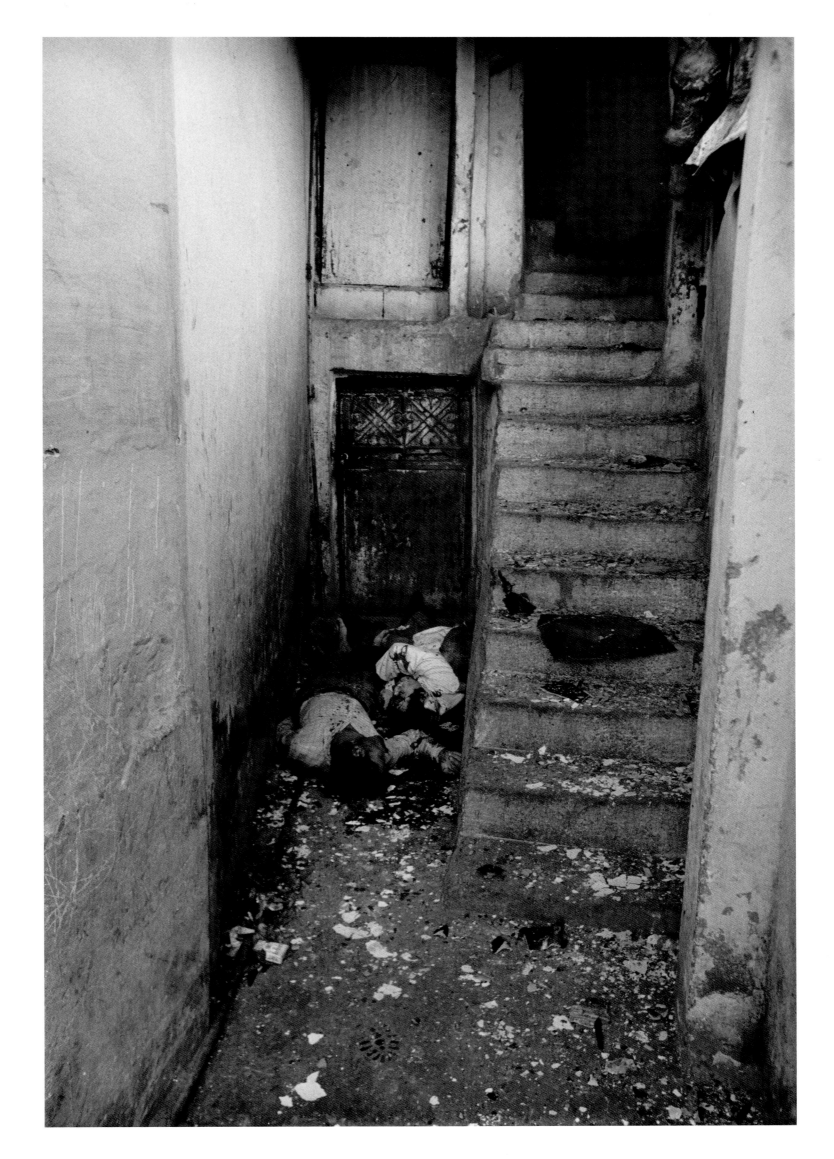

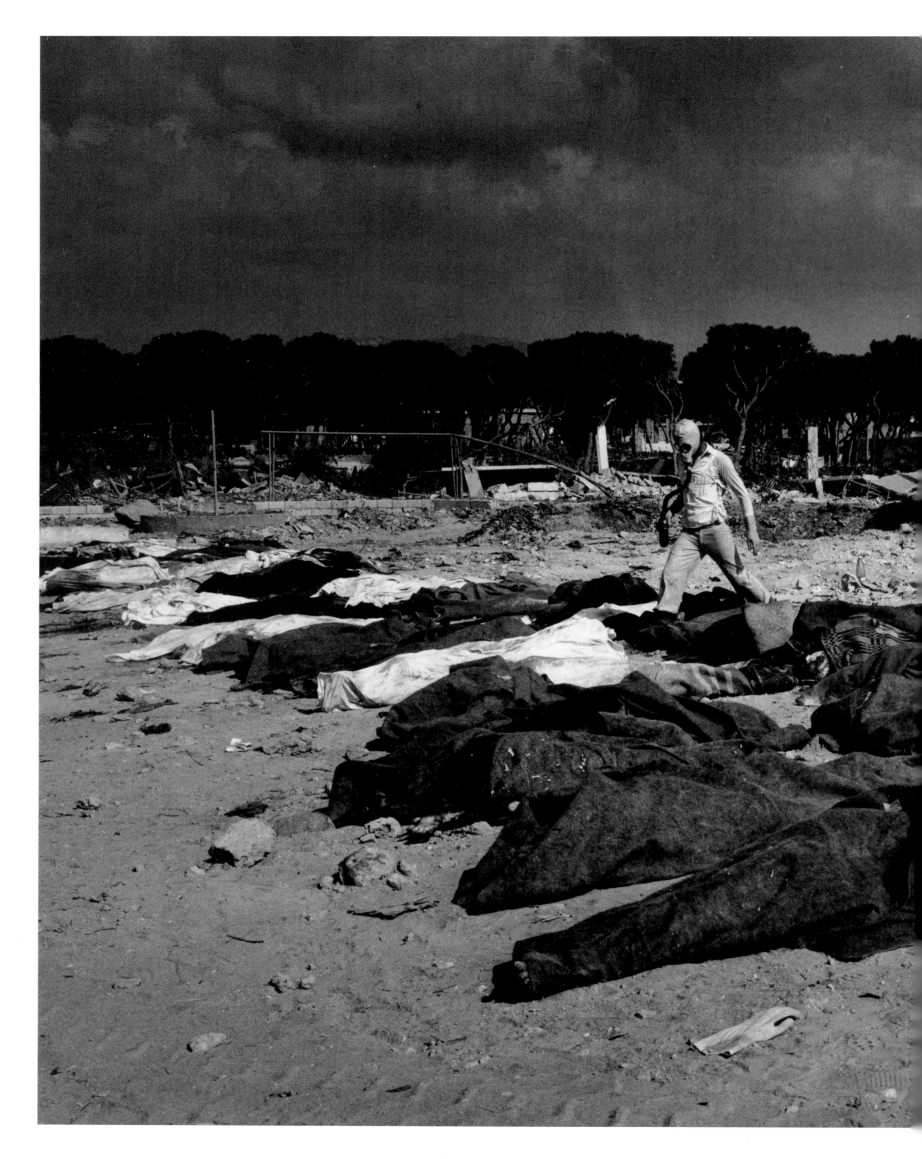

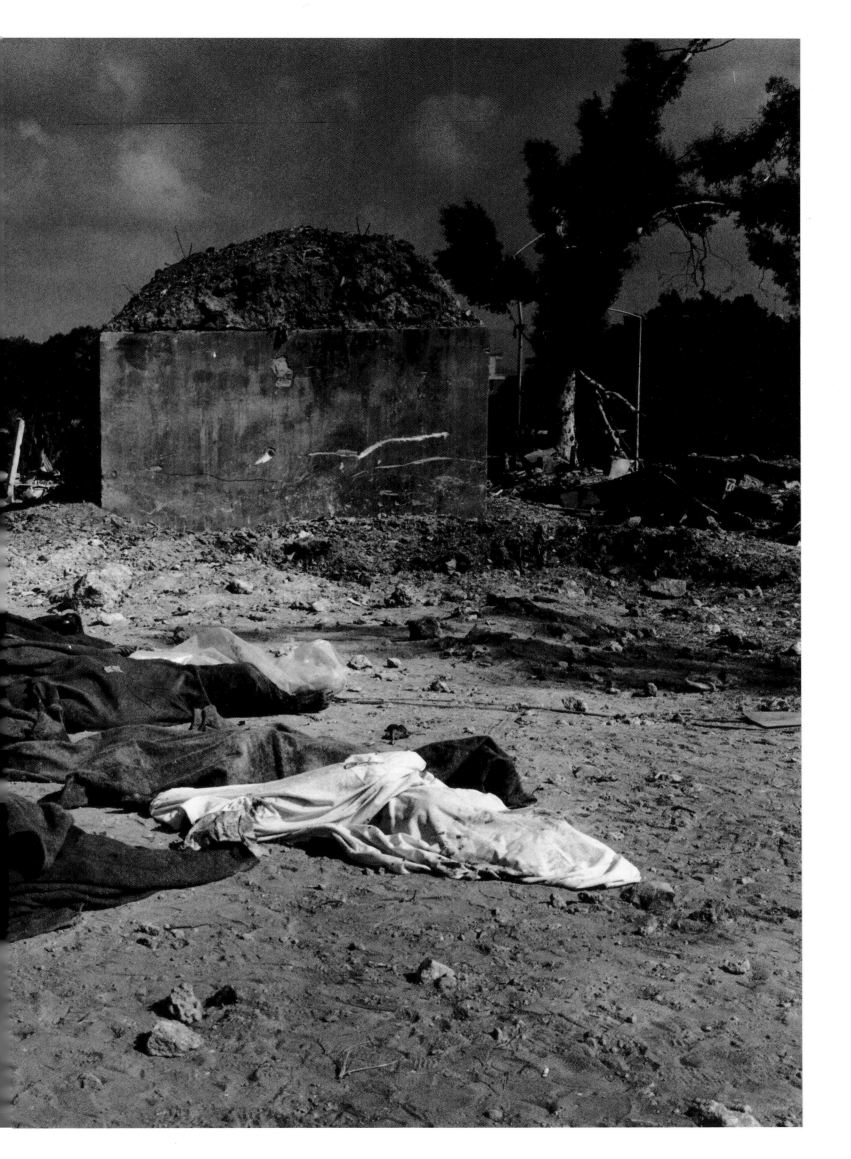

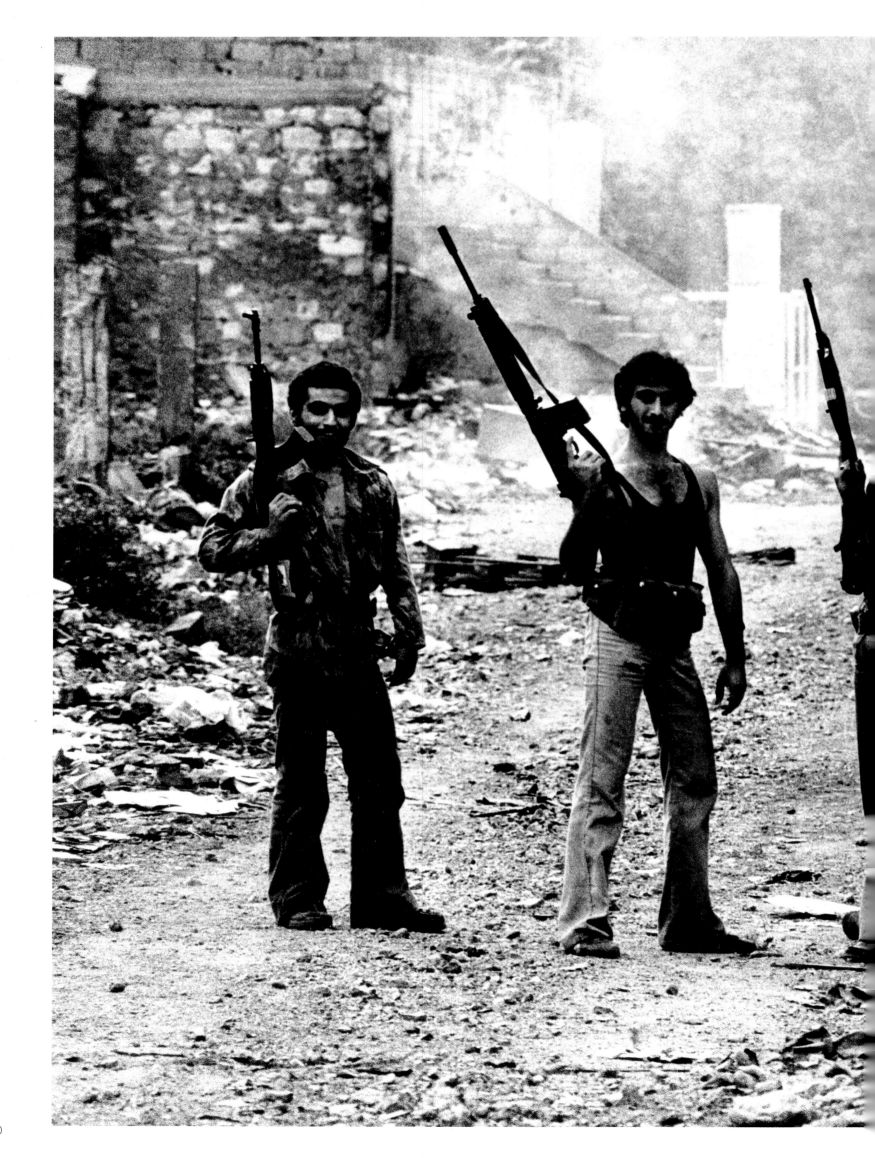

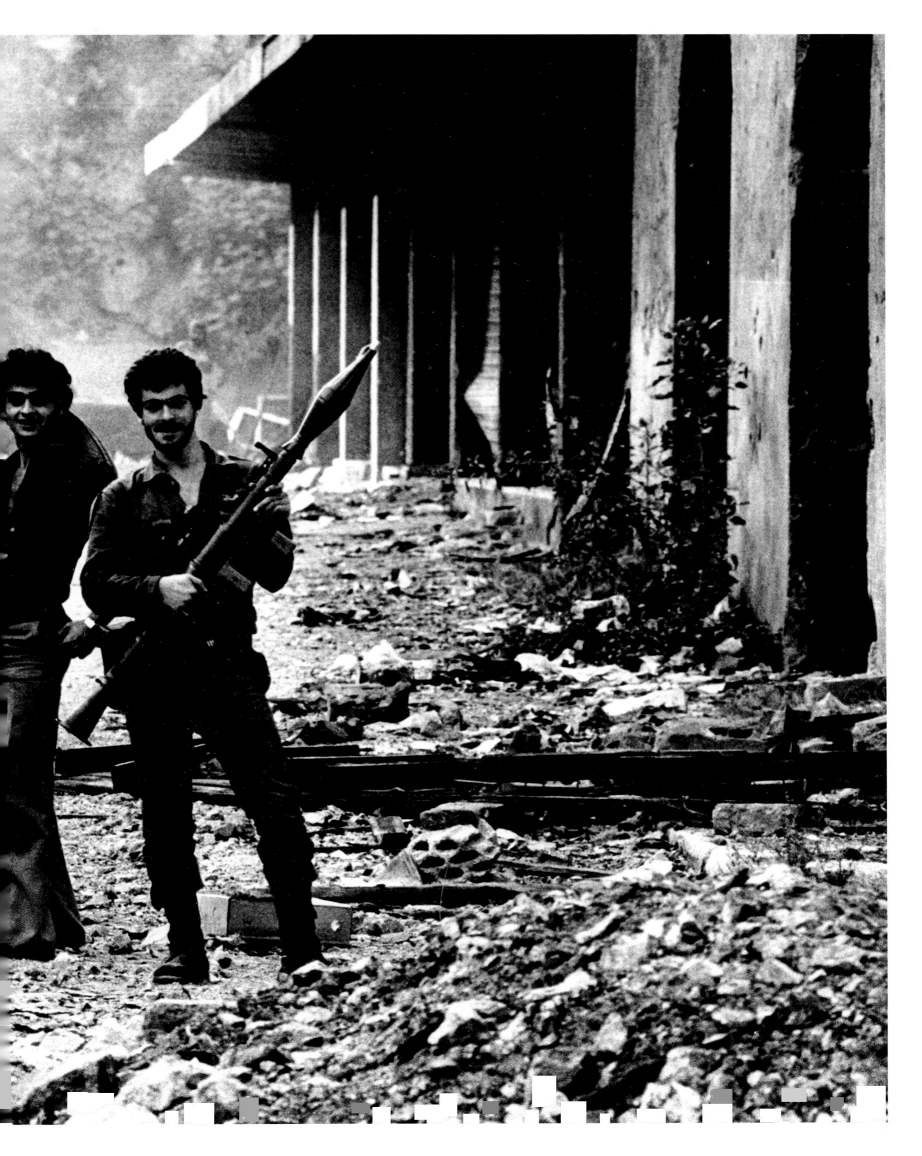

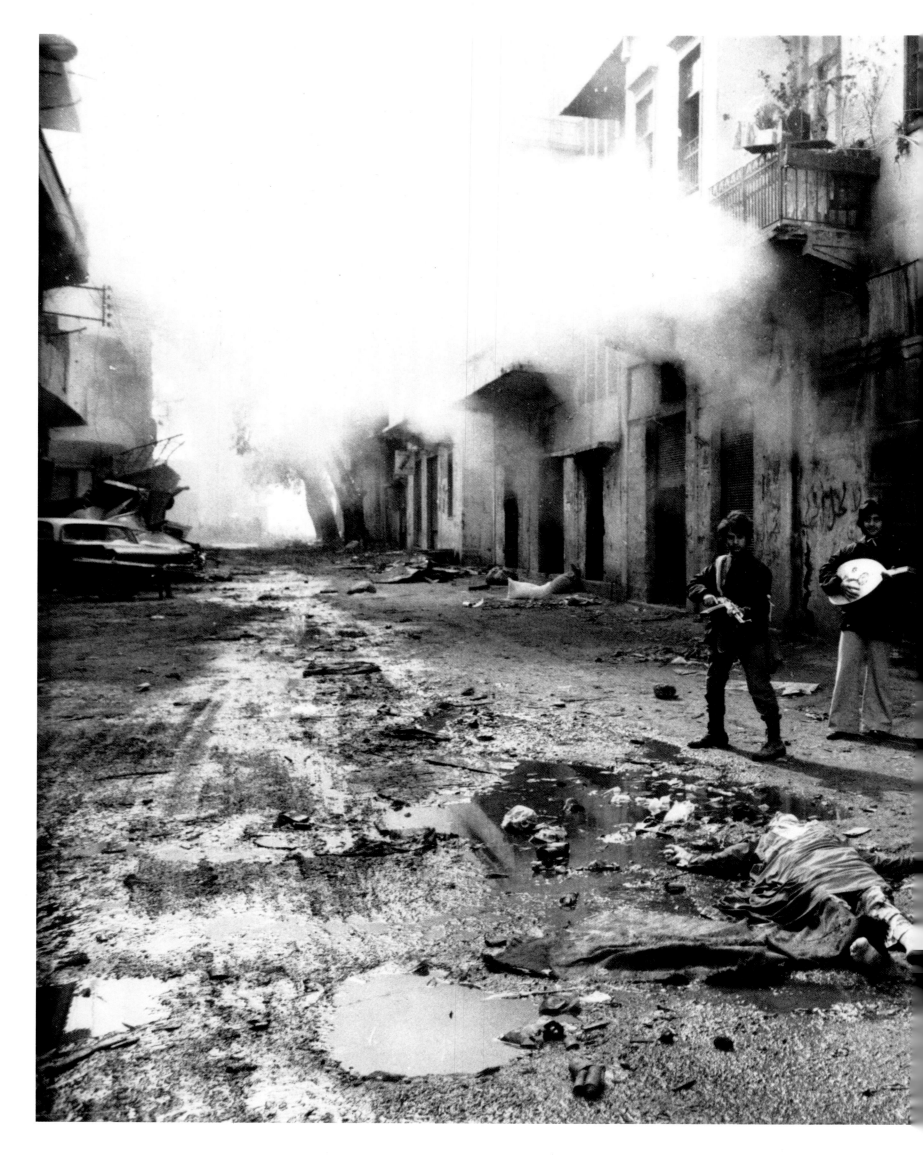

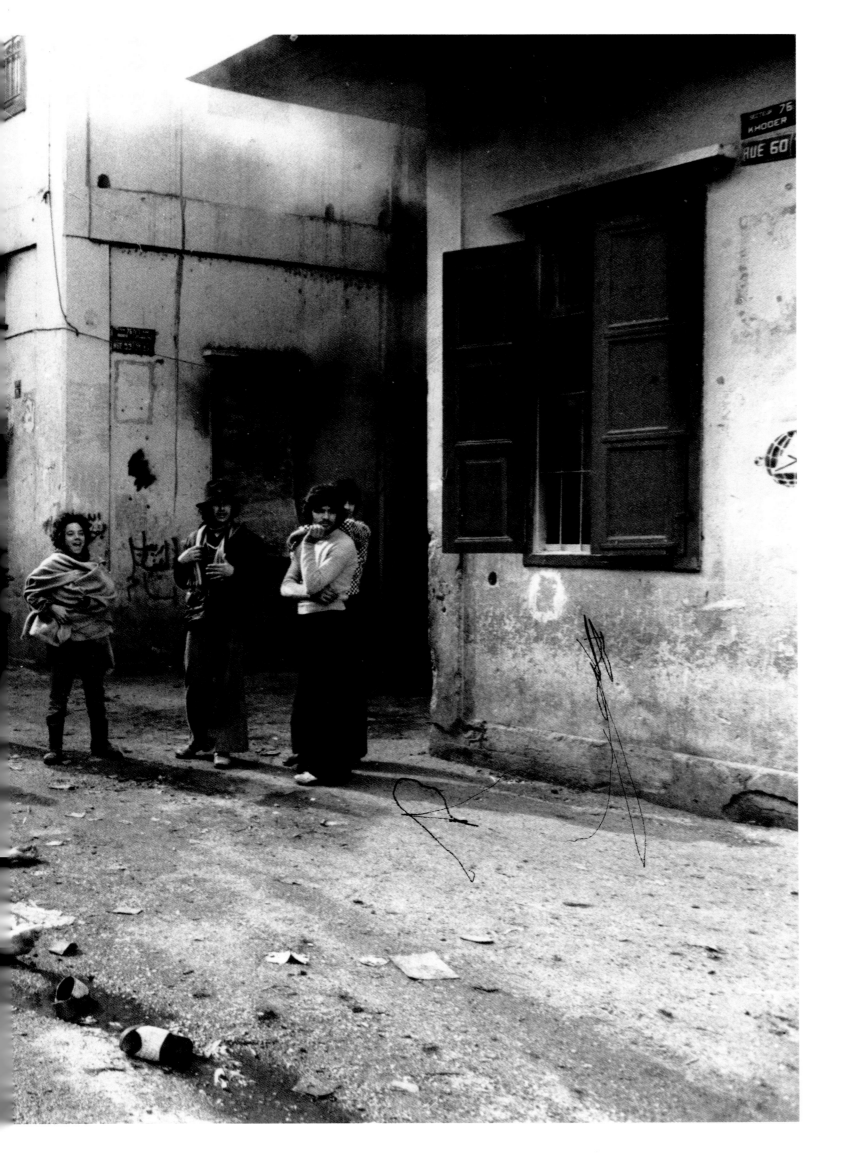

Pages 148-49
**Palestinian victims of
the massacres at Sabra
and Shatila, Beirut,
Lebanon, 1982**

Pages 150-51
**Phalangists,
Beirut, Lebanon, 1982**

Pages 152-53
**Phalangists with the
body of a Palestinian girl,
Beirut, Lebanon, 1976**

Right
**Palestinian women grieve
after the massacres at
Sabra and Shatila,
Beirut, Lebanon, 1982**

and taken inside. 'I'm going to cut your throat. You're going to die for this', I was told. 'They massacred our people. You're one of them!' I went into free fall. I was with somebody else and felt really stupid. We were in the room for an hour and the door kept being opened and people looked in. Eventually a man came in, smoking a cigarette, and said, 'You've been very foolish. I understand your situation. You've given them a Christian Phalange pass. We know you need this pass. They've just witnessed this terrible massacre and they want to kill you, but I'm going to let you go. Would you like a coffee?' I was almost down at his feet for saving my life. You travel this extra distance that has nothing to do with being a photographer or a newspaper person. Suddenly your life is on the line. It was all about stress and not knowing about things. I had simply made a wrong decision.

Later, back in London, I was preparing a book on the Palestinians with Jonathan Dimbleby for Naim Attallah, a publisher who was, in fact, a Christian Palestinian. It was a good opportunity to show some support for the Palestinians. During those days in Beirut in the civil war, I had actually spent some time with Yasser Arafat. I got close to the Palestinian question. Doors started opening once they knew I was doing the book. I wasn't so impressed by Arafat. He was surrounded by thugs and street boys. Back in England I read in the newspaper about the massacres at Sabra and Shatila and jumped on the next plane back to Beirut. I fought my way into the camps. I knew exactly where they were, but there was an army ring around them.

The Israelis had captured Beirut. Ariel Sharon had always sided with the Christians and pulled his troops back, so allowing the massacres to take place. I arrived about a day later and started taking photo-

graphs. A Lebanese officer came and said, 'Please leave the area, but before you leave, please give me your film.' I looked him in the eye and said, 'I haven't got any film. I've just arrived and I *need* film!' Of course I wasn't telling the truth. I had some wonderful film. I wasn't about to give it up. It was *so* important. I got some very strong photographs. You're constantly using your wits to save yourself and your film.

You had to be careful with people who came with tall stories, because Beirut was particularly dangerous and later became a place for taking hostages. One morning a man asked me to come with him to the hospital at Sabra and Shatila. The American woman journalist I was working with couldn't be bothered to get out of bed, so I was the first person on the scene. It was ghastly. Children were tied to the beds – insane children. They were lying on plastic sheeting completely submerged in their excrement. They had been tied because the hospital had been shelled for five days and nights from Israeli ships offshore. One man had been decapitated sitting up in his bed. The children who were mobile were crawling and cutting themselves to pieces on the broken debris and glass.

A Palestinian nurse had stayed throughout, trying to provide food and water. She told me she wanted to show me something. She opened a big door into a room with no windows. Inside there were twenty deaf and blind children who had defecated all over themselves. The temperature must have been about one hundred and ten degrees. They were like blind baby rats crawling out of this filth. These children were blind *and* insane *and* deaf. It was too terrible for words.

Some kind of command had been given and amid all the debris of the shelling they were trying to evacuate. The insane were moving the insane. Screaming

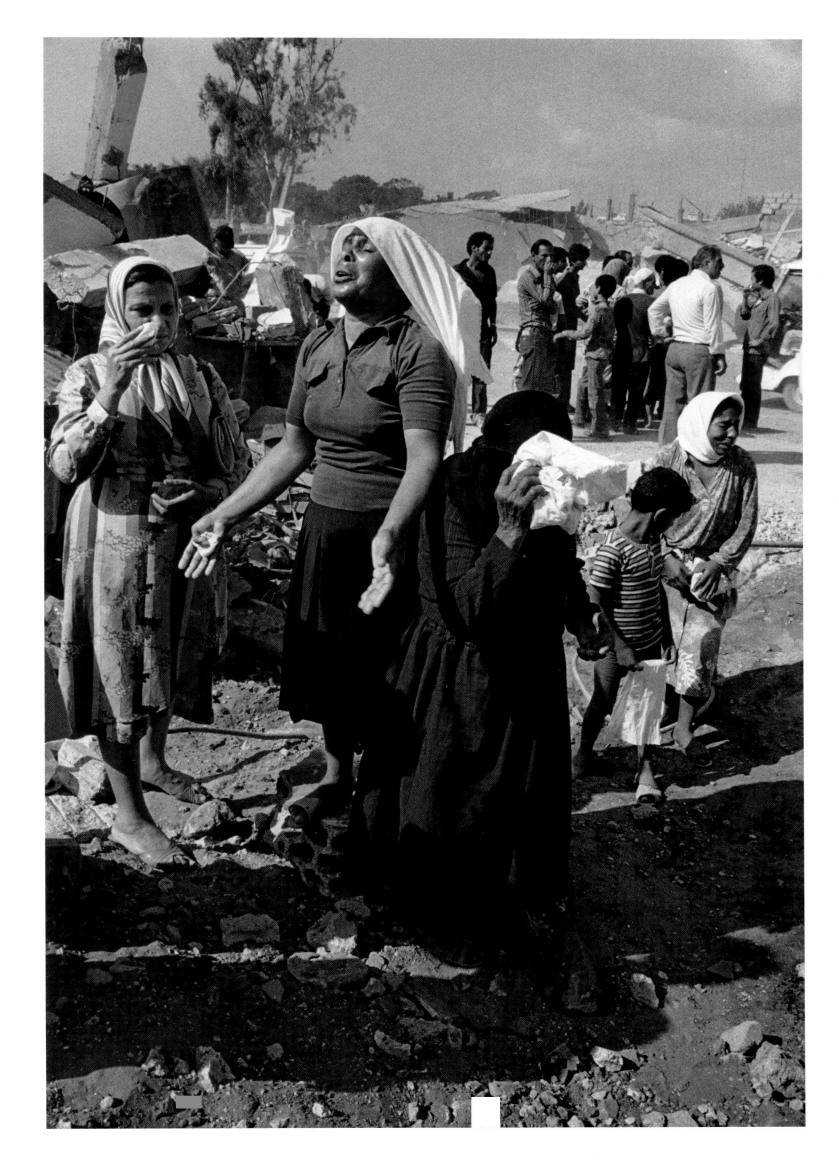

children were being carried like sacks of coal. An insane woman asked me in French where she should take a half-naked, insane child. I always knew that war itself was pure insanity. Days like that can never be eradicated from memory. They can enter my thoughts at night or at any time of the day – on an aeroplane, on a bus, in my car, on a beautiful summer's day at home in Somerset. These things will never leave me. That's impossible.

My next conflict was in the Falklands in 1982. When the Falklands War was imminent, I asked the *Sunday Times* to get my name on the official list with the Ministry of Defence. I was told not to worry. My name was already on the list. A week went by and nothing happened. Then a second week and I started getting really worried. Ships were beginning to leave. I'd just come back from the war in El Salvador. I had shattered my left arm and broken all my ribs in a fall from a roof in a gun battle. I could still function with my right arm, and thought that if I could get on the hospital ship, the SS *Uganda*, I'd be able to have physio and be in good shape when I arrived in the Falklands after six weeks.

For reasons known only to the MoD, I was excluded from the task force. I was a broken man. I wanted, for once, to be with the British Army. I was fully trained. I'd seen more action than any of those generals or soldiers would ever know. I was desperate. I went to the Imperial War Museum and said I wanted to go to the Falklands. They welcomed that and asked me my fee. 'One pound a week,' I answered. They told me my work would become Crown copyright but I still wanted to go and it never happened. In the end I knew it was too late. I wrote a letter to *The Times* and complained publicly about this experience. The MoD claimed there was no space on the boats, but I read they'd room to take three million Mars bars. Obviously I was excluded because of my work in Vietnam. The Americans blamed the press for losing them the war. The press never lost them that war. The North Vietnamese

Army won the war. Ho Chi Minh's determination to overcome the mightiest country in the world was extraordinary. That I didn't go to the Falklands is one of those memories that hurts me to this day. There's no great record of the war and the sacrifice our people made to secure those islands. The decision to exclude me was a huge mistake. I've even spoken to generals who say it's a shame I wasn't there.

By then I was hugely experienced in warfare. I knew the sound of an AK-47 and that would mean the presence of the North Vietnamese, the Vietcong or the Khmer Rouge. I also knew the sound of an M16 rifle and of the RPG 7 rocket. The RPG 7 and the AK-47 are two Russian weapons that are still traumatising our soldiers. These are favoured guerrilla weapons. The RPG was the most feared weapon in Vietnam for the Americans. It had a penetrating, destructive warhead on it that used to make a colossal noise and produce huge damage.

Strangely enough, in 1972 when I was in another huge battle on the An Loc Road – the road from Saigon to Phnom Penh – for the first time, I was nearly killed by my ignorance. I was with the Vietnamese Army lying in a culvert and I could hear a screaming noise coming towards us. Everyone looked at each other. A column of tanks behind me was slowly edging forward. I could see this huge white ball of fire coming, rising and dipping over the contours of the road. My mouth was wide open. I'd never seen anything quite like it in my life. I watched it strike the tank just behind me. It was the first time I'd seen a wire-guided missile knock a tank out. It was an American tank driven by Vietnamese. It marked a new chapter in the shape of the war that was coming and that others would encounter later. Even though I went to the first and the last Gulf wars, things have changed dramatically since I was on a battlefield.

I don't assume photography or images belong to me personally. I was treading on very thin ice. I felt obliged to create a set of rules that I could work with. That's why I never liked working with the

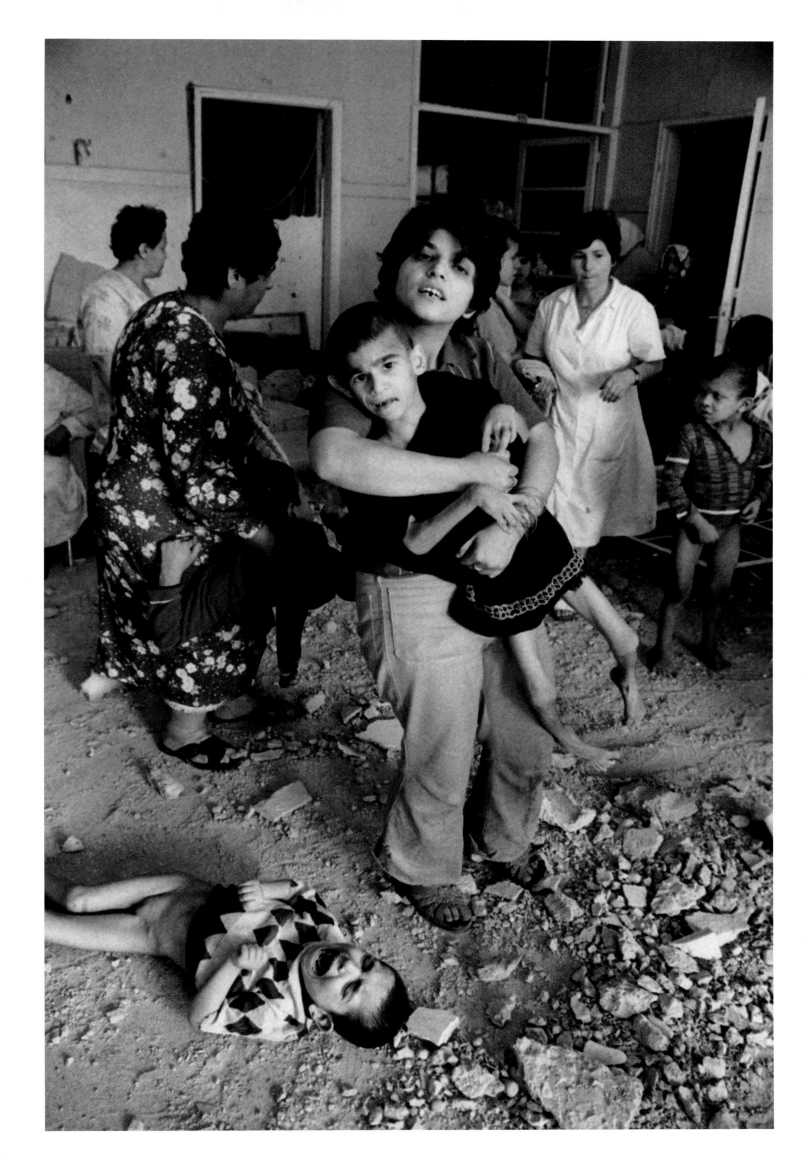

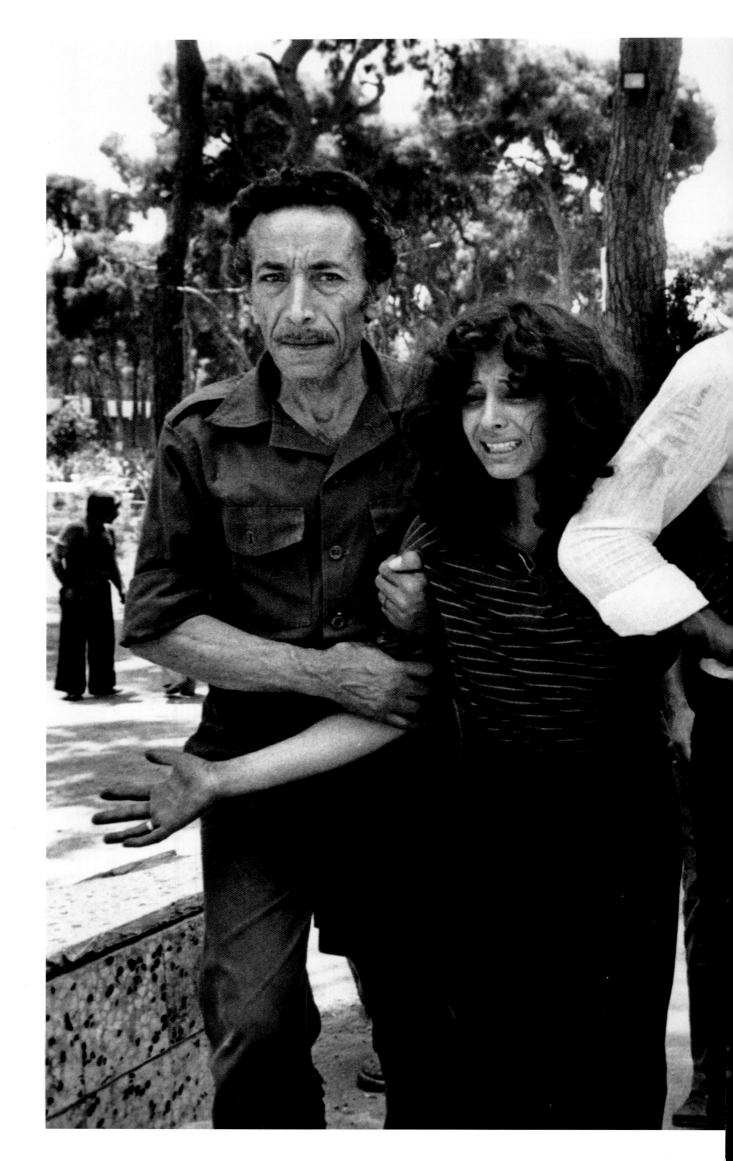

Grieving Palestinian family
after the burial of the
young woman's husband,
Martyr's Cemetery,
Beirut, Lebanon, 1976

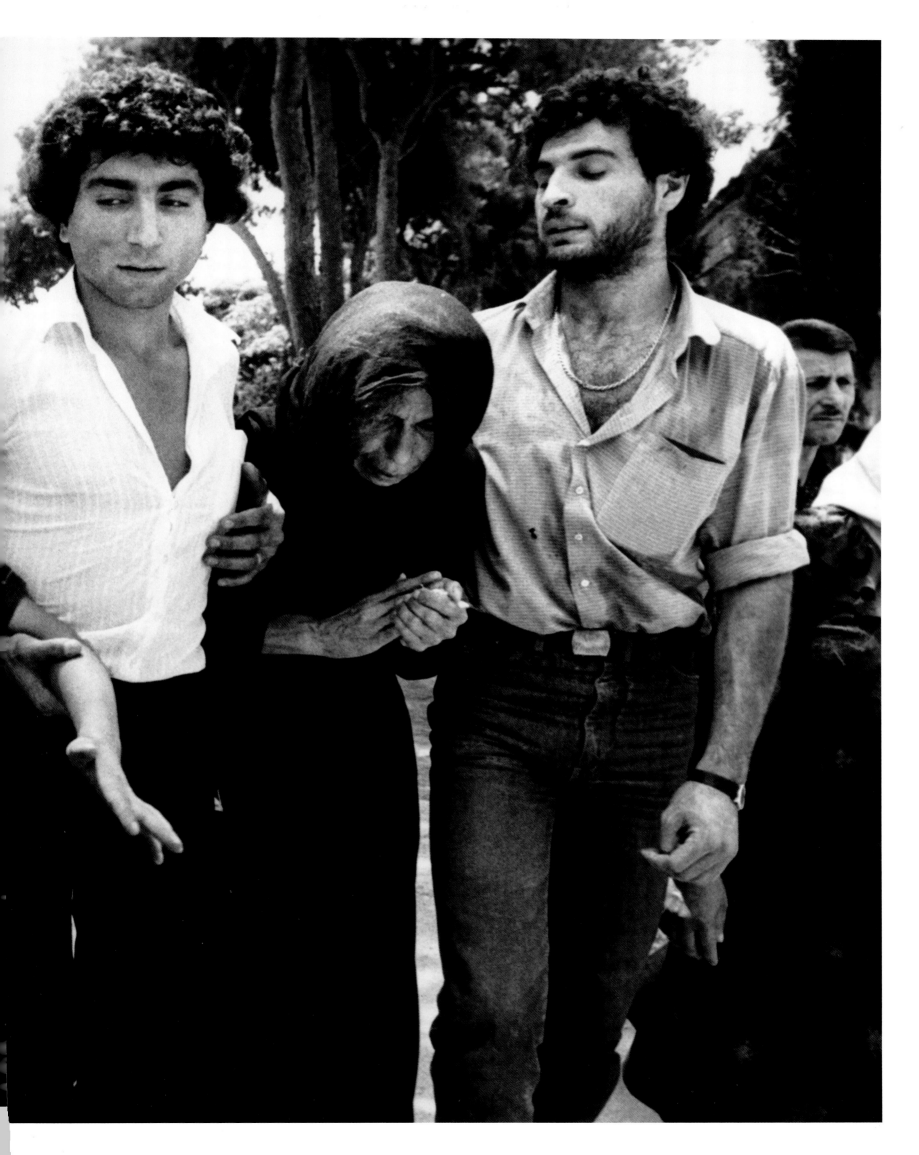

pack. I've seen the most appalling things happen when the pack arrives – stepping on people, pushing people. I had my own code of conduct and I've kept it to this day. It is about being a decent human being and not assuming the world belonged to me. I'm responsible for acting in the right way. It's about simple respect and common decency. It's served me well. Only once did it let me down, because I was foolish – just on one occasion.

In Beirut one day, an Israeli bomb had collapsed a block of flats and turned it into what could only be described as a club sandwich. A woman came round the corner in the most hysterical way, knowing that all her family were in that building. I foolishly pulled my camera out very quickly and took a picture. She saw me and started pounding me. Those blows were really horrendous and I had to take them. To be truthful, I deserved them. I mismanaged the moment. I had always been careful not to step on other people's grief. I took those blows in front of an audience of hundreds of Lebanese Palestinians and then I tried to walk away. Somebody, thankfully, took her away. Then, I tried to proceed, I faced a man with a 9mm pistol pointing into my face, who was trying with his other hand to take away my Nikon F camera. I wouldn't let it go and he was pulling my arm, which I'd just broken in Salvador. But resisting him – he would have undoubtedly smashed the camera – might have made him actually pull that trigger. I got back to the Commodore Hotel in some distress and was sitting down to drink a coffee when another member of the press told me the woman had just been killed. Another bomb went off and blew her across the road. A day like that is best forgotten. It was one of the worst days I can recall. I'm ashamed of it, of all the things I've seen in my life, of all the blood, all the burnt children. I'm disgusted with the whole business, but I did it for thirty years. I suspect I was suffering a mental breakdown in a way. I was basically nothing less than a war junkie. I recognise that today. At the time it

was all I could do – to go to war. If I wasn't in war, I was at home and unhappy. I have a lot to account for really. I'm not what you call clean. I went through all that war and lived through moments when I was excited about it. That was totally wrong.

The end of the war in Lebanon was the beginning of the end for me. My relationship with the *Sunday Times* was beginning to deteriorate, because by then Rupert Murdoch was in charge. Working for Roy Thomson and under Harold Evans had been a joy. Murdoch took on the unions, took over the *Sunday Times* and *The Times*, and brought in Andrew Neil. Many of the great people on the paper were paid off because Neil wanted to create a new team. Sooner or later I was going to be in line for trouble. *Granta* magazine published a profile of me in which I said I was slightly sick of hanging around at the *Sunday Times* with the safari jacket on but with no safari. Andrew Neil called me in and said I had to leave. He was not going to have me working there, taking my pay and criticising the paper. So I said, 'Fine.' I left. In many ways it was a curious turn of fate. I might have been sent to Chechnya or Bosnia and got killed. Instead of that, I turned my back, walked out of the office and started looking at other aspects of life, like the landscape and still lifes.

To my shame, I did some advertising. For me, advertising work was a form of contamination. For a single day of advertising work I would be given a cheque that was equivalent to two or three months of pay from the *Sunday Times*. I felt like I'd prostituted myself. I had been proud of my commitment to photojournalism. Being sacked had taken away some of my dignity. I let myself fall apart.

But I did make some extraordinary journeys. I went several times to Indonesia and India and began taking totally different kinds of pictures. I started anthropological explorations, which I would have been quite happy to have made all my life, and in

THE SUNDAY TIMES

P.O. Box 7, 200 Gray's Inn Road, London WC1X 8EZ *Telephone 01-837 1234 Telex 22269*

From the Editor 8 April, 1982

Mr. Don McCullin,
Hill Farm,
Farnham,
Nr. Bishops Stortford,
<u>ESSEX.</u>

Dear Don,

Further to our telephone conversation yesterday,
I want to tell you how fully I understand and sympathise
with your immediate disappointment at the non-appearance
of your Salvador pictures in the mid-May issue of the
colour magazine. I am sure everyone here knows and
appreciates just how much you did, and the dangers you
ran, to get these pictures.

But I must respect Peter Jackson's editorial judgement
that, with the Falklands business boiling up fast, it would
be a mistake to publish these Salvador pictures until the
Falklands business is out of the way. Once that has happened
(and in my view, it cannot be a long drawn out affair) then
the way should be clear for publication of your marvellous
pictures.

Do please look after yourself, and take time to
recover from your injuries. I thought the black and
white pictures in last Sunday's paper, together with
your own story, made some marvellous reading.

Good luck Don, and if you are in or around the office
please come and put your head around my door.

Yours ever

Frank.

Frank Giles
Editor

TIMES NEWSPAPERS LIMITED
Reg. Office P.O. Box 7, New Printing House Square, Gray's Inn Road, London WC1X 8EZ
Reg. No. 894646 England

Government fighter,
Usulutan, El Salvador,
1981

Page 164
Civilians take cover from
FMLN guerrilla gunfire,
El Salvador, 1981

Page 165
Prisoner suspected of
being a government
sympathiser is led by
FMLN guerrillas to
probable execution,
El Salvador, 1981

Government troops
under fire from FMLN
guerrillas in a church
tower, Usulutan,
El Salvador, 1981

Pages 166-69
Bodies of FMLN guerrillas
after a two-hour gun
battle, El Salvador, 1981

Pages 170-71
Sunday Times magazine,
June 20, 1982, featuring
Don McCullin's coverage
of El Salvador, which was
held back for one month
due to the Falklands
conflict

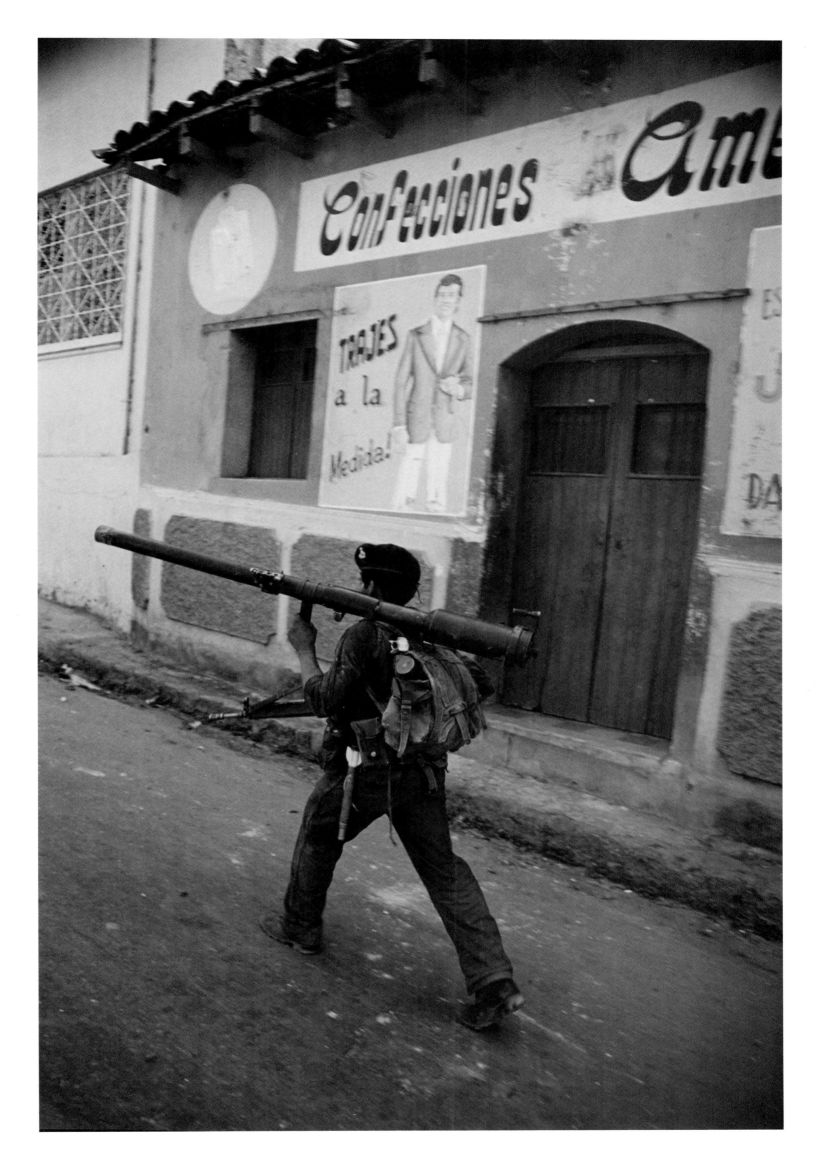

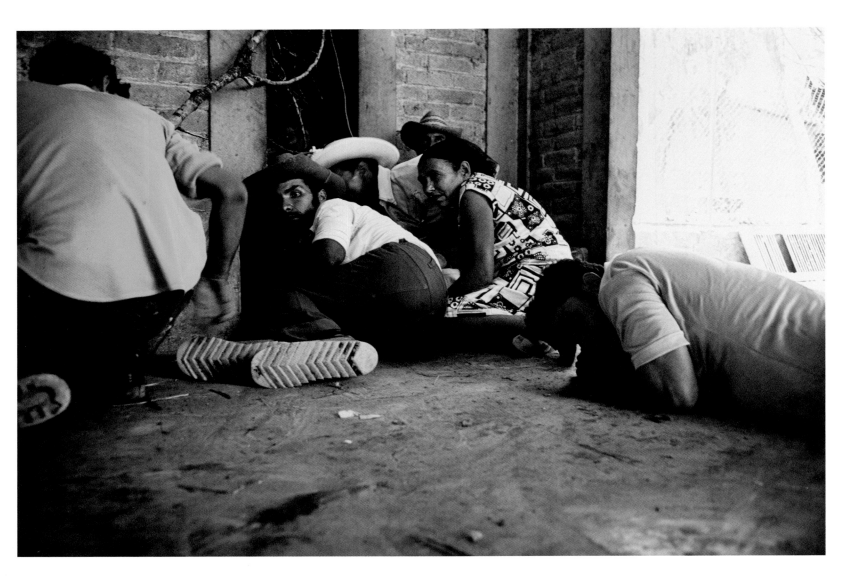

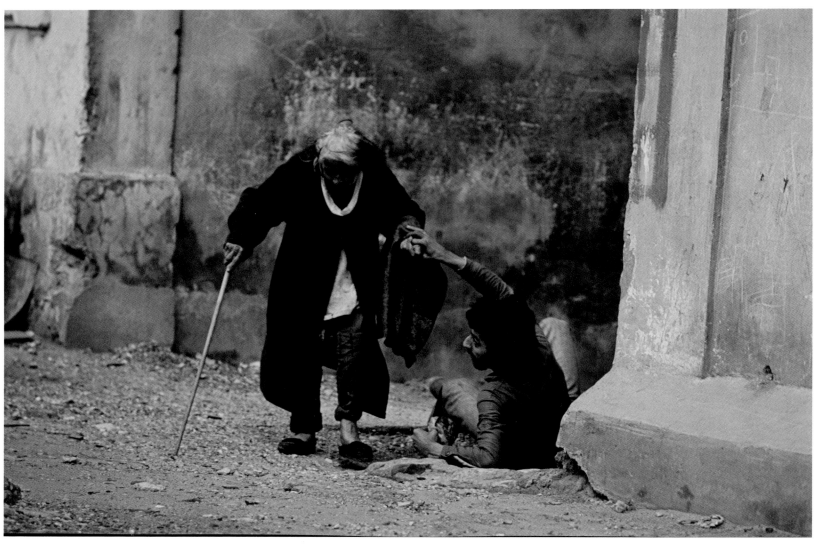

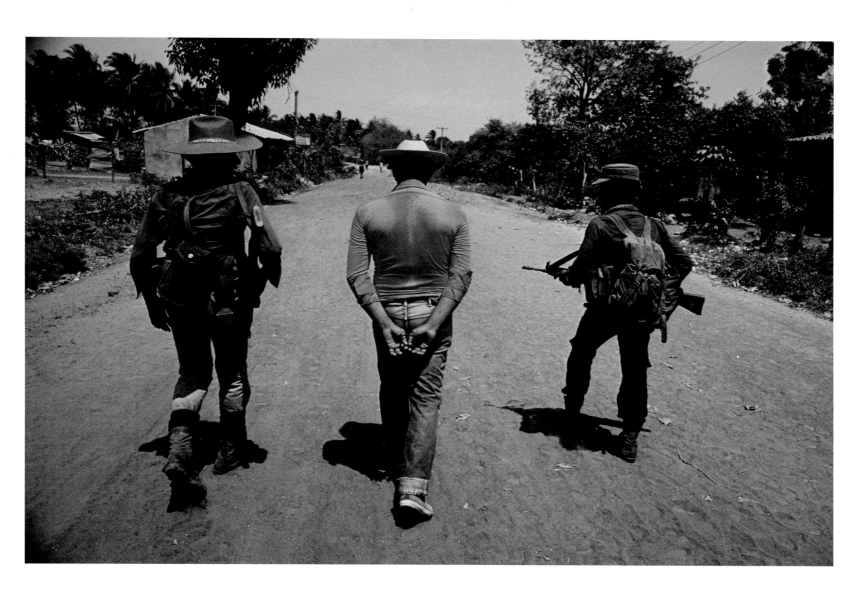

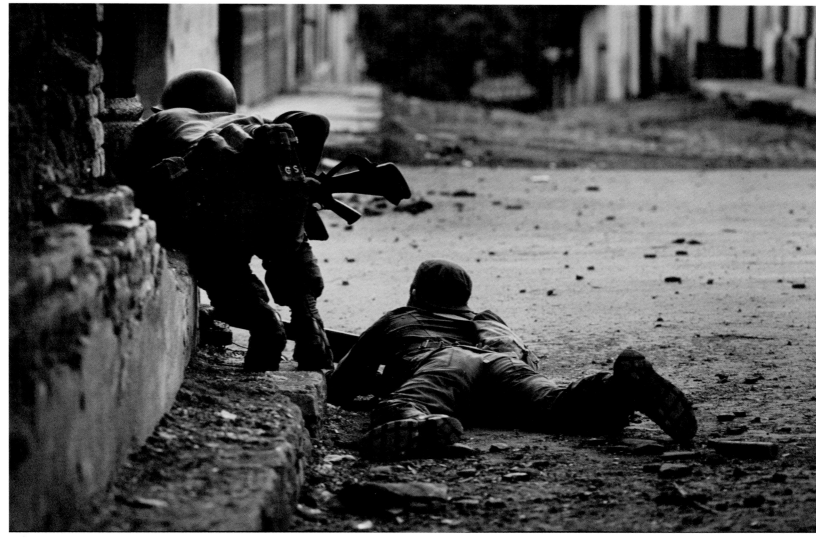

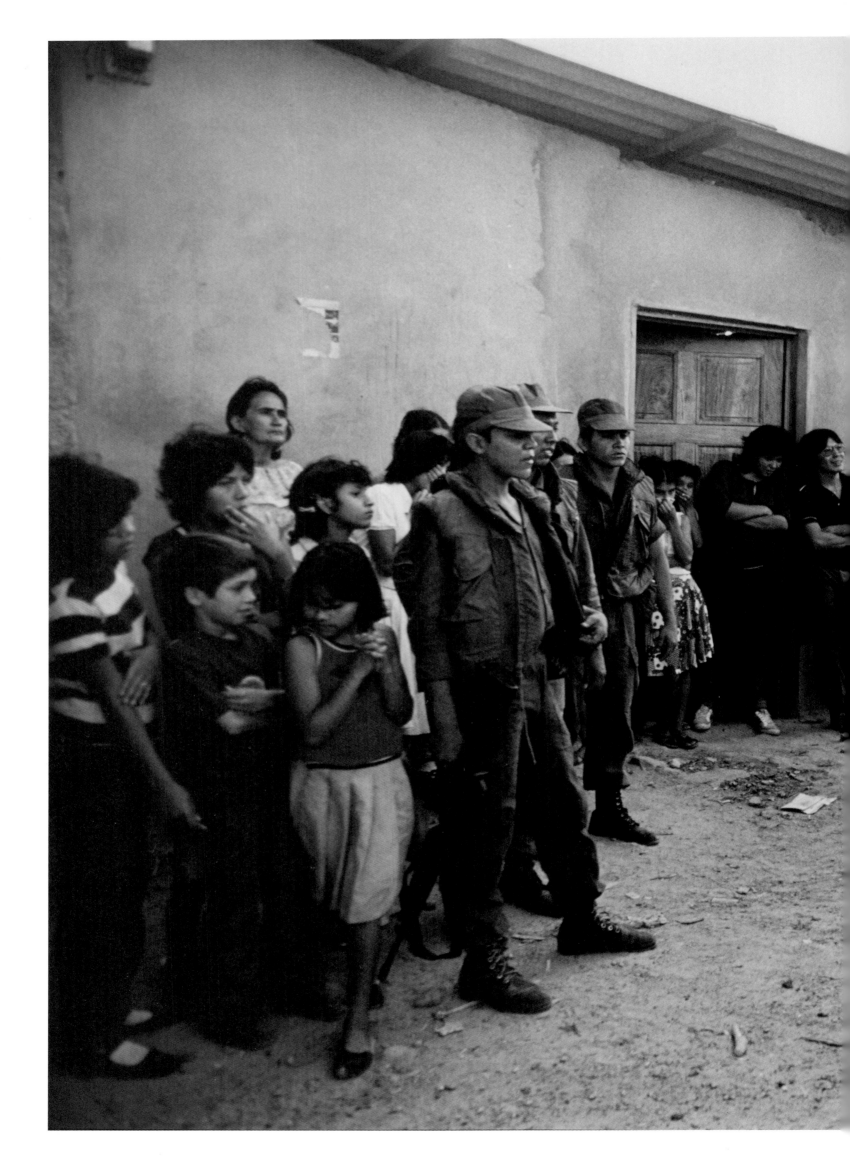

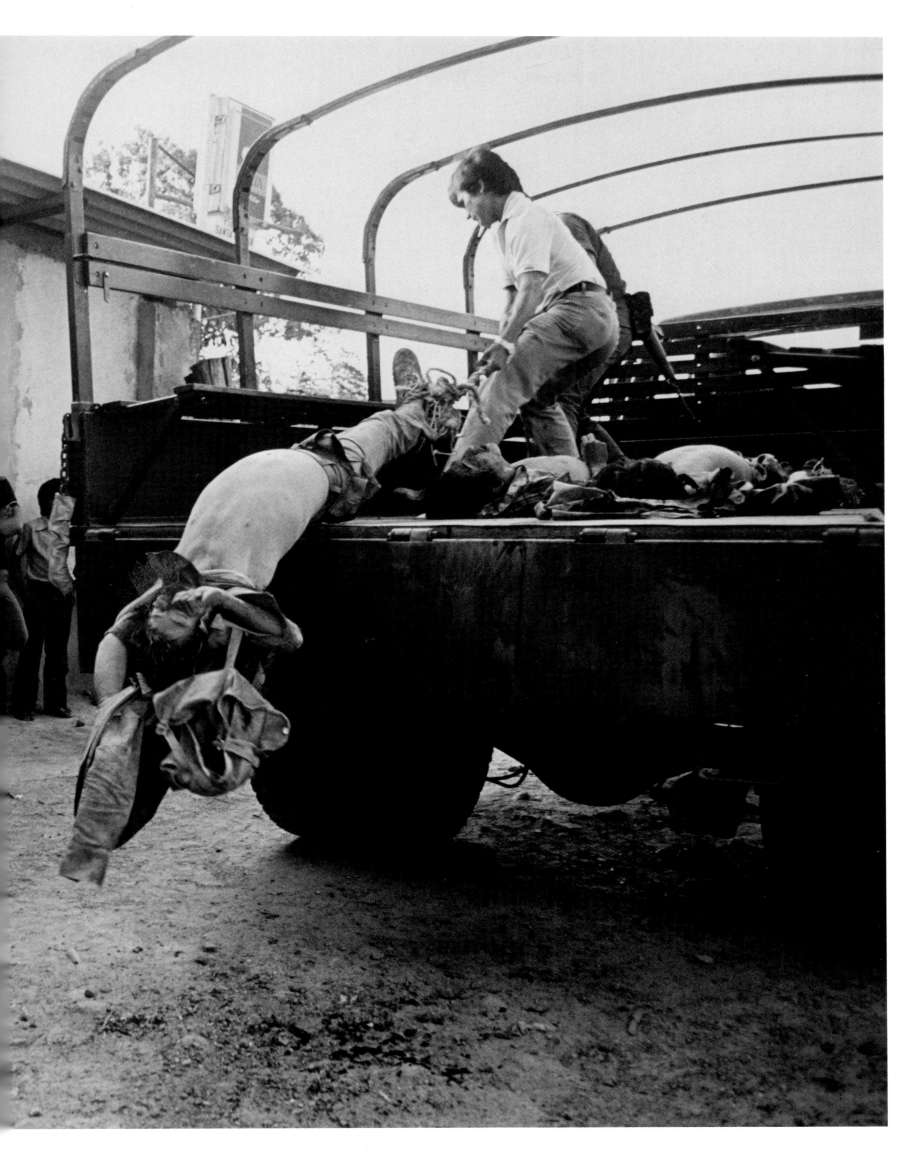

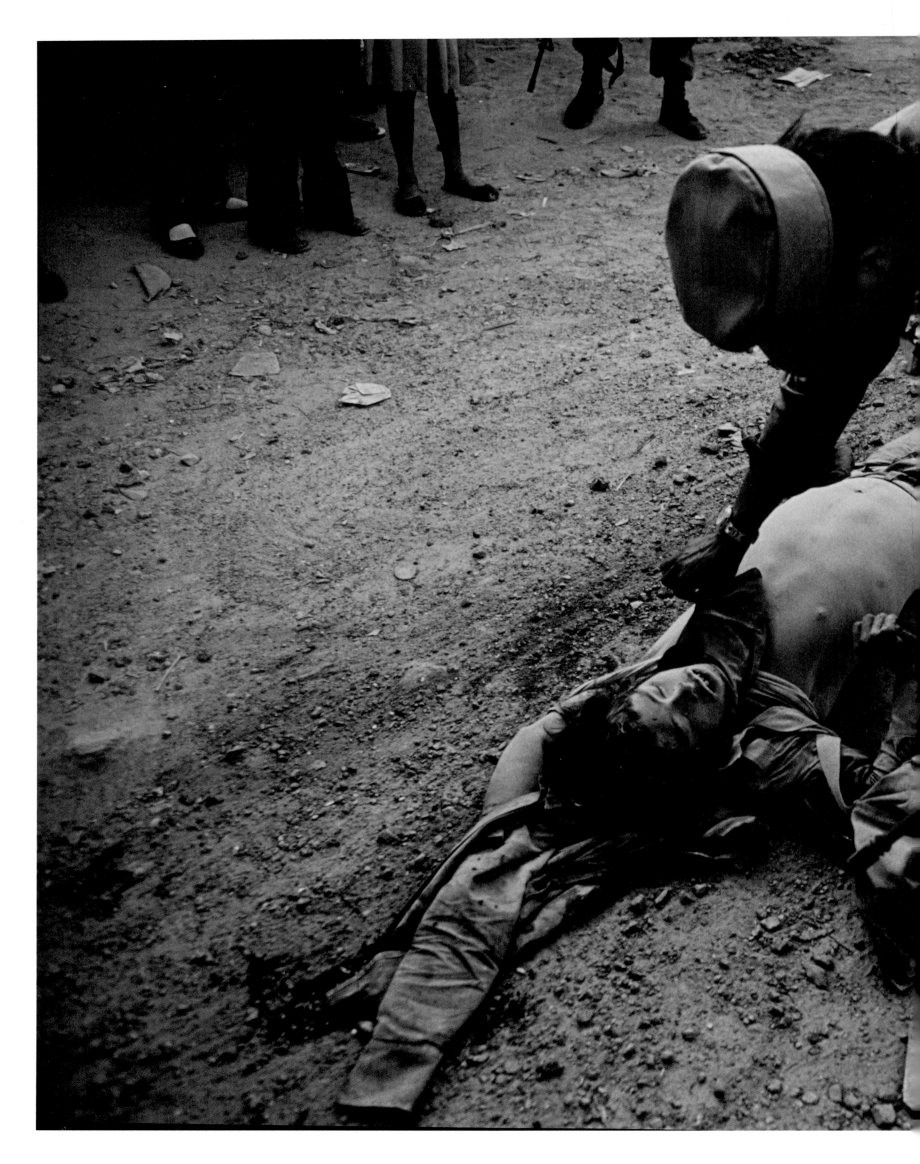

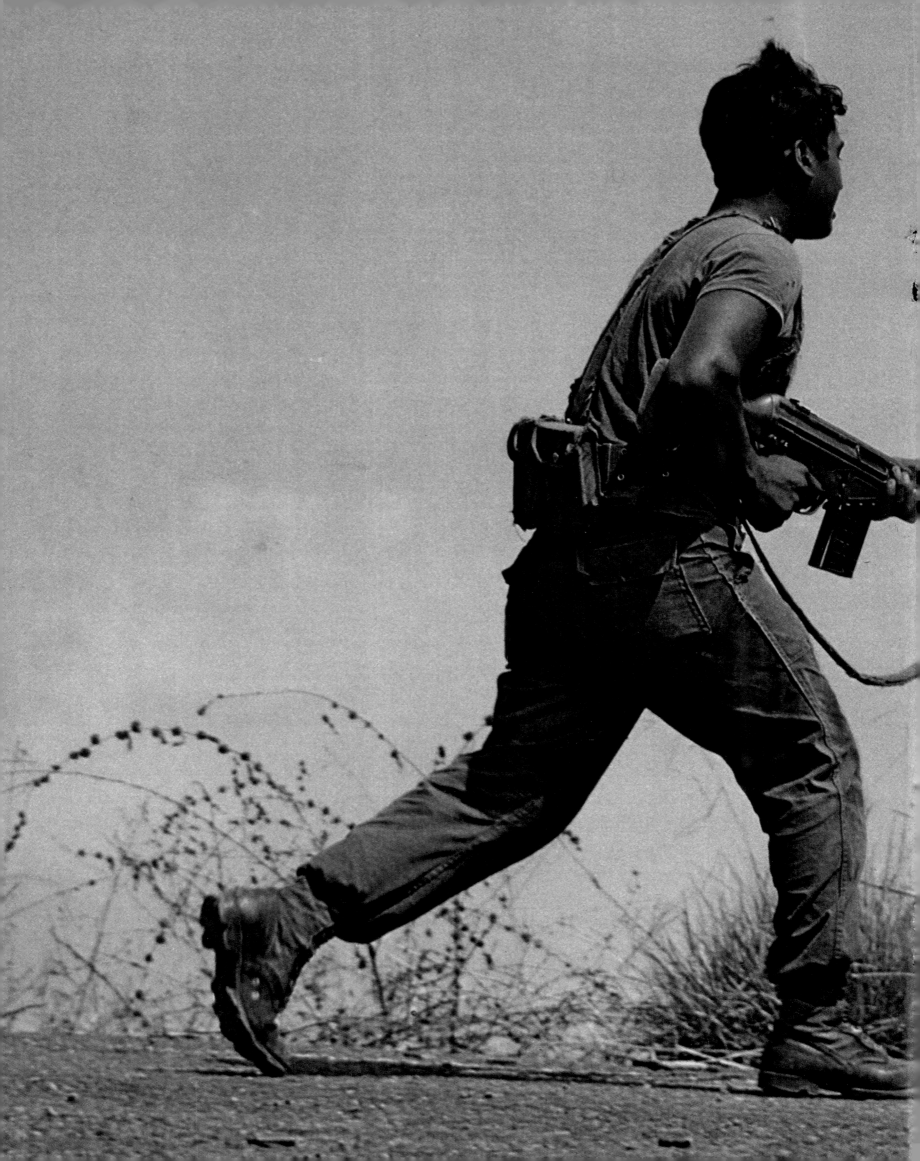

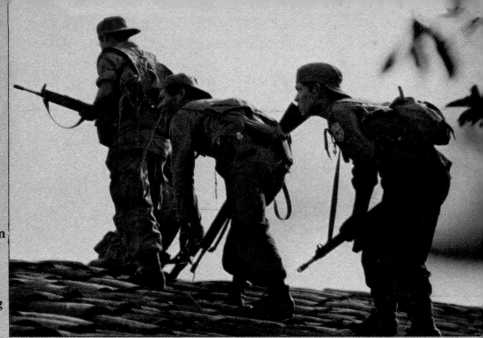

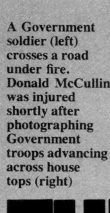

A Government soldier (left) crosses a road under fire. Donald McCullin was injured shortly after photographing Government troops advancing across house tops (right)

THE WAR THAT WON'T GO AWAY

Wars fall in and out of fashion. For months a conflict somewhere in the world holds the headlines. Names of people and places crowd the television-viewer's mind. Then, suddenly, the focus shifts, and the affair is forgotten. Last year, and for the first, bloodstained months of 1982, the spotlight was on El Salvador. A brutal civil war left corpses, refugees, and a tiny, tortured nation at the storm centre of international politics. Then came the Falklands, and the sufferings of El Salvador were brusquely wiped from the news bulletins. But death does not stop. El Salvador is as violent and dangerous today as it was: maybe more so. In the first six weeks of confrontation in the South Atlantic, some 350 people died; over the same period 952 bodies piled up in El Salvador. The struggle continues, and could still fire a general conflagration in Central America. Donald McCullin, probably the greatest war photographer today, has been back to El Salvador for the pictures on these pages. He fell from the roof of a building under cross-fire, shattered his arm and lay for 13 hours before he was rescued. Wars, unfortunately, don't just go away when TV news crews jet to the next killing ground. *Peter Wilsher, Foreign Editor, The Sunday Times*

Photographs by Donald McCullin

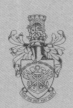

from the Secretary of the Museum
Jonathan Chadwick

Imperial War Museum

Lambeth Road London SE1 6HZ
Telephone 01-735 8922

JJC/GAN 21 May 1982

Dear Mr. McCullin,

This letter of agreement is to confirm the terms which we have
agreed for your commission for the Imperial War Museum Trust to make
a photographic coverage of the Falkland Islands crisis. The
terms are as follows:-

1. The Museum has used its good offices to arrange that permission
 be given to you by the Ministry of Defence to undertake
 this commission at your request, and you do so at your own
 risk.

2. The Museum will pay you a Commission fee of £1 and the expenses
 of your travel, board and accommodation to be arranged by
 you through the Ministry of Defence up to a limit of £2,000.
 This sum will cover, on the best information available, the
 return Air Fare to Ascension Island, the return ship voyage
 to the Falkland Islands (board and accommodation) and
 subsistence on the Falkland Islands.

3. All photographs of the assignment will be deposited by you
 in the Imperial War Museum in the form of a complete set of
 prints, and the copyright in them will belong to the Trustees
 of the Imperial War Museum. The original negatives will
 remain in your possession but property in them shall remain
 in the Museum who shall be free to make its own set of negatives
 from the prints supplied and on your death the original
 negatives shall be returned to the Imperial War Museum.

4. You will bring back the films for processing in the United
 Kingdom in a manner satisfactory to the Ministry of Defence
 and submit them to that Ministry for security vetting before
 they are lodged with the Museum.

5. The Imperial War Museum will adminster jointly with you the
 arrangements for the release and publication of the photo-
 graphs after you return in accordance with any special con-
 siderations raised by the Ministry of Defence Public Relations
 Office and subject to Ministry of Defence clearance.

/Contin....

6. Any photographs printed will bear the credit 'The Imperial War Museum - Don McCullin collection'.

7. The Museum will have the right to use the photographs for its own purposes without fee including the licensing of reproductions by third parties for a fee, and the use of the photographs for the Museum's own publications, displays etc.

8. The Museum grants to you the right to use the photographs, subject to Ministry of Defence clearance, for your own purposes eg in publications or for exhibition and you have agreed that the money accruing from these activities will be shared between you and the Imperial War Museum Trust on the basis of 50% each.

9. You undertake to make no claim against the Museum for any loss or personal injury (including personal injury leading to death) which you may suffer and to indemnify the Museum against any claim for such injury or death which may be made by any other party, including any costs which the Museum may incur in defending any proceedings instituted against the Trustees.

Yours sincerely,

Jonathan Chadwick

War coverage

From Mr Donald McCullin

Sir, With reference to Fred Emery's article dated June 10 on "kit" and "minders" — Ministry of Defence versus the Press: after 16 years of international war coverage, 13 of them on behalf of *The Sunday Times*, I was repeatedly turned down by the Ministry of Defence for permission to be part of the press corps that is now covering the Falklands crisis. Their excuse was that there was not enough accommodation on board any of the ships, even though they managed to accommodate three million Mars bars.

When I think of the wasted opportunity to provide my country with a graphic and historical document illustrating what our men are contributing in the defence of freedom and democracy, we owe it to their courage to give them a proper place in our history.

The one thing you will discover in the front line of wars is that the soldiers up at the sharp end always welcome your presence as a jounalist and are often warmed to know that their loved ones and country can understand their dangers and hardships, which they are living through. We in turn have learnt nothing about the war, apart from its technological details and capabilities of these deadly, obscene weapons.

Ironically, I have just learnt through reliable sources that my application to accompany the task force was met with some enthusiasm at the Ministry of Defence, but was later turned down flat by a high-ranking military officer who, I suppose, considered my experience in war coverage a threat to the image that they would find comfortable.

Yours sincerely,
DONALD McCULLIN,
(Photographer),
Hill Farm,
Levels Green,
Farnham,
Bishop's Stortford,
Hertfordshire.
June 10.

Pages 172-73
Letter of commission by
the Imperial War Museum
in anticipation of Ministry
of Defence approval for
Don McCullin to join the
task force heading for
the Falklands, 1982.
Permission was withheld
and the letter never sent

Left
Don McCullin, letter to
The Times, June 1982

Pages 176-77
Lumb Lane, Bradford, 1978

doing so would have avoided that carnage of war. I started to learn new aspects to photography.

I always had a fascination with the north of England. In 1963, after my eldest son was born, my wife let me go away for a few days to the north. In my yellow Ford Consul I drove three hundred miles all the way up to West Hartlepool. I was there for no particular reason. It was the bitter winter of '63 and I was frozen in my car. I climbed into my sleeping bag in the back. I'd actually bought a bottle of Tizer and a custard tart for my breakfast. When I woke my custard tart was frozen like a rock and my Tizer was solid. So were my legs from the knees down. I got out, stretched, looked around and saw the huge, smoking chimneys of a steel foundry at dawn. I imagined I could have been looking at the chimneys of a concentration camp. It was an extraordinary scene. The smoke was drifting to the left and there was a broken fence. The wasteland was frosted. I thought the scene needed a human being and sure enough, a man came round the corner, hunched into his old raincoat, and walked towards that foundry. I took one picture, got in my car and thought, 'I'm going home.' I know it was madness. I had just this one picture, but somehow I thought I'd got something. As I was driving out of town, I crashed into a bus, so I was very depressed. I had to stay the night and calm down. I went to a dreadful lodging house, knocked on the door and asked for a room. I went upstairs and there were lots of lorry drivers sitting on the edges of double beds, exhausted from driving and scratching themselves as if they had lice. I went down to my car to get my bag but jumped in and drove out of town as quick as I could. I moved on to the next town and found somewhere to stay. The following day, I saw men gathering coal dust from the sea. I couldn't believe what I was seeing. This looked like a scene from Bill Brandt, whose work had originally inspired me to go north. I only exposed two and a half rolls of film, made a six-hundred-mile round journey, smashed up

my car and got one of the best pictures of my life. It was worth the effort.

I recently published a book on England in which I said that the country has changed enormously. Now we have an endless diversity of minority groups, endless cultures and foods – all kinds of aspects of life that weren't in the England I knew as a child. The fear of immigration is on many people's minds in every country. But we couldn't run our hospitals, our railways or anything now without these people who have been willing to come and share our lives. In Finsbury Park, where I grew up, there were some of the first wave of West Indians. They were resented and still are in some areas. We are living in a changed Britain, an evolving nation. For me, the greatest thing of all is the fact that we no longer govern other people's lives in our colonies. Thankfully they have regained their dignity and freedom from the Empire.

In Africa and India people wouldn't have dreamt that you could find poverty in England. They imagine everybody in England is comfortable. But the truth is, I could still go back to the north today and find people living below the breadline. There's a different psychology in our society now. People go down the drain quicker these days because they've lost their dignity. There are alcohol and drugs, so calamity comes earlier, especially to those minorities. Others have done rather well, probably too well.

I went back to Bradford and found Shias flogging themselves on the Day of Ashura. I've seen this in Iran. I've seen the blood pouring off the shoulders and backs of men who were thrashing themselves with chains. To find this in the north of England, in Bradford, is quite extraordinary. There is always something to discover. It's as if I'm a child on a Cornish beach, turning over stones looking for marine life, crabs and little creatures. It's fascinating and it's nothing to do with photography. It's what you make of your life and how you perceive that life.

5

A NEW DIRECTION
1983–2009

Somerset, 1992

Still life with souvenirs
from Vietnam, Somerset,
1992

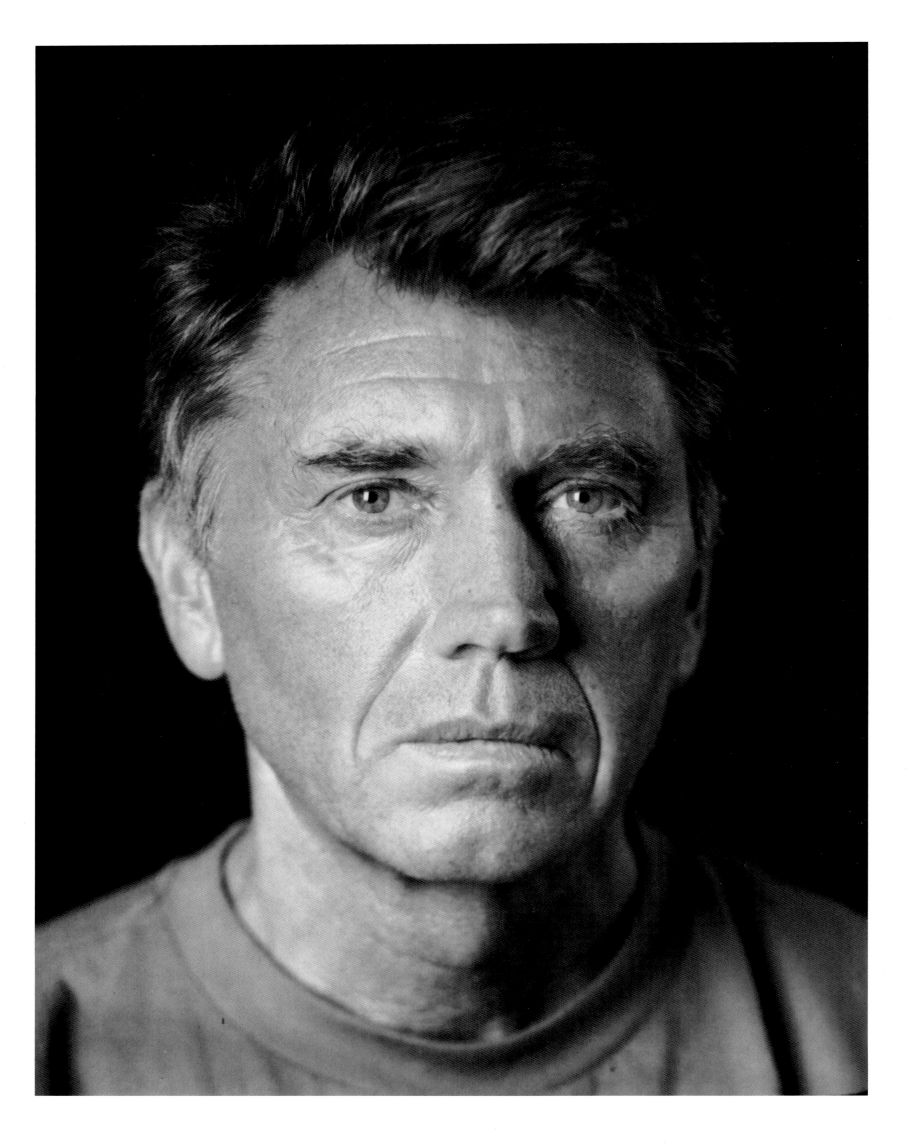

My landscapes have become a form of meditation. They've healed a lot of my pain and guilt. When I was injured in wars, I thought it was good for me to bleed, to hurt and have pain. Why should I stand over others and photograph their pain and see their blood? The landscape gave me a sense of balance. When I came back to England, I could return to peace, to the assurance of knowing I could walk into my house and there would be protection, food and warmth. Now I'm also surrounded by glorious countryside. Some of it, which I choose to photograph, is the landscape of Arthurian myth.

I only photograph in the winter, because I'm afraid of making summer landscapes that look like chocolate-box pictures. I love photographing when the trees are bare and the Somerset Levels, the Vale of Avalon, are temporarily flooded. I like the reflections of the wild, naked trees and the flooded land. You occasionally see otters splashing in the dykes. I love watching the cloud formations coming from the Atlantic on the flows of winds and currents. I can't wait to get my camera out and go and stand in some cold, muddy field or on the side of a hill, and I don't have to talk to anybody. I don't have to ask permission from anybody and it's sheer joy. It's like a man who goes fishing. Sometimes he sits there all day long, eating his sandwiches and catching no fish. It never bothers him. There's just the joy of being there – being there is what it's all about.

In summer, the trees are almost clogged with leaves. In winter, they are defined. I can indulge myself in many ways, but I cannot allow myself to miss a winter's day if there's a chance of getting my camera onto a tripod and of standing at the edge of a field and watching the clouds. They change almost as if they are talking to me. I can understand Turner's passion for skies. I like my landscape photographs to have the most perfect composition, because I want them to be kind on the eye. I want you to fall in love with them.

You're not going to love one of my war photographs, because they were never made for that reason. But my landscapes are for you to enjoy.

I can't explain how happy I am in my darkroom. I process my own film, which in itself is a tremendous excitement. Many photographers today don't get involved with this. I keep everything close to my chest. I shoot the picture, I process the film, I make the print and it's like bringing a baby into the world. Some of my negatives are now fifty years old and they are showing signs of fragility. The emulsion is beginning to crack. It's all about time really. Photography doesn't belong to me. I just borrow it.

It's a very personal process. Because everything is moving towards digitalisation, markets change and manufacturers have ceased making the papers that I liked to use. They provided such quality, such beauty. Now I'm struggling with paper which is equally, if not more, expensive. My life is changing. I can no longer sustain eight, nine or ten hours in the darkroom. For the last fifty years I've been inhaling the photographic chemicals and they are not good for me. When it all ends for me, I will have run my time, and it's been a very enjoyable one.

After a ten-year break I went back to war in northern Iraq in 1991. A friend called me from Damascus and said there would be a visa waiting for me at the airport. I rang the *Independent* and they said they'd look after me when I got back. I left the Sheraton Hotel in Damascus at six in the morning and we headed north-west to the Kurdish area. I remember seeing what I thought were Roman columns in the distance and of course they were. Many years later I came back to that site, Palmyra, and photographed those very columns.

We eventually arrived in Kurdistan, on the borders of northern Iraq and Syria. We'd arranged to cross into Kurdistan and the first thing we saw was a group of about a hundred Iraqi prisoners the Kurds had captured and were threatening to kill. I photographed

the prisoners, who were all a bit edgy and asking for cigarettes, which I don't carry. Then we joined the Kurds and made our way towards the town of Arbil. A few days later they said they were going to capture the city of Kirkuk, the great oil town of northern Iraq. I joined a convoy of 4x4s to the edge of Kirkuk. The Kurds had overrun the outskirts and were fighting for the railway station. I joined that battle. When they captured the station, they were very excited. They also captured all kinds of anti-aircraft guns and other weapons.

Towards the evening, standing on one of the buildings, it was suddenly obvious the Iraqis were counter-attacking. Thousands of tracer bullets were coming in and we rapidly left along the very straight road to Arbil. Halfway down the road we could feel the battle was pinching us in. We had to drive like fury to avoid being caught in the cauldron by the Iraqis who were cutting off the road. We just managed to escape back to Arbil. Unfortunately, three correspondents were taken prisoner in Kirkuk. One was murdered on the spot by Iraqi soldiers. The other two were taken blindfolded to Baghdad, where they were mistreated and then thrown out.*

The pincer battle continued the following day and I was with about thirty Kurdish fighters in a tank bunker, which actually belonged to the Iraqi Army who'd vacated it. I took some photographs of them all crouching behind the bunker and then it became rather dull and I went down the road about two hundred yards. As I was talking to other Kurdish fighters on the road, a direct hit landed on the bunker, killing four of the Kurds. I could see the explosion and the men running, then the cars started bringing the wounded, covered in blood.

I can go back to a war now and do exactly the same thing. I'm totally conditioned. I couldn't do what I did in Afghanistan with the mujahideen in the early eighties. I can't walk over mountains any more or run. But there's nothing about war that would defeat me

because of my nerve. I have fears of course, but I also have ways of controlling those fears.

I did, foolishly, go back to the Iraq War in 2003. I was supposed to receive preferential treatment from the Kurds whom I'd been with before, but that didn't happen. We flew to Turkey and there was a whole brigade of press trying to get in. They'd been refused entry from Kuwait in the south by the Americans. Seeing two thousand journalists squabbling made me realise I had to get away from the circus and connect with the Kurds I knew, but they wouldn't help. For some reason they went cold on us. I suspect it was because the Americans based in the north told the Kurds to keep us out. So I joined up with Ahmed Shalabi and his motley band of mercenaries.

I saw absolutely no action whatsoever. It was a blow. Also, I was stuck inside Iraq. The Turks who took us in wouldn't let us out. We couldn't go south, because Saddam was still in control. We couldn't go to the Syrians. I was trapped there for two months. I never got a decent picture. Not one, except for a lovely picture of some children in Arbil. It's one of my nicest pictures. Not all my photographs are terrible.

Now I don't have any desire to go to war. I have said it before, but this time I mean it. I would dread above all to be in a war with my family. I have always known that on my own I could try to survive. I would be terrified if I was with my own family in a war.

I have new plans. I've completed a book about the southern frontiers of the Roman Empire. As well as seeing Palmyra at dawn, as I described, many years ago I was with Bruce Chatwin in a Roman ruin in Algeria. It stuck in my mind. I wanted to explore the Roman world. My publishers, Jonathan Cape, gave me strange glances, but I decided to start in Palmyra and Baalbek, then show them some prints. I did just that. I came back and made big prints and took them to Cape. Mark Holborn, who designs and produces my books, was fine, but I knew they still needed some convincing,

which fired me up. I've completed this huge project and now the book is under way

Those colossal Roman stone structures from two thousand years ago filled me with awe, then it dawned on me how they were achieved. Through cruelty. Through wickedness and slavery. The staggering accomplishment was the product of brutality. It reminded me of the German camps where people worked until they dropped. This achievement was being stolen from me as I looked at it. I thought I almost could hear the cries as people were crushed under those huge stones. One comes away with mixed experiences, and they're valid feelings.

I tried to go back to Algeria and I went to a consulate in London, but they mocked me. I rang the Algerian Embassy in Holland Park and arranged to meet the Culture Secretary, who was very charming. He offered me tea and I showed him a couple of my photographs from Baalbek and he helped me. I got my visa, arrived in Algeria, had my passport stamped and felt on top of the world. I walked into the main airport and my cameras were immediately taken from me, put through the X-ray machine and confiscated. I was under the wing of the British Council and the embassy in Algiers, so four days later the cameras were released and then a man introduced himself as a BBC fixer. He said, 'You need help and I'm going to help you. Be ready at eight o'clock in the morning. You're going to the Foreign Ministry with me. I know the people there. We'll get the permissions.' A woman at the ministry gave me the stamp of approval and even said she knew my work, and the next moment I was on my way to Timgad, one of the southernmost Roman outposts.

I also went to Morocco, Tunisia, Jordan, Syria and Lebanon. I ended my book on a strange note by going to Hadrian's Wall in a blizzard, because I was trying to put myself in the mind of a Roman soldier. He'd probably have been a Goth or a Gaul, not necessarily Roman. It must have been the last place in the world a soldier would have wanted to be posted to. It's almost like being posted to the Canal Zone, as I was long ago.

As well as landscapes, I am fascinated by still lifes. I have spent a great deal of time in museums looking at the Flemish and Dutch masters. I love the great draughtsmen – Leonardo and Michelangelo. For me, looking at them is like having a transfusion. It's the same with photography. I most admire the photographers from the turn of the nineteenth century, like Peter Henry Emerson who photographed the Norfolk Broads. He recorded the simple way of life. My still lifes provide an even deeper form of escapism than my landscapes. I've always turned to God to save me, which is a typical Judas-like action. But in the still life I can build on a different aspect. I've amalgamated and married my bronze Buddhist pieces with cuttings from the hedgerows here in Somerset. I've included the gleaning of the fields with mushrooms, nuts and fruit from my orchard. People say my landscapes are about war, which is hurtful for me, and they say my still lifes are about religion, because I've married other people's faiths.

I suppose you can see in my landscapes the dark Wagnerian clouds, which I darken even further in my printing, the nakedness of the trees and the emptiness, which make the earth look as if it had been scorched or pulverised by shells. There is a look of Flanders about some of my pictures. I'm remembering the image of the broken trees and flooded shell-holes of Passchendaele. It's just the way I see things. There's a darkness in me. There's no possible way there couldn't be. I'm not mad. But someone might say I'm probably suffering from controlled madness. I am disciplined. I have a fetish about cleanliness and tidiness. There is precision in what I do. I believe in myself and I believe in my work. I don't believe I can trust humanity. I love my nearest and dearest and this landscape. But I'm very untrusting. I'm bound to be when I've seen so many men murdered.

I've only played with the truth once in my life –
on the single occasion I moved objects to arrange a
picture. I saw two American soldiers hunting for
souvenirs from the body of a North Vietnamese soldier.
He could only have been eighteen or nineteen. They
were gingerly creeping closer to him, fearing a booby-
trapped body. When they'd finished what I regarded
as looting and had marred his few possessions, I was
disgusted. They called him a dead gook. Now that's
terrible. This man had sacrificed his life. He was an
innocent young man fighting for national reunification.
I *hated* them and yet I was part of them. I was sharing
their food, their uniform, their daily lives. They
trampled on his possessions, his pictures of his mother,
his sister, the little snapshots of seated children.
Ironically, there was even a medical kit and this man
had a bullet through his teeth and the rest of his brains
were shot out the back of his head. I felt he deserved
protecting. He deserved a voice. He couldn't speak so
I was going to do it for him. I shovelled his belongings
together and photographed them. That's the only
contrived picture I've taken in a war. You don't need
to contrive war pictures. Things happen very fast.
People die in front of you. People scream. People claw
at you to help them. There's no need to go around
arranging the still life on the battlefield. But that's the
only time, truthfully, I've ever done that. Many people
ask me about the photograph. I have no shame in saying:
'Yes I did it.' He couldn't speak. I spoke for him.

I'll not stop until it's over. I've asked to be
cremated and I want my ashes scattered down by my
little river, so I can be free, like the Orientals, to walk
at night and maybe fish with my eyes. I don't go
fishing any more – I can't bear to take the hooks out
of their mouths. I look at them. I know exactly where
they're hiding from me. I can always stalk them and
see them swimming in their glory. It's fantastic to
watch trout move from side to side across the river.
It's magical. It's like a ballet. There's no need to kill a
trout that's too small for the plate. I don't kill anything
here. That's why I bought the land on the other side of
the river. Somebody wanted to buy it to stalk the deer.
I won't allow them to shoot on my land. I wake up in
the morning and see the deer under my apple trees,
about five hundred yards away, and I couldn't be hap-
pier. It's about making the right decisions for the last
part of my life.

* The Imperial War Museum has acquired photographs of Operation Journalist – the Royal
Marines mission to track down what happened to the correspondents – taken by professional
photographer Giles Pryce who was serving in Kurdistan with the Royal Marines. The group
(who were originally with the party that had crossed into the area with Don McCullin) were:
Gad Schuster Gross, a photojournalist on assignment for *Newsweek* magazine; Alain Buu, a
Vietnamese-born photographer for Gamma-Liaison (who'd fled Vietnam during the exodus
of boat people in 1975); and Frank Smyth, on assignment for the *Village Voice* and CBS Radio.
Buu and Smyth were imprisoned for eighteen days in Baghdad before being released. Schuster
Gross was murdered on 21 March, 1991 and was the only journalist to die during the Gulf War.

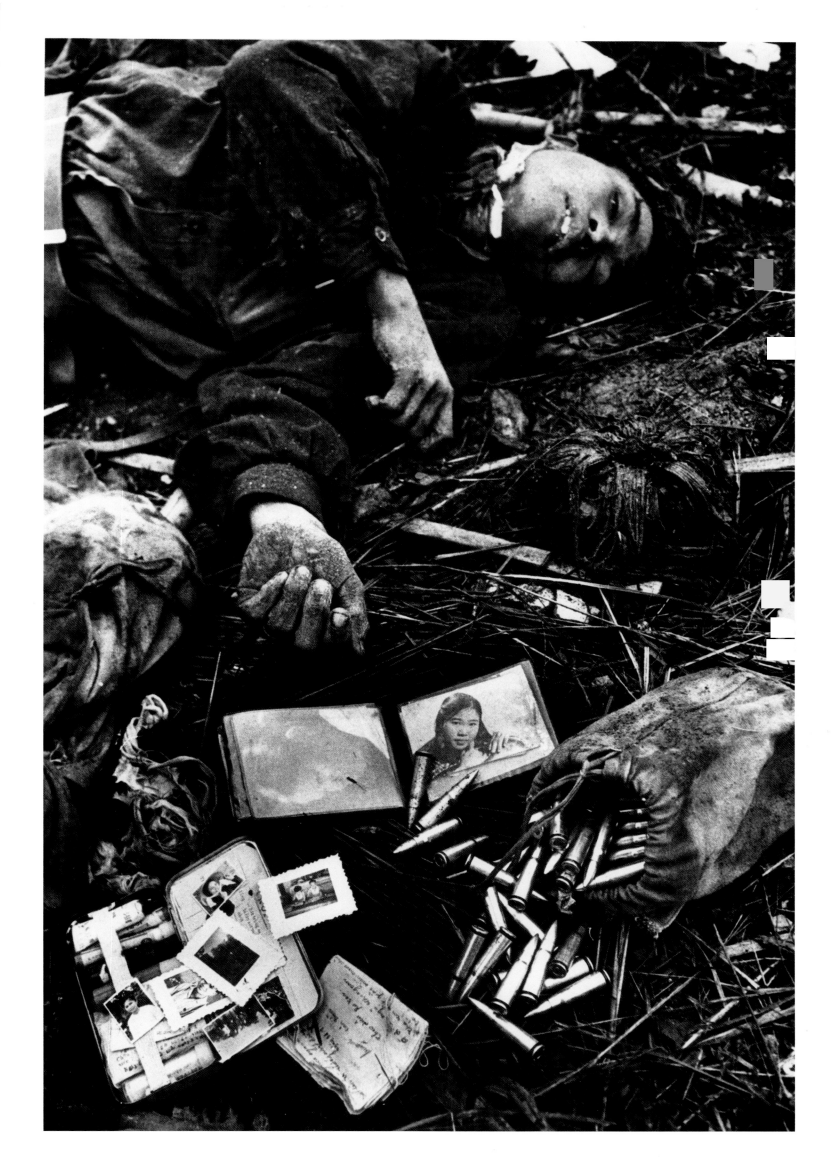

DON McCULLIN
AND THE HISTORY OF PHOTOGRAPHY

YEAR	DON McCULLIN	PHOTOGRAPHIC TECHNOLOGY	PHOTOJOURNALISM AND WAR PHOTOGRAPHY	WORLD EVENTS
1933		• Introduction of the Leica III 35mm camera with interchangeable lenses and coupled rangefinder. The robust, flexible and portable camera produces high-quality images, ideal for photojournalists	• Start of a 'golden age' in photojournalism • Bill Brandt starts documenting British society	• Adolf Hitler appointed Chancellor of Germany
1935	• Frederick McCullin, a fishmonger, marries Jessie Harvey in St Pancras, north London. Their first child, Donald, is born in the Middlesex Hospital on 9 October • Frederick suffers from severe asthma and is only capable of occasional work. The family live in two rooms in Northdown Street, Islington, London, before moving to Fonthill Road, Finsbury Park	• Associated Press introduces Wirephoto service for news photography	• US Farm Security Administration commissions documentary photographers to record impact of the depression and drought on US farmers • Bill Brandt publishes his first book, *The English at Home*	• Germany starts to rearm • Italy invades Ethiopia
1936	• Birth of Don McCullin's sister, Marie	• Introduction of Kodachrome 35mm colour transparency film and Agfacolor-Neu colour transparency film	• Henry Luce launches *Life* magazine in America • Robert Capa photographs *Death of a Loyalist Soldier*, supposedly the first war photograph to show the moment of death in combat	• Germany occupies the Rhineland • Spanish Civil War begins
1937		• Edwin Herbert Land founds the Polaroid Corporation in Massachusetts	• Robert Capa, David 'Chim' Seymour and Henri Cartier-Bresson work as staff photographers for the French *Ce Soir* newspaper	• Japan invades China • Hindenburg disaster
1938		• Hans Hass, a German Army diver, develops a homemade watertight camera housing and experiments with underwater photography	• German Army starts to recruit official photographers to generate propaganda, using the Leica camera • Edward G. Hulton and editor Stefan Lorant launch *Picture Post* magazine in Britain • Bill Brandt publishes *A Night in London*	• Germany annexes Austria and the Sudetenland in Czechoslovakia • Munich Agreement
1939	• Don McCullin starts school at Finsbury Park Primary School. Struggles due to undiagnosed dyslexia and disruption caused by periods of evacuation during the Second World War • On outbreak of war, Don and sister Marie are evacuated to Huntingdon, Cambridgeshire. They return home when air raids fail to materialise	• Agfa introduces Agfacolor, the first colour negative motion-picture film	• German and British air forces start aerial reconnaissance photographic missions • Control of Photography Order (listing what may not be photographed) issued in Britain on outbreak of war • Ministry of Information Photograph Division set up in London. Censorship and war pool arrangement introduced to facilitate distribution and publication of officially approved press photography • Professional photographers, including Cecil Beaton and Henri Cartier-Bresson, volunteer to serve as official photographers in their respective countries	• End of Spanish Civil War • Start of Second World War • Evacuation of children from British cities • The 'phoney war'
1940	• Don McCullin and sister Marie are evacuated for the second time to Norton St Philip, Somerset. Brother and sister are sent to separate homes • Frederick McCullin serves as air-raid warden	• RAF develops technique for aerial night photography	• RAF Photographic Development Unit set up. Evolves into Photographic Interpretation Unit. • Henri Cartier-Bresson captured during fall of France. Buries his Leica camera to save it from falling into enemy hands and becomes a prisoner of war • Bill Brandt, Cecil Beaton, George Rodger and others photograph the Blitz in Britain	• Food rationing starts in Britain • Fall of France • Winston Churchill becomes Prime Minister • Battle of Britain • Blitz begins
1941	• Don McCullin returns home after 18 months. Marie remains in Somerset	• Kodachrome colour film made available to British official photographers after America enters the war	• MOI Photograph Division in London processing 1,000 photographs a day • Formation of British Army Film and Photographic Unit (AFPU). First unit deploys to North Africa • Bert Hardy joins *Picture Post* magazine • George Rodger undertakes the longest single assignment of the war for *Life* magazine	• Japan, America and Russia enter the war

YEAR	DON McCULLIN	PHOTOGRAPHIC TECHNOLOGY	PHOTOJOURNALISM AND WAR PHOTOGRAPHY	WORLD EVENTS
1942	• Don McCullin's brother Michael born	• Kodak introduces Kodakcolor colour negative film	• Cecil Beaton covers the war in Africa and the Middle East for the Ministry of Information • US Signal Corps official photo library and laboratory move to the Pentagon after producing first wartime publication, a book on Pearl Harbour • Edward Steichen becomes Director of US Naval Photographic Institute • Robert Capa covers the North African landings for Life • Bert Hardy joins the AFPU as an official army photographer	• Japan invades Burma • Fall of Singapore • Battle of El Alamein
1943		• RAF starts experimenting with infrared aerial photography, the first military use of infrared technology in Britain	• Cecil Beaton covers the war in the Far East for the Ministry of Information • Robert Capa and George Rodger meet in Naples and discuss the concept which will become the Magnum Photographers Cooperative • Henri Cartier-Bresson escapes from German POW camp, returns to France, retrieves his Leica, joins the Resistance and photographs the occupation	• Allied landings in Sicily and Italy
1944	• Don McCullin is evacuated for the third time, to a chicken farm in Lancashire, to escape the V-weapons campaign	• Infra-red aerial photography used to locate V-weapon launch sites in Europe	• Photographers of the AFPU, the US Army Signal Corps and Robert Capa (on behalf of Life) cover the Allied landings in Normandy on D-Day. • Erich Salomen, a German pioneer of photojournalism, dies in Auschwitz concentration camp. • Cecil Beaton covers the war in the Far East for the Ministry of Information	• Normandy Landings • V-weapons campaign begins
1945	• Don McCullin returns home for the final time	• First transatlantic transmission of a colour photo by wire, showing heads of state at Potsdam. Transmission takes 21 minutes	• AFPU team enters Belsen concentration camp to take the first published images of the camp • George Rodger decides to give up war photography after spending a day at Belsen on behalf of Life magazine	• Liberation of Nazi concentration camps in Europe • Dropping of atomic bombs on Japan • End of Second World War • Allied occupation of former Axis countries begins
1946	• Don McCullin attends Tollington Park Secondary Modern School (now George Orwell Secondary School), Turle Road, Hackney, London, but continues to struggle with his education	• Kodak introduces Ektachrome colour transparency sheet film (the first colour film which can be processed by any photographer) and the dye transfer process for making colour prints • In occupied Japan, Nippon Kogaku designs first Nikon 35mm SLR camera, combining elements of the Leica and Contax cameras	• AFPU disbands. Arrangements for Royal Navy and Royal Air Force photographers continue unchanged. • National Press Photographers Association founded in US	• Cold War begins • Start of First Indo-China War • BBC Television resumes service
1947			• Magnum Photos founded in New York • Ministry of Information reconstituted as Central Office of Information and starts to transfer official wartime photographs to Imperial War Museum • RAF Photographic Interpretation Unit becomes Joint Air Photographic Intelligence Centre (JARIC). Aerial reconnaissance missions continue	• Departure of British from India which is partitioned into India and Pakistan
1948		• Hasselblad introduces first medium-format SLR camera • Nikon I goes into production	• Bill Brandt explores the application of high contrast black-and-white photography to surrealism, portraiture and landscape • Robert Capa sustains minor bullet wound in Tel Aviv at the start of the Arab-Israeli conflict	• Start of Berlin Blockade and Airlift • End of British Mandate in Palestine • End of rationing and establishment of the National Health Service in Britain
1949	• Don McCullin awarded Trade Arts Scholarship for drawing ability at Hammersmith School of Arts, Crafts and Building, London		• Henri Cartier-Bresson covers Chinese Civil War	• End of Berlin Blockade and Airlift • Formation of North Atlantic Treaty Organisation (NATO) • USSR detonates its first atomic bomb

YEAR	DON McCULLIN	PHOTOGRAPHIC TECHNOLOGY	PHOTOJOURNALISM AND WAR PHOTOGRAPHY	WORLD EVENTS
1950	• Frederick McCullin dies and Don leaves art school, aged 14, to find employment. Works briefly at Britains Toy Soldier Factory, Hornsey, London, then as a dining-car attendant with London, Midland and Scottish Railway		• Korean War covered by official and press photographers, including David Douglas Duncan and Bert Hardy. The owner of *Picture Post*, Sir Edward Hulton, dismisses editor Tom Hopkinson for refusing to accept Hulton's ban on the publication of Hardy's photographs from Korea • Bill Brandt explores high-contrast black-and-white landscape photography	• Start of Korean War • National service extended from 18 months to two years in Britain
1951	• Don McCullin starts work as messenger boy at W.M. Larkin Cartoon Studios, London			• United Nations Headquarters opens in New York • Festival of Britain
1952			• George Rodger covers the plight of Palestinian refugees for Magnum. The images are not published	• Start of Mau Mau Uprising, Kenya • First test of hydrogen bomb • Death of King George VI
1953			• Joint Air Photographic Intelligence Centre renamed Joint Air Reconnaissance Intelligence Centre JARIC	• End of Korean War • Coronation of Elizabeth II End of First Indo-China War • Egypt becomes a republic
1954	• Don McCullin reports to RAF Cardington at the start of national service. After completing basic training at Wilmslow, he is deployed as a photographic assistant to RAF Benson, Oxfordshire, sorting Second World War aerial re-connaissance films. Volunteers for overseas service		• Robert Capa killed while photographing in Indo-China • George Rodger covers the Mau Mau Uprising (despite hoping to give up war photography)	• End of First Indo-China War • Rationing in Britain comes to an end
1955	• Don McCullin is deployed to RAF photographic sections at Suez (12 months), Kenya (RAF Eastleigh, Nairobi, during Mau Mau Rebellion for 6 months), Aden and Cyprus (RAF Episkopi). Fails written RAF photography trade test but purchases first camera, a Rolleicord 4, while in Kenya		• Helmut & Alison Gernsheim publish their book *History of Photography*, the first comprehensive work on the subject	• Formation of Warsaw Pact • USSR announces the end of its war with Germany
1956	• Don McCullin is demobilised and returns to work at W.M. Larkin Cartoon Studios as darkroom assistant.	• Kodak starts to sell film without processing being included in the purchase price, thus allowing its film to be processed by any laboratory	• David 'Chim' Seymour of Magnum killed while covering Suez Crisis	• Suez Crisis • Hungarian Revolution • Israel invades Sinai
1957	• Don McCullin pawns his Rolleicord camera which is subsequently redeemed by his mother	• Russell Kirsch, a computer scientist with the National Standards Bureau, produces a computer image of his baby son, believed to be the first digital image, from a prototype drum scanner	• Joint Air Reconnaissance Intelligence Centre and Joint School of Photographic Interpretation relocates to RAF Brampton • *Picture Post* ceases publication	• Launch of Russian sputnik satellite triggers space race between US and USSR
1958	• Following the murder of a policeman by a London gang member, Don McCullin offers his photograph of The Guv'nors to *Observer* picture editor, Cliff Hopkinson, who commissions further photographs			• Race riots in London and Nottingham • Common Market formed
1959	• Don McCullin's first photographic feature published in the *Observer* • Marries Christine Dent. They go on to have three children: Paul, Jessica and Alexander	• Introduction of the Nikon F camera, the photojournalist's 'workhorse'	• Newspaper production in Britain severely affected by the first national strike by print workers since 1926. Printing strikes would hamper the newspaper industry for the next 20 years	• Start of Vietnam War • Cuban Revolution • Opening of the first British motorway, the M1

YEAR	DON McCULLIN	PHOTOGRAPHIC TECHNOLOGY	PHOTOJOURNALISM AND WAR PHOTOGRAPHY	WORLD EVENTS
1960	• Don McCullin starts work as a freelance photojournalist, supplying material to *News Chronicle*, *Town* and the *Observer*			• Communist insurgents defeated in Malaya • Cyprus and Congo gain independence • End of Mau Mau Uprising
1961	• Don McCullin travels to Berlin (without assignment) to cover construction of Berlin Wall • Photographs published by the *Observer*. Wins British Press Photography Award for Berlin work. Placed under contract as part-time freelance photo-journalist for the *Observer*. • Sells Rolleicord and purchases 35mm Pentax SLR camera on advice of Philip Jones Griffiths			• Construction of Berlin Wall • Bay of Pigs invasion, Cuba • Russian cosmonaut Yuri Gagarin first man in space • Sierra Leone and Tanganyika gain independence
1962	• Don McCullin covers protests against Cuban Missile Crisis and other protests by anti-war campaigners		• US Army photographers attached to Department of the Army Special Photo Office (DASPO) deployed in Vietnam • First issue of the *Sunday Times* magazine	• Cuban Missile Crisis • UK introduces immigration controls from West Indies and Pakistan
1963	• Don McCullin travels to north of England during the harsh winter where he completes his first major photographic essay on the steelworkers of West Hartlepool	• Polaroid introduces Polacolor Type 48, the first instant colour film • Introduction of Cibachrome silver dye bleach process for making prints from colour transparencies	• RAF School of Photography founded at RAF Cosford	• Coldest winter in Britain since 1740 • Assassination of US President John F. Kennedy • Fighting breaks out in Cyprus • Kenya, Malaysia and Zanzibar gain independence
1964	• Don McCullin covers Congo disguised as mercenary, including the Stanleyville massacres		• First war assignment for Bryn Campbell, picture editor of the *Observer*. Becomes the first British photographer to win the World Press Photo Award for his coverage of Cyprus • Michael Rand appointed Art Director of the *Sunday Times* magazine • Launch of *Daily Telegraph* and the *Observer* colour supplement magazines • *Daily Herald* newspaper becomes *The Sun*	• Leonid Brezhnev becomes leader of Soviet Union • United Nations peace keeping Force established in Cyprus • Fighting escalates in Vietnam • Yasser Arafat becomes leader of Palestinian Fatah guerrilla force • Start of Bush War in Rhodesia
1965	• Don McCullin leaves the *Observer* to become freelance photojournalist for The *Sunday Telegraph* • Covers the Vietnam War (the first of 15 trips to Vietnam) for the *Illustrated London News*	• Fuji Photo Film USA Company established in New York	• Royal Army Ordnance Corps (RAOC) takes on responsibility for British Army photography • US combat unit photographers start work in Vietnam • Formation of the US Army 221st Signal Company, a photographic unit, to cover Vietnam • David King appointed Art Editor of the *Sunday Times* magazine	• US military build up and bombing campaign in Vietnam • Unilateral Declaration of Independence (UDI) in Rhodesia
1966	• Don McCullin joins *Sunday Times* magazine at invitation of David King. His first assignment, a feature on life in Mississippi, USA, published June 26 1966		• Bill Brandt publishes *Shadow of Light*, a compilation of his best work • Lord Thomson buys *The Times* • *The Times* starts printing news on its fron page, 3 May 1966	• France leaves NATO • 116 children die in Aberfan Disaster, Wales • England wins the football World Cup • International protests against US policy in Vietnam
1967	• Don McCullin signs exclusive contract with the *Sunday Times* magazine. He works primarily with Michael Rand (art director) and David King (art editor) under the overall direction of Harold Evans • Briefly joins Magnum • Covers Field Marshal Lord Montgomery's return to El Alamein and the Six Day War in Jerusalem		• Harold Evans appointed editor of the *Sunday Times*	• Six Day War, Middle East • British economic blockade of Rhodesia

YEAR	DON McCULLIN	PHOTOGRAPHIC TECHNOLOGY	PHOTOJOURNALISM AND WAR PHOTOGRAPHY	WORLD EVENTS
1968	• Don McCullin's *Sunday Times* assignments include: Vietnam, Battle for Hue, Tet Offensive and Czechoslovakia (for *Time*)	• First photograph of the Earth taken from the Moon	• US Army photographer Ronald L. Haeberle photographs My Lai Massacre • Eddie Adams (Associated Press) photographs South Vietnamese National Police Chief Brigadier General Nguyen Ngoc Loan as he shoots a Vietcong prisoner in the head	• 'Prague Spring' is crushed by Soviet forces • Tet Offensive, South Vietnam • Assassination of Martin Luther King
1969	• Don McCullin's *Sunday Times* assignments include: Biafra, Vietnam and the London homeless		• Publication of Haeberle photographs in *Life* magazine leads to international condemnation of US and are used as evidence in subsequent war crimes trial	• Start of the 'troubles' and British Army deployment in Northern Ireland • US begins withdrawal from Vietnam • Yasser Arafat elected Chairman of Palestine Liberation Organisation • First Moon landing
1970	• Don McCullin's *Sunday Times* assignments include: New Guinea, Chad, Jordan, Cambodia (during which he is wounded at Prey Veng) and Northern Ireland • Witnesses destruction of three hijacked airliners by Palestinian gunmen in Jordan		• Death of photojournalists Gilles Caron and Kyoichi Sawada in Cambodia	• Khmer Rouge gain power in Cambodia • President Nixon announces withdrawal of US troops from Vietnam. Launches incursion into Cambodia, leading to widespread protests in US • End of Biafran War • PLO hijacks three passenger aircraft to Jordan
1971	• Don McCullin's *Sunday Times* assignments include: Guatemala, Bangladesh cholera epidemic and Northern Ireland Londonderry riots • First book published: *The Destruction Business* • First exhibition opens: *The Uncertain Day* at Kodak Gallery, London	• Introduction of the Nikon F2 camera	• Death of *Life* photographer Larry Burrows and three other photojournalists when their helicopter is shot down by North Vietnamese over Laos • Photographer Francis Bailly murdered by Khmer Rouge • First use of phototype in *The Times*	• US public opposition to the Vietnam War continues to grow • Decimal currency introduced in Britain
1972	• Don McCullin's *Sunday Times* assignments include: Vietnam (retreat of South Vietnamese Army during North Vietnamese Easter offensive), China (with Lord Thomson) and Uganda (arrested, jailed in Makindye prison and deported)		• RAF School of Photography becomes a joint service unit at RAF Cosford • Nick Ut (Associated Press) photographs Phan Thi Kim Phuc, a nine-year-old Vietnamese child, fleeing a US napalm attack • *Life* Magazine ceases publication	• Last US combat troops leave Vietnam • Bloody Sunday, Northern Ireland • Ugandan Asians expelled by Idi Amin • Bangladesh established as sovereign state • President Nixon visits China • North Vietnam launches Easter Offensive • Watergate affair begins
1973	• Don McCullin's *Sunday Times* assignments include: Cambodia (narrowly escapes death when aircraft he decides not to travel in is shot down), Tuaregs famine, Niger, London homeless and Israel (Yom Kippur War) • He is recalled to London following death of friend and journalist Nick Tomalin on Golan Heights		• Death of Edward Steichen • Journalist Nicholas Tomalin killed on the Golan Heights by Israeli fire (while wearing a flak jacket borrowed from Don McCullin)	• Britain joins the Common Market • IRA detonates first car bomb in London • Yom Kippur War in the Middle East • Arab countries restrict oil supplies, causing economic crisis. Acute fuel shortage causes three-day working week in Britain
1974	• Don McCullin's *Sunday Times* assignments include: Algerian immigrants in Marseilles, Consett and Durham		• New editorial policy at *Sunday Times* magazine concentrates on local and European stories	• President Nixon resigns over Watergate affair • Bangladesh floods kill thousands

YEAR	DON McCULLIN	PHOTOGRAPHIC TECHNOLOGY	PHOTOJOURNALISM AND WAR PHOTOGRAPHY	WORLD EVENTS
1975	• Don McCullin's *Sunday Times* assignments include: Cambodia (fall of Phnom Penh), Paraguay with Norman Lewis and Angola • Barred from Vietnam after being classified as 'undesirable' (following 1972 coverage of South Vietnamese Army's retreat)	• Steven Sasson of Kodak designs and builds the first digital camera, generating black-and-white images at 0.01 megapixel resolution. The camera is a research prototype, not intended for commercial production	• David King leaves *Sunday Times* magazine	• Khmer Rouge take power in Cambodia, leading to genocide • End of Vietnam War. North Vietnam invades South Vietnam and reunites the country under Communist rule
1976	• Don McCullin's *Sunday Times* assignments include: Beirut, Lebanon, Berlin and Bradford	• Fuji introduces the first ASA 400 colour negative film		• Death of Chairman Mao, China • Massacre of Palestinians, Karentina enclave, Beirut
1978	• Don McCullin starts work on landscape and British photo reportage, covering Bradford and poverty in the north of England	• Konica introduces first point-and-shoot autofocus camera	• *Times* and *Sunday Times* suspend publication for 11 months due to strike action at Times Newspapers Ltd • Magnum photographer Susan Meiselas covers Nicaragua Revolution	• Communist regime installed in Afghanistan
1979	• Don McCullin's *Sunday Times* assignments include: Beirut (photographing Yasser Arafat) and Iran Revolution • Publishes *Homecoming and The Palestinians* (with Jonathan Dimbleby)		• Harold Evans publishes *Pictures on a Page*, his seminal work on photojournalism and picture editing • End of strike at Times Newspapers Ltd on 12 November	• Iranian Revolution • Soviet Union invades Afghanistan • Winter of Discontent in Britain • End of Bush War, Rhodesia • Margaret Thatcher becomes Prime Minister
1980	• Don McCullin's *Sunday Times* assignments include: Mujaheddin in Afghanistan (not published) • First major exhibition at Victoria & Albert Museum, London, & ICP New York: *Donald McCullin* • Publishes *Hearts of Darkness*, introduction by John Le Carr	• Sony introduces first video camcorder • Introduction of Nikon F3	• Following a further strike by journalists, Lord Thomson decides to sell *The Times*	• Gdansk Agreement, Poland • Iranian Embassy siege, London • Start of Iran–Iraq War • Rhodesia gains official independence under Robert Mugabe and is renamed Zimbabwe
1981	• Don McCullin's *Sunday Times* assignments include: Rhodesia's Operation Agila (Rhodesian peacekeeping force) and subsequent independence and El Salvador		• Rupert Murdoch's News International purchases Times Newspapers from the Thomson Corporation • *The Times* publishes first full-page colour photograph on the front page (of the Royal Wedding) • Harold Evans leaves *Sunday Times* to become editor of *The Times*	• Ronald Reagan becomes US President • Rhodesia becomes Zimbabwe • Lady Diana Spencer marries the Prince of Wales • Solidarity Uprising, Poland
1982	• Don McCullin is badly injured in fall from roof in El Salvador. Publication of El Salvador work delayed due to Falklands Conflict • Refused permission to cover the British Task Force and Falklands campaign for *The Times* and the Imperial War Museum • Last major assignment for the *Sunday Times*: covers Israeli siege of Beirut and Christian Phalange massacre of Palestinians in Sabra and Chatila	• Kodak introduces disk cameras and film	• Last use of Linotype by *The Times* which becomes the first national newspaper to be set entirely by photocomposition • Falklands Conflict covered by official and amateur photographers. One press photographer (Martin Cleaver) is allowed • Harold Evans resigns from *The Times* citing policy differences over editorial independence. Replaced by Andrew Neil	• Falklands Conflict • Israel invades Lebanon. Yasser Arafat and PLO forced to leave Beirut
1983	• Don McCullin is dismissed from *Sunday Times* after disagreements with editor Andrew Neil regarding lack of serious foreign and social coverage • Publishes *Beirut: A City in Crisis*		• Creo Company is established in Canada	• US invasion of Grenada

YEAR	DON McCULLIN	PHOTOGRAPHIC TECHNOLOGY	PHOTOJOURNALISM AND WAR PHOTOGRAPHY	WORLD EVENTS
1984	• Don McCullin's first visit to Indonesia • Experiments with new photographic forms: travel, landscape, advertising and commercial work (including work for the Metropolitan Police recruitment programme)	• Epson Corporation introduces the SQ-2000, the first inkjet printer • Kodak introduces videotape cassettes		• Beirut civil war
1985	• Don McCullin makes television documentary with BBC Arena programme: *Homefront* • Photographs in Indonesia			• Mikhail Gorbachev becomes leader of the Soviet Union
1986	• Don McCullin separates from Christine • Sets up home with Laraine Ashton with whom he later has a son, Claude		• Eddie Shah launches *Today*, the first British daily paper to feature all-colour photography • Start of Wapping Dispute. Rupert Murdoch breaks the power of the print unions and relocates News International titles (including *The Times* and *The Sun*) to a new building in Wapping equipped with computer-based printing technology. 6,000 print workers strike over changes, leading to violent confrontations	• US aircraft bomb Libya • Chernobyl nuclear disaster, Soviet Union
1987	• Don McCullin photographs in Indonesia • Publishes *Perspectives* • Publishes *Skulduggery* with Mark Shand	• Kodak and Fuji introduce disposable snapshot cameras • Introduction of PhotoMac photo-editing software, the first photo-editing software for professional photographers, for Macintosh computers	• End of Wapping Dispute	• Gorbachev announces perestroika policy
1988	• Christine McCullin dies of cancer on the day of son Paul's wedding		• Nearly all major UK newspapers leave Fleet Street, their traditional London base, for London Docklands	
1989	• Don McCullin accompanies Mark Shand on a 100-mile walk in India where he photographs the elephant festival • Publishes *Open Skies* (first book of landscapes)	• Tim Berners-Lee introduces what will become known as the Internet (World Wide Web)		• Soviet Union withdraws from Afghanistan • Tianamen Square protests crushed, China • Romanian Revolution
1990	• Don McCullin begins using large-format Linhoff Karolan 5x4 inch stand camera • Travels to India for social documentary project • Publishes autobiography (written with Lewis Chester): *Unreasonable Behaviour*	• Introduction of first commercial digital camera, the Dycam Model 1 • Introduction of Kodak Photo CD system, enabling photographs to be digitised and viewed on a television monitor • Introduction of Adobe Photoshop digital image processing computer software for Macintosh computers	• Harold Evans appointed President of Random House Trade Group • *Observer* reporter Farzad Bazoft is arrested and executed for espionage in Iraq • An exhibition of Robert Mapplethorpe photographs causes a Cincinnati museum to be prosecuted for obscenity	• Reunification of Germany • Iraq invades Kuwait • Release of Nelson Mandela and end of apartheid in South Africa
1991	• Don McCullin covers Kurdish Rebellion in northern Iraq for the *Independent*. The Gulf War triggers brief return to war photography. • Collaborates with HTV (Bristol) on two-part television documentary about his work • Exhibition: *Don McCullin, A Retrospective* (curator Pam Roberts) at Royal Photographic Society, Bath, and elsewhere	• Kodak introduces Professional Digital Camera System (DCS) and first digital camera, the DCS 100 (1.3 megapixels), based on a Nikon F3 camera	• Photographer Gad Gross killed by Iraqi forces while covering the Kurdish Rebellion in northern Iraq	• End of Cold War • Gulf War • Kurdish Rebellion in northern Iraq

YEAR	DON McCULLIN	PHOTOGRAPHIC TECHNOLOGY	PHOTOJOURNALISM AND WAR PHOTOGRAPHY	WORLD EVENTS
1992	• Don McCullin photographs: Irian Jaya (West Papua), Indonesia and Scotland (landscapes) • Awarded Erich Salomon Prize for Photojournalism in Germany	• Cibachrome prints renamed Ilfochrome		• Implementation of no-fly zone over Iraq • Start of Bosnian Civil War
1993	• Don McCullin is awarded CBE • Publishes *Empire of the East: Travels in Indonesia* • Awarded Honorary Doctorate by University of Bradford	• Nikon introduces the Coolscan, the first 35mm film scanner • Introduction of Adobe Photoshop for Microsoft Windows • Prototype mobile camera phone developed by Daniel A. Henderson	• Royal Logistic Corps takes over responsibility for British Army photography from RAOC	• US cruise-missile attack on Iraqi intelligence headquarters, Baghdad • Ahmići massacre, Bosnia
1994	• Don McCullin publishes *Sleeping with Ghosts*,	• Seiko-Epson introduces Epson Stylus Color, the first high-quality colour inkjet printer	• *Electronic Telegraph* becomes the first online version of a British national newspaper	• Genocide in Rwanda
1995	• Don McCullin joins Contact Press Images agency • Spends most of his time in the United States	• Imacon Company is established in Denmark and goes on to introduce the FlexTight 1 Precision Scanne		• Srebenica massacre, Bosnia • Oklahoma bomb • End of Bosnian Civil War
1996		• First Polaroid digital camera • Introduction of APS (Advanced Photographic System) film enables photographers to use standard or panoramic formats interchangeably • First mobile phone with internet connectivity	• Michael Rand leaves the *Sunday Times* magazine after 22 years • Times Online is launched	• First Chechnya War • End of IRA ceasefire sees terrorist attacks in Britain • Osama bin Laden declares Jihad on Americans in Saudi Arabia
1997	• Don McCullin photographs India • Marries Marilyn Bridges, but they retain separate homes and eventually divorce in 2002	• First colour photograph appears on the front page of the *New York Times*		• Tony Blair becomes Prime Minister, ending 18 years of Conservative government
1998	• Don McCullin continues to photograph in India • Retrospective exhibition at the Barbican, London	• Launch of Google Internet search engine		• Operation Desert Fox aims to destroy Iraq's nuclear, biological and chemical weapons programme
1999	• Don McCullin photographs HIV/Aids victims in Africa (South Africa, Botswana and Zambia) for Christian Aid	• Introduction of Nikon D1, first digital SLR camera (2.73 megapixels) for professional photographers	• British army photographers use Nikon D1 digital cameras in Kosovo in addition to colour film	• Račak massacre, Kosovo • Nato intervention in Kosovo
2000	• Don McCullin photographs First World War battlefields for the Royal Mail	• First commercial mobile camera phone, the Sharp J-SH04 by J-Phone (Softbank), Japan • Microsoft releases Windows Me		• George W. Bush becomes US President • Vladmir Putin becomes Russian President • Israel withdraws from Lebanon after 22 years • USS *Cole* damaged by al-Qaeda suicide bombers
2001	• Don McCullin publishes monograph *Don McCullin* • Publishes *Cold Heaven: Don McCullin on Aids in Africa*	• Polaroid Company goes out of business, USA	• British Army photographers cover Exercise Saif Sareea exclusively in digital format	• al-Qaeda terrorist attacks on United States, '9/11' • Anglo-American force moves into Afghanistan
2002	• Don McCullin photographs people of the Omo Valley, Ethiopia • Marries Catherine Fairweather, with whom he has a son, Max	• Digital cameras outsell film cameras		• President George W. Bush and Prime Minister Tony Blair threaten to respond to threat posed by Iraq

YEAR	DON McCULLIN	PHOTOGRAPHIC TECHNOLOGY	PHOTOJOURNALISM AND WAR PHOTOGRAPHY	WORLD EVENTS
2003	• Don McCullin covers invasion of Iraq for *The Times*	• First digital disposal camera, the Ritz Dakota Digital 1.2mp camera (costing $11)	• Invasion of Iraq, first British military operation to be photographed entirely in digital format	• Invasion of Iraq
2004		• Kodak discontinue manufacture of slide projectors and announce plans to discontinue selling reloadable 35mm film cameras in USA and Western Europe	• Trophy' photographs taken by US military personnel provide evidence of US abuse of Iraqi prisoners at Abu Ghraib prison, Iraq • *Daily Mirror* publishes fake photographs of alleged British abuse of Iraqi prisoners. Editor Piers Morgan resigns in following scandal	• Madrid terror bombings • NATO expands to include Eastern European states • Start of Iraq insurgency • American prisoner abuse scandal, Abu Ghraib, Iraq • Boxing Day Tsunami
2005	• Don McCullin publishes *Don McCullin In Africa* • Starts work on Southern Frontiers project	• Kodak discontinues selling reloadable 35mm film cameras in USA and Western Europe • Agfa ceases trading Germany	• Camera phones are the primary source of images recording London terrorist bombings • Royal Navy and Royal Air Force switch to digital photography	• London terrorist bombings
2006		• Nikon discontinues selling most film cameras • Konika Minolta discontinues manufacturing cameras entirely		• British troops deploy to Afghanistan
2007	• Don McCullin covers Darfur refugees from Sudan in Chad for Oxfam • Publishes *Don McCullin In England* • Awarded Centenary Medal by Royal Photographic Society		• *Daily Telegraph* launches Telegraph TV online television service	• End of Operation Banner, the British Army deployment in Northern Ireland
2008	• Don McCullin covers 90th anniversary of the end of the First World War for Ministry of Defence • Publishes *Don McCullin: 100 photos pour la liberté de la presse* with Contact Press Images for 19th World Press Freedom Day	• Bill Gates steps down as Chairman of Microsoft	• Photojournalists and reporters prevented from covering Israeli assault on Gaza Strip	• Israel attacks Gaza Strip • Fidel Castro resigns as President of Cuba • Benazir Bhutto assassinated, Pakistan • War in Ossetia between Russia and Georgia • Greek and Turkish Cypriot leaders meet for peace talks
2009	• Don McCullin photographs Hadrian's Wall to conclude Roman Empire project • Supports *Reporters Without Borders* campaign against the restriction of access to photojournalists in war zones with article in *The Times* commenting on coverage of the Tamil defeat in Sri Lanka and criticising lack of access provided to photojournalists in current conflicts	• Kodak discontinues selling Kodachrome colour film after 74 years	• *Sunday Times* plans to launch its own online edition, separating its content from *The Times'* Times Online website	• Departure of British forces from Iraq • Tamil Tigers defeated in Sri Lanka after 26-year conflict
2010	• Don McCullin's first exhibition and publication with the Imperial War Museum (Feb) • Publication of *Southern Frontiers: A Journey Across the Roman Empire* book (March)			

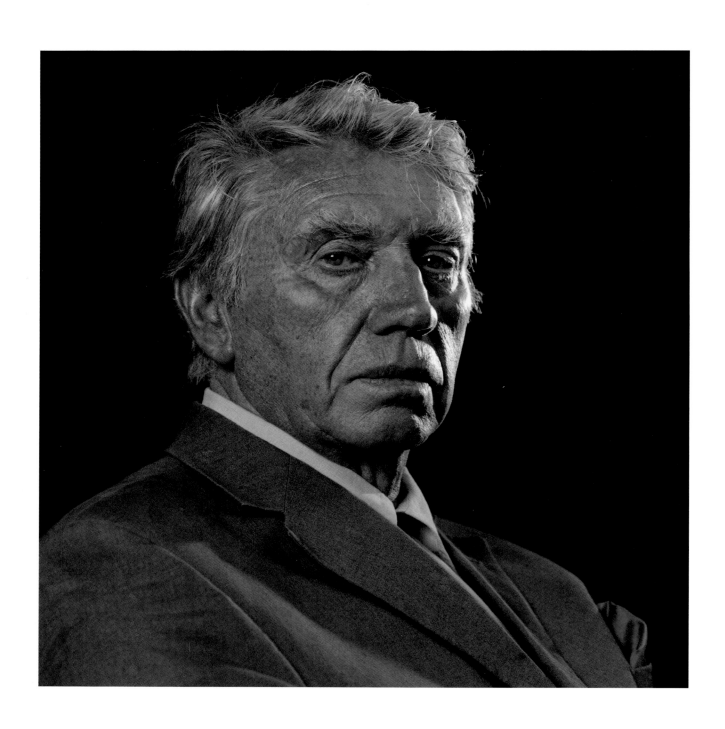

Pages, 204–05,
The Somme battlefield,
2000

Don McCullin, 2009,
photograph by
Richard Ash,
Imperial War Museum

Published by Jonathan Cape in association with the Imperial War Museum

2 4 6 8 10 9 7 5 3 1

First published in Great Britain in 2010 by
Jonathan Cape
Random House
20 Vauxhall Bridge Road
London SW1V 2SA

In association with the Imperial War Museum

www.randomhouse.co.uk
www.iwm.org.uk

The Random House Group Limited Reg. No. 954009

A CIP catalogue record for this book is available from the British Library

ISBN 9780224090261

Photograph by Cecil Beaton on page 9 (IWM MH 2718), photograph on page 11 by Bill Brandt (IWM D 1553) and photograph on pages 16 and 17 (IWM HU 65885) are courtesy of the Imperial War Museum

Photographs of Don McCullin in Chapter 1 and on page 36 are courtesy of Don McCullin. Photographs at RAF Eastleigh on pages 18 and 19 are courtesy of Geoff Dunning. Photographs of Don McCullin on pages 46 and 47 are copyright © John Bulmer. Photograph of Field Marshal Montgomery on page 73 courtesy of Viscount Montgomery. Photograph of Don McCullin on page 81 copyright © Nik Wheeler. Photograph of Don McCullin on page 102 copyright © Foundation Gilles CARON / Contact Press Images. Photograph of Don McCullin by Kyoichi Sawada on page 104 courtesy of UPI. Photograph of Don McCullin on page 140 copyright © Saddri. Photograph of Don McCullin on page 185 copyright © Philip Vermès. Photograph of Don McCullin on page 206 courtesy of the Imperial War Museum.

The Observer, Sunday, February 15, 1959 on pages 26 and 27 are courtesy of the Observer. The cover and title page of The Illustrated London News from March 8, 1965 on pages 62 and 63 are courtesy of The Illustrated London News. Covers and pages from the Sunday Times magazine on pages 68, 69 and 70, 74 and 75, 83, 105 and 105, 106 and 107, 108 and 109, 113, 114 and 115, 16 and 117, 119, 120 and 121, 172 and 173 are courtesy of the Sunday Times. Pages from Paris Match on pages 84 and 85 are courtesy of Paris Match.

Photographs of contact sheets on pages 86 and 87 and of personal documents and artifacts are all courtesy of the Imperial War Museum. The photographs by Don McCullin have been reproduced, where possible, from vintage prints, which accounts for tonal variations throughout the book.

Mark Holborn: Editor
Hilary Roberts: Head of Collections Management, Imperial War Museum Photograph Archive

Abigail Ratcliffe: Publishing and Licensing Manager, Imperial War Museum

Design by Design Holborn

Neil Bradford: Production Director
Printed and bound in China by C&C Offset Printing Co. Ltd

We are most grateful to Lyn Smith and Stu McKenzie for their filmed interviews with Don McCullin and we are especially grateful to Richard Ash for his work photographing objects, documents and publications at the museum. We are indebted to Diane Lees, the Director-General of the museum for granting permission to reproduce previously confidential correspondence. Hilary Roberts at the Photograph Archive of the Museum is grateful to assistance in her research from Mark Haworth-Booth, Anne Tucker and Pam Roberts. Thanks are also extended to Richard Bayford, Jonathan Chadwick, Damon Cleary, Josephine Garnier, Colin Harding, Sarah Henning, Richard McDonough, Michael Nicholson, Roger Smither and James Taylor.

We are indebted to those newspapers and magazines who have allowed reproduction from the actual publications. Special thanks should go to Sinead Porter and Cathy Galvin of the *Sunday Times* who have generously enabled us to have free reproduction of the relevant material. The *Sunday Times* is an important part of Don McCullin's story and this acknowledgement should not pass without tribute to Michael Rand and David King, who were so important in bringing McCullin's work to the public.